Bali

Portraits of Life, Culture and Ritual

TONY NOVAK-CLIFFORD

Kokomo Road Productions • Maui, Hawai'i

A Kokomo Road Production

Printed in South Korea
ISBN#: 978-0-692-17503-3

Acknowledgement

This book is dedicated to my wife, Beth. Thank you for your limitless patience and support through false starts and procrastinations, for keeping the home fires burning during month-long journeys away from home, and for your quiet encouragement to see this project through. Without your love and support, this book would not be possible.

A host of others have lent their knowledge, their time, and their efforts towards making the volume you now hold in your hands come to life…

I will be forever grateful to Tony Van Den Hout, long time Bali resident and fellow photographer of astonishing talent, dealer of fine Asian antiquities, Hindu holy man, possessor of a kind nature, infectious smile, limitless patience and perhaps the best travel companion any curious soul could want. Without your friendship, guidance, and interpretation of the fascinating Balinese world that lies beyond the tourism enclaves, this project would have been impossible.

To photographer/journalist and Ubud fixture Rio Helmi, I extend my most sincere gratitude for providing roof and sustenance, inspiration and advice, friendship, wisdom and laughter.

To Ida Bagus Putu Adi and his family, my first guides into Bali. Always arriving at the airport to fetch me, no matter the hour. For your skilled and patient maneuvering through endless traffic congestion, remote mountain trails to nowhere, crowded markets, shabby and delicious roadside food stalls, temple and cultural protocol, and for your friendship I am blessed.

To the late Michael White (Made Wijaya) – your collected early Bali Post journals provided my first glimpses into the world of the Balinese. They piqued my curiosity and inspired my deep desire to explore and study further. Thank you for your knowledge, humor, insight, and prolific output covering all things Balinese. I am certain I speak for many when I say your efforts remain a valuable resource for which I am grateful beyond words.

To Roy Thompson and his wife Ni Nyoman Eri, I am blessed to know your friendship and to have been welcomed into your family. I have benefitted immeasurably from your essential introductions and from your knowledge and guidance.

To Zenobia Lakdawalla, your advice, aesthetic and assistance in layout and design have contributed immensely to this project.

To Tad Bartimus for the taste of the lash, the keen eye, valuable suggestions, and constant encouragement. Bless you!

To Paul Wood for voluntarily shaping grammatical chaos into order, I extend my heartfelt gratitude.

And to the people of Bali… you have endured my ignorance, my photographic intrusions and my endless questions. You have welcomed me into your homes, your temples and your hearts. You have fed me, looked after me, instructed me, protected me, entertained me and infected me with contagious good will. A sincere Thank You to all.

-Tony Novak-Clifford, November 20, 2017

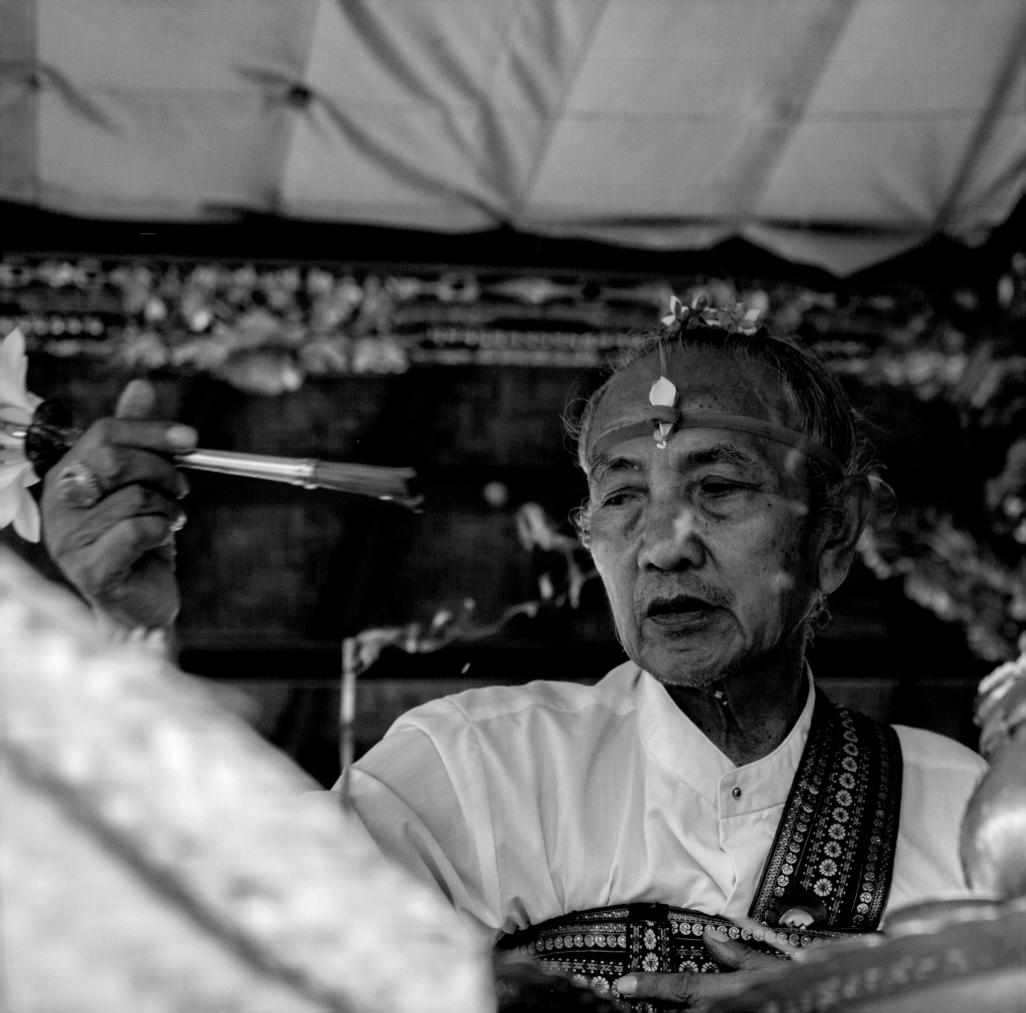

Introduction

I first traveled to Bali in the mid-1980s in search of the fabled waves pictured in surfing magazines. Word was spreading in the tales of fellow surfers who had made the long trek to this exotic island in search of surfing perfection. Other than the surf and beach lifestyle, I knew almost nothing about the island, its people, or its culture.

Finally saving up enough money to make the journey, my wife and I managed to make the trip. Our ultimate destination was the resort-area of Kuta Beach on the southern coast of the island. In the mid-1980s the Kuta Beach area was already developing into the congested sprawl of beach-side hotels, private villas and small home-stays. Tiny, poorly lit shops sold Balinese handicrafts, clothing, and any number of other items for purchase by visitors on cheap holiday. The beach-front village of Legian, just north of Kuta Beach, was far less developed then. Small rice paddies (sawah) were still interspersed among clusters of private villas, small hotels, shops, restaurants and a handful of nightclubs catering to hedonistic travelers from Australia and Europe. Seminyak, another small village north of Legian, was still at that time largely taken over by rice farming.

The beaches fronting these areas were long, wide stretches of sand lined with towering coconut palms. Enormous waves crashed continuously just offshore. Visiting surfers bobbed and sliced through the waves. Local vendors walked the beaches plying their wares… sarongs, pineapple and watermelon slices, cheap massages and manicures, counterfeit luxury watches, and newspapers and magazines from Australia and Europe.

Days were spent surfing, lounging on the warm sands of Kuta Beach and fending off the hundreds of aggressive beach vendors intent on making a sale at all costs. Evenings, when the brutal tropical sun began to set and the temperatures began to cool, were occupied with strolling the main street of Jalan Raya Kuta (Kuta Main Street) in search of souvenir treasures and gifts for friends and family back home. Inexpensive dining could be found on nearly every block. Late nights were spent drinking and comparing travel notes with fellow wanderers in the handful of nightclubs and discos that dotted the strip. Local beer was cheap and delicious, libidos were in overdrive and suntanned bodies moved to a hedonistic beat.

This was the Bali that most visitors to the island seemed keen on exploring. Yet still, in the midst and fringes of these relatively modern distractions, it was difficult not to notice the Balinese quietly going about their daily ritual life in acknowledgement and appeasement of their gods and demons. Intricate little baskets woven from bits of palm leaf and holding sprinklings of cooked rice, colorful flower petals and smoldering sticks of incense were liberally scattered along sidewalks three times each day – offerings to appease mischief-making lower spirits in hopes of warding off bad luck, illness, and other misfortunes. Through the congested street traffic one could often see parades of village women wrapped tightly in their finest sarongs and elegant lace blouses known as "kebaya". Walking straight-backed and single file while balancing intricate pyramids of delicately arranged fruit and other offerings high atop their heads, they would disappear through the gates of numerous temples scattered between the hotels and shops. Occasionally we would stumble upon the large, ornate papier-mache animal figures and multi-roofed towers lying in the roadside awaiting preparation for a cremation procession to the nearby graveyard or Pura Dalem (Temple of the Dead).

It was during that initial trip that I caught my first glimpse of Balinese ritual. We had been told that a large cremation was to take place in late morning. Grabbing cameras, I made my way to the appointed gathering place only to be swept up in an enormous procession full of gleeful faces and excited villagers – men, women and children, making their way to the cremation grounds just outside the village of Legian, a course of perhaps two miles. Along the procession route were groups of men bearing a multitude of bamboo palanquins on which rested large foam and papier-mache towers housing the remains of the deceased (all in all, approximately seventy bodies I was later told). During the procession, the bearers would shout and laugh excitedly, occasionally stopping along the route to spin the towers in order to confuse the spirits of the deceased so that they would not be able to find their way back home and would, therefore, return to heaven in preparation for their next lives. The air was electric, the mood of the crowd raucous. Once the procession arrived at the cremation grounds, the towers and remains were placed upon pyres made of cut banana trunks and firewood. More villagers paraded around the remains bearing piles of offerings and other paraphernalia rituali essential in ensuring that the spirits of the deceased enjoy safe passage

from the earthly realm. Elaborately dressed dancers bearing spears performed a regimented dance known as Baris Gede, and a short time later the remains and towers were set ablaze.

Throughout this procession and many individual ceremonies performed by various families of the deceased, I was enthusiastically welcomed by everyone I encountered. Noticing my cameras, villagers would either move out of my way or encourage me to areas around the grounds where I might have a better view of the proceedings. Everyone in attendance seemed in a joyous and festive mood. In my own mind, I could not help but contrast this "funeral" occasion to those somber, grief-filled funerals I had attended back home in the West. Imagine attending a funeral in America or Europe with camera in hand and the reactions such actions might elicit from those in attendance! I later learned that the Balinese consider cremations to be a joyous occasion, as the deceased is finally set free from the suffering of this life on earth and the soul is released from its attachment to the physical body. Should the deceased have led a good and proper spiritual existence during his or her time on earth, the laws of Karma would dictate that a better life would be enjoyed in their next incarnation.

At the end of that day, I returned to my hotel elated – not by the promise of the images that might have been captured on film earlier that day, but by the overwhelming generosity, hospitality, and good will I had been afforded as a stranger in a strange land. Determined from this point on to learn as much as possible about the ways of this remarkable Balinese culture and to photograph as much of it as humanly possible, I have been returning at every opportunity.

With that in mind, we should begin perhaps with some basic background about the island and its residents.

Bali is an island within the Indonesian archipelago. Lying approximately eight degrees south of the equator, the island covers roughly 5577 square kilometers and is populated by just over four million residents.

The Republic of Indonesia is primarily a Muslim nation. The island of Bali stands alone within the archipelago as having a population made up primarily of adherents to the Hindu faith with approximately eighty-five percent practicing a form of Hinduism known as Agama Hindu Dharma. This form differs from the Hinduism generally practiced in India. While having its roots in the Indian version, Agama Hindu Dharma liberally incorporates aspects of ancestral worship, animism, and Buddhist philosophy.

What sets Bali apart from other exotic destinations is its sophisticated culture. Highly refined forms of language, architecture, music, painting, dance and shadow puppetry originating in the Royal Palaces of ancient Java were brought to Bali with the expansion of the Majapahit Kingdom's influence into neighboring islands sometime around the thirteenth century. The Royal Javanese court's influence over Bali culminated with the eventual flight of the entire Majapahit court to Bali following the conquest of Java by Muslim rulers in 1478. The flight of these Javanese nobles and priests can best be described as a continuation of that Hindu-Javanese culture. Bali remains a "living museum" of Javanese Majapahit culture to this day.

For centuries, Balinese life has centered around a myriad of daily ritual activities meant to appease and please an extensive pantheon of gods, spirits and demons in order to maintain universal order. To this end, the arts have played a prominent role, whether it be through the sculpture decorating temple walls and gates, highly stylized and expressive paintings, intricately constructed offerings, or highly developed forms of dance and music required to entertain the gods and encourage them to linger as long as possible in the earthy realm. Balinese belief in invisible, spiritually benevolent and malevolent forces play and equal, if not greater, role in daily life as do the tangible aspects of the visible world familiar to us all. One of the most fascinating aspects of Balinese belief is that, unlike Western Judeo-Christian beliefs, both the forces of good and evil are essential. Maintaining the proper balance between the two opposing forces is what brings a sense of order to the universe and the abundant blessings of the gods. The Balinese refer to these forces as Sekala (seen) & Niskala (unseen). Whatever the variations in practice and ritual may be as one travels from village to village, region to region, there is little doubt that Balinese culture and ritual practice is perhaps one of the most graceful and colorful forms of worship on the planet.

The Balinese have always believed that their island home is at the center of the universe. Bestowed upon their heads is the responsibility and sacred duty of maintaining order and balance not only to their world but also to ours, through repeated religious ceremony, offerings and prayers, and a relentless observance and appeasement of their gods, demons, unseen spirits and deified ancestor spirits.

Central to the concepts of this cosmic balancing act are the manifestations of the mythological creatures Barong and Rangda. Barong is portrayed in the form of a large bear or lion-like creature much resembling a Chinese lion. The Barong costume is most often covered in thick fur adorned with gilded jewelry and pieces of mirrors. It walks on four legs and requires two men to operate the costume. The Barong mask is most often painted red with large eyes, protruding fangs, and snapping jaws. I have included in this volume photographs of the Barong of Selumbung village in the Regency of Karangasem, where the body of the costume is covered with a tiger-striped fabric. Barong is the king of spirits, leader of all benevolent forces and the protector of the village. Barong's mythological enemy is Rangda, the demon queen and evil witch-mother. Rangda, practitioner of black magic and the embodiment of all things evil, walks upright on two legs. Her costume operated by a single dancer, is covered in long, matted white hair, has a meter-long tongue resembling flames displays large, pendulous breasts and wears a necklace of human entrails. During dramas played out at temples in every village, the appearance of Rangda brings forth forces of men (and sometimes women) bearing magical, curved-bladed daggers known as Kris, intent on attacking and killing the witch queen. Rangda's dark magic repels the daggers, turning them back on the attackers, who stab themselves frantically while in a state of trance. Barong appears. His benevolent power protects the Kris bearers from harm using his powers for good. For centuries, this popular dance-drama has been repeatedly performed as a reminder of the importance of maintaining the essential balance between good and evil.

It is also worth noting that within the Balinese cosmos, all spiritual attention is turned inland towards the island's tallest volcanic mountain, Mount Gunung Agung. In Balinese belief, the surrounding ocean is the realm of profane, evil spirits where danger, both physical and spiritual, is forever lurking. To my knowledge, Bali remains the only island on the planet that does not seek spiritual sustenance from its surrounding waters.

It is nearly impossible to generalize in any way regarding traditional (adat) practices and traditions throughout Bali, as these may vary slightly, sometimes greatly, from village to village. This volume you now hold in your hands is the collective product of roughly thirty years and numerous visits to this incredible island. On the pages that follow, I make my best attempt to introduce you to its people, their villages, temples, rituals, and lifestyle. You will find some of the iconic scenes familiar to most visitors to the island. You will also find quite a few images made in places well of the beaten tourist path. Together we will meet a remarkably hospitable people, visit remote mountain villages and temples of remarkable architecture, and observe spiritual practice that would make a pope envious.

I remain, admittedly, a novice in my understanding of this unique island culture. It has been my great fortune that with each visit a little more of the curtain is lifted and a growing insight into and acceptance by its residents is the reward. The photographs contained within these pages have served as a visual reminder of the people I have met along the way, of the events I have witnessed, of the places I have ventured. This is my gift of thanks, my love song to the people of Bali.

The Balinese

A Portrait of the People

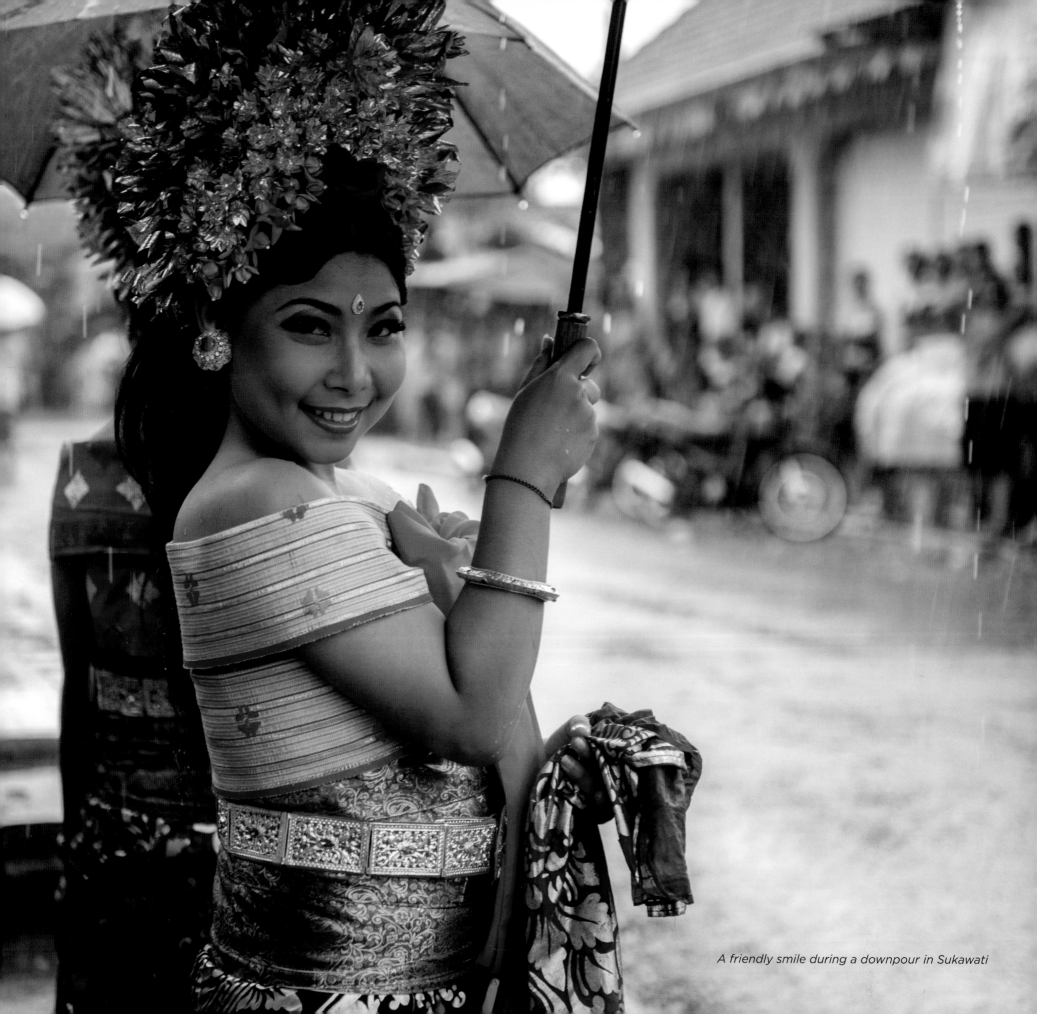

A friendly smile during a downpour in Sukawati

Reknowned dancer A.A. Gede Bagus Mandera Erawan (Gus Aji) of Puri Kaleran Pusaka, Peliatan, Ubud, performs a highly stylized dance known as "Trompong Keybar".

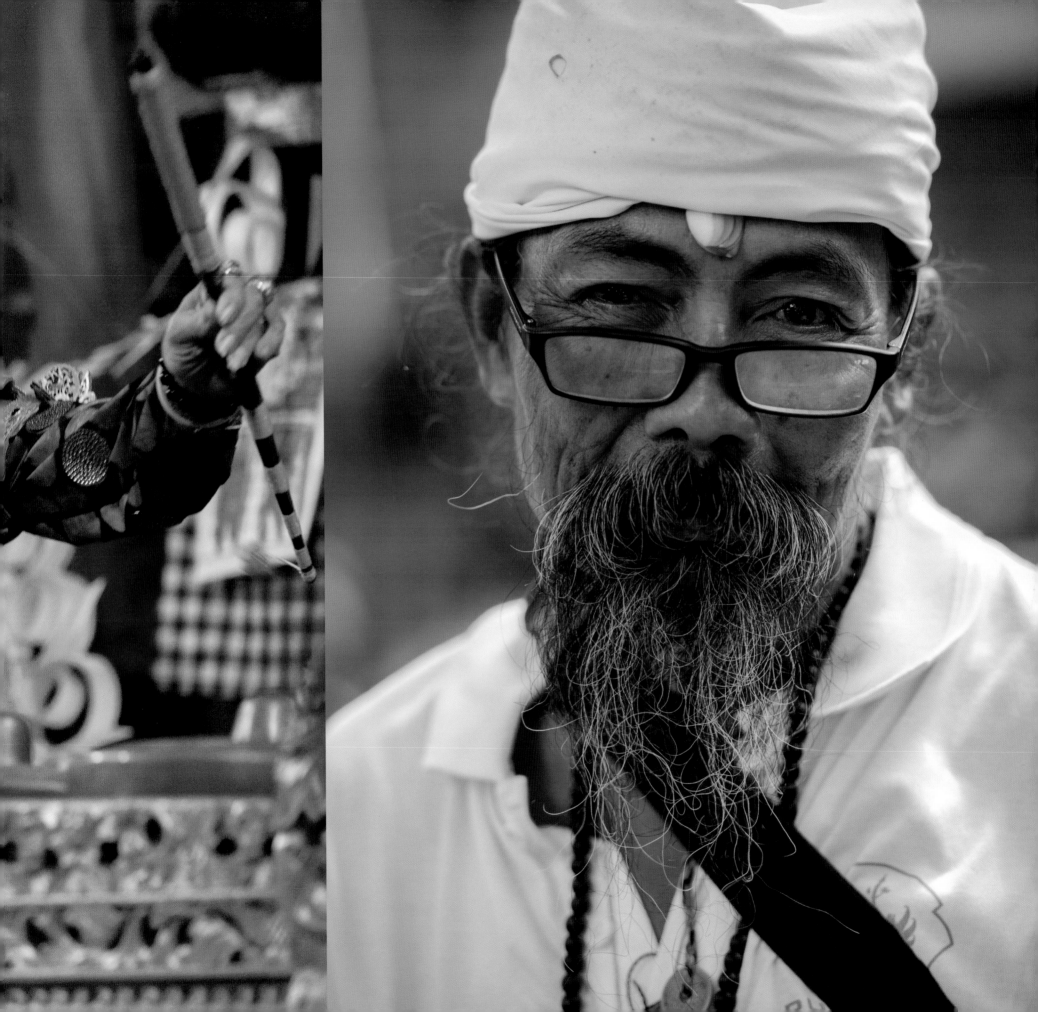

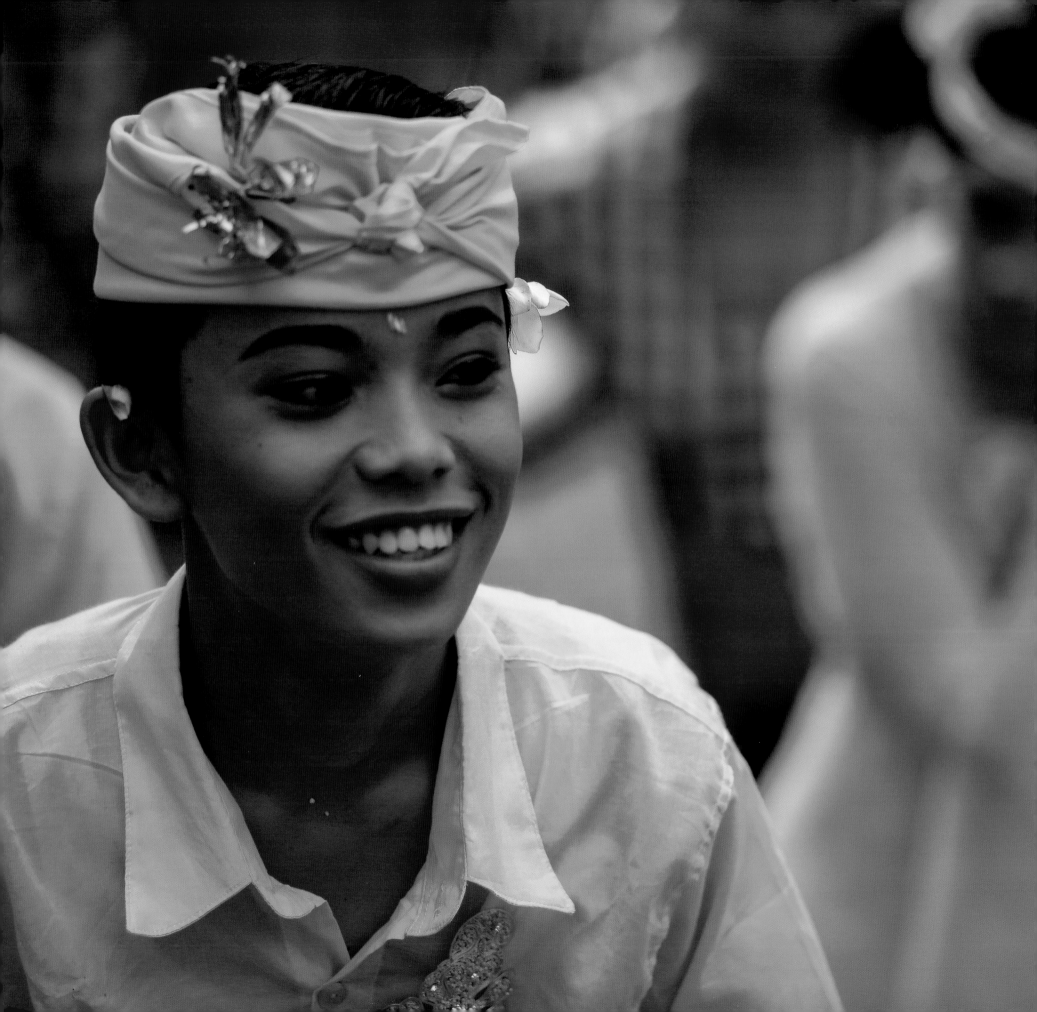

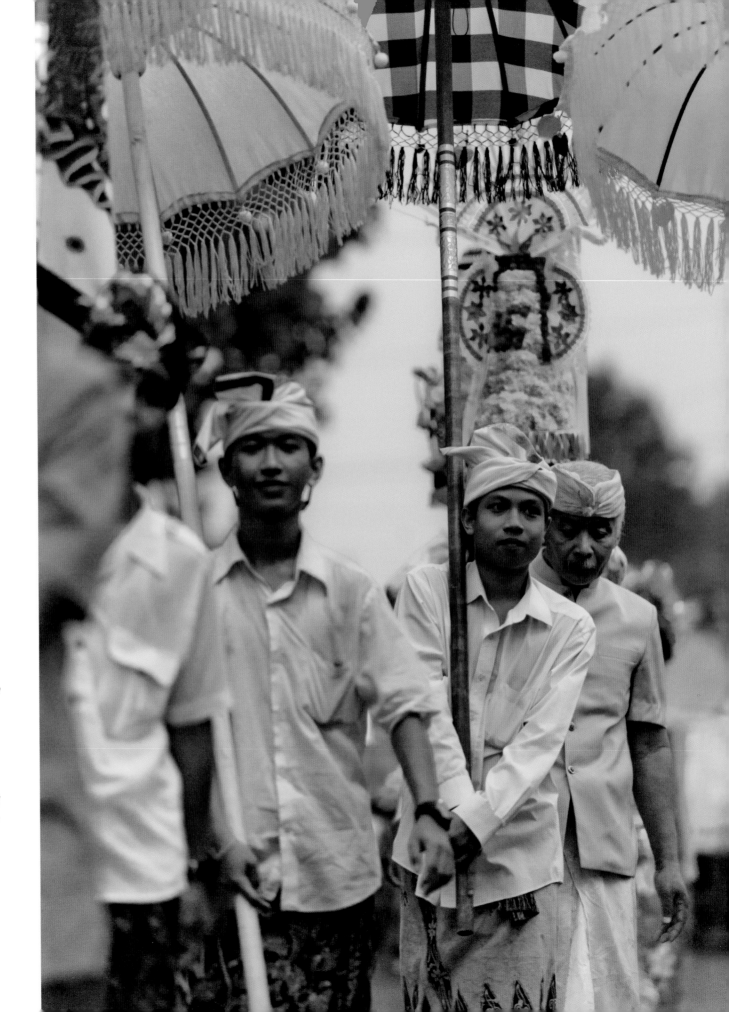

This Page: A ceremonial procession in the village of Klungklung during Balinese New Year (Galungan) ceremonies. The island of Bali is, without doubt, at its most beautiful during the ten day period marking the beginning of Galungan and ending on Kuningan. Galungan is a time for celebrating the triumph of dharma (virtue) over adharma (the unnatural, disorder). It is believed that during this ten day period, the gods return to temples around the island. Every village is elaborately decorated with tall, curved bamboo poles adorned with intricate weavings of palm leaf. Residents are dressed in their ceremonial finest and take time away from jobs to return to their ancestral homes for reunions and rituals welcoming and paying homage to their gods.

Facing Page: A young boy, dressed in his ceremonial finest, during re-dedication ceremonies at Pura Gunung Lebah in Tjampuhan.

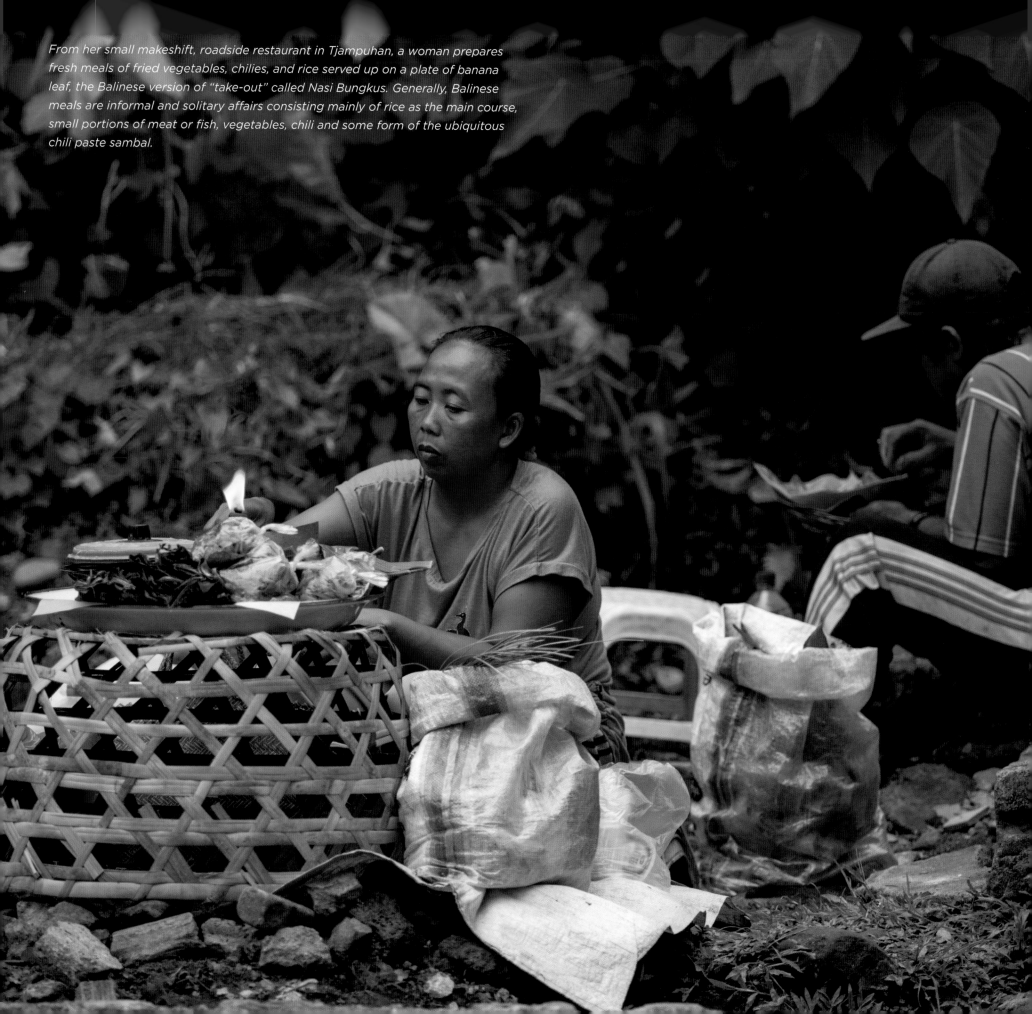

From her small makeshift, roadside restaurant in Tjampuhan, a woman prepares fresh meals of fried vegetables, chilies, and rice served up on a plate of banana leaf, the Balinese version of "take-out" called Nasi Bungkus. Generally, Balinese meals are informal and solitary affairs consisting mainly of rice as the main course, small portions of meat or fish, vegetables, chili and some form of the ubiquitous chili paste sambal.

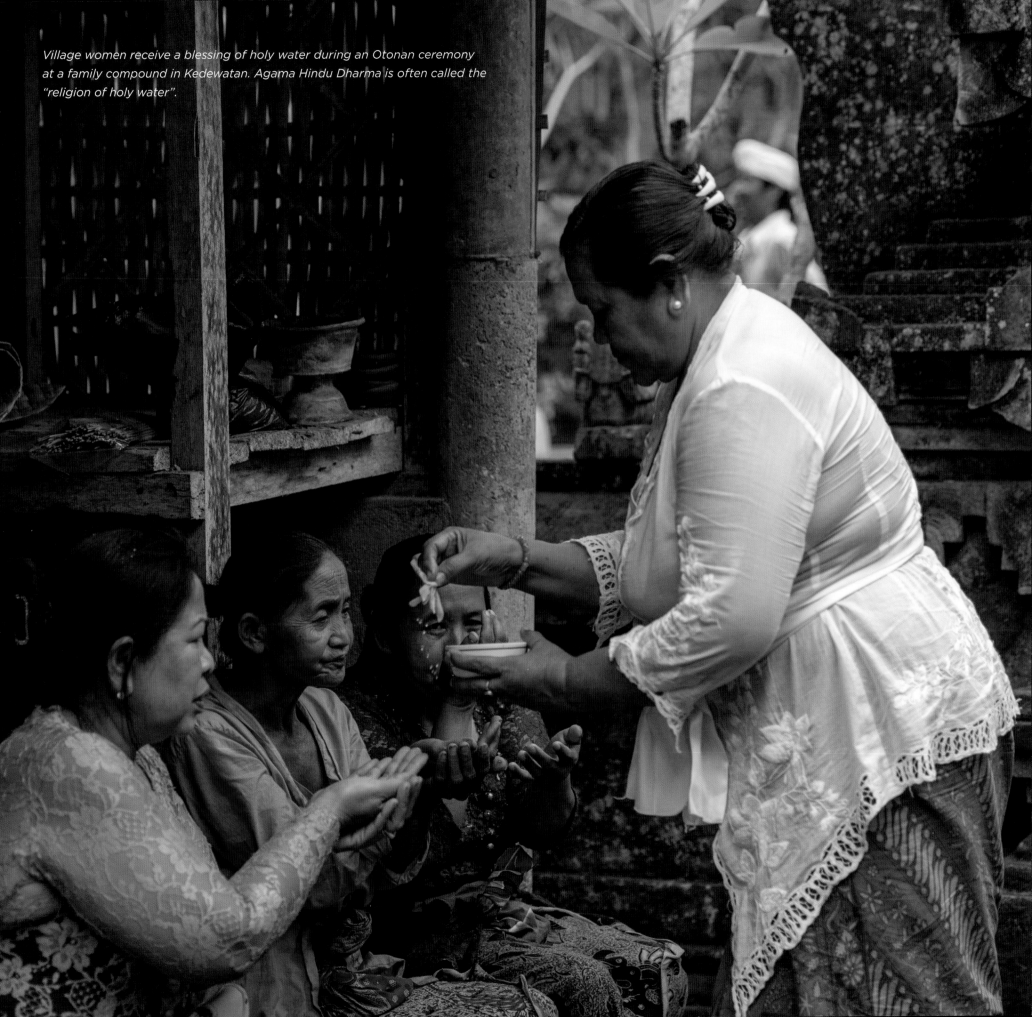

Village women receive a blessing of holy water during an Otonan ceremony at a family compound in Kedewatan. Agama Hindu Dharma is often called the "religion of holy water".

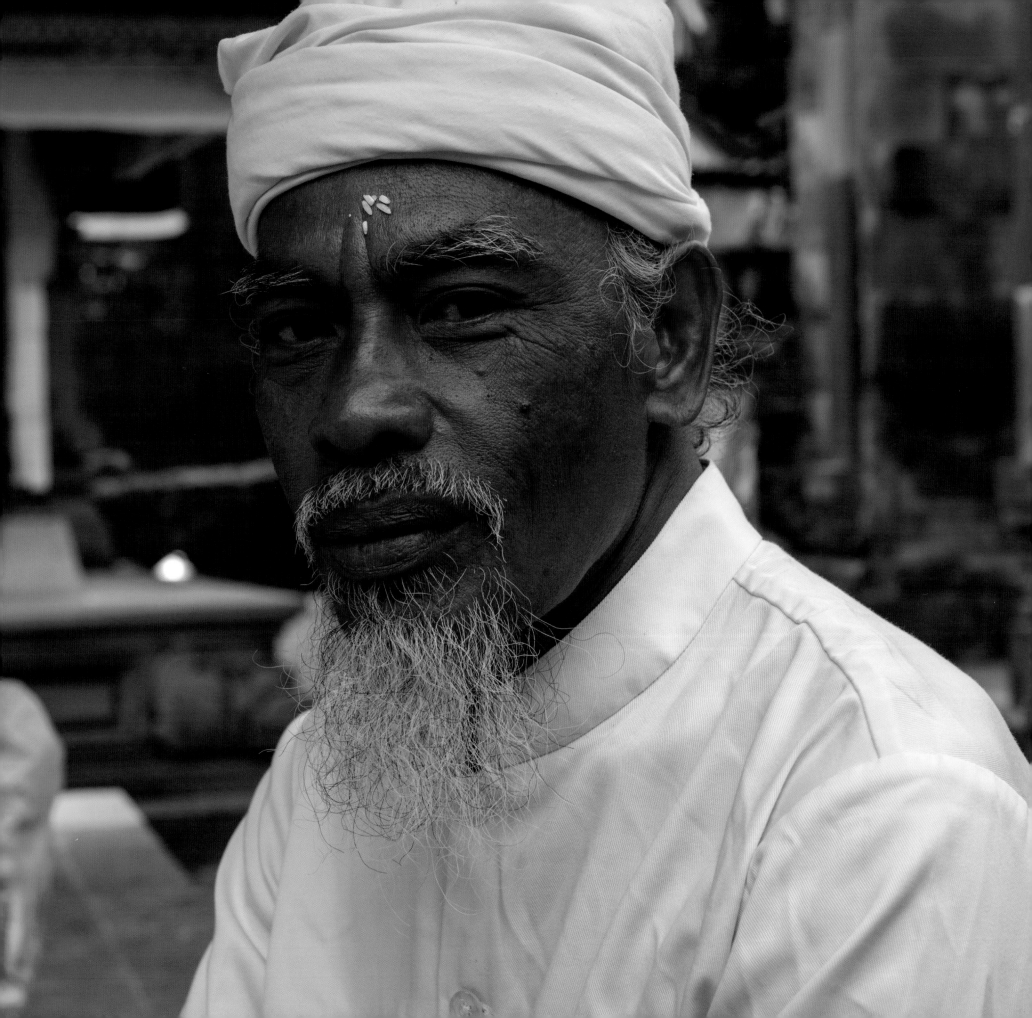

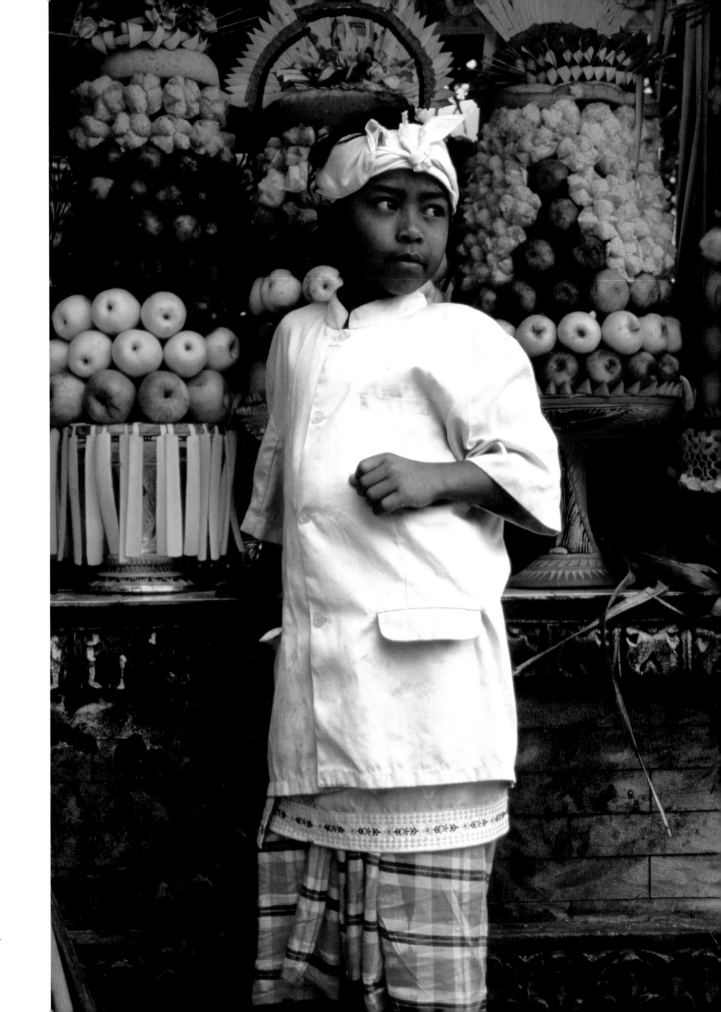

This Page: A young boy and temple altar at Pura Taman Sari, a remote temple high in the mountains of Tabanan Regency.

Facing Page: A Permangku, (Temple Priest) at Pura Gunung Kawi in Tampaksiring.

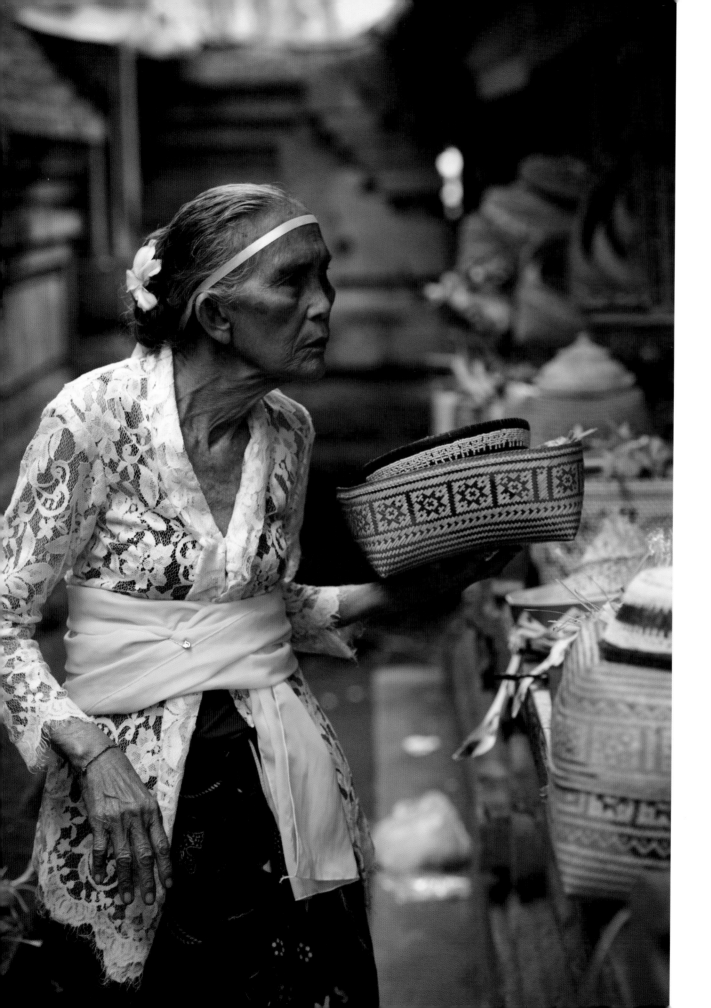

This Page: *Bringing her offerings, a woman comes to pray at the Temple of the Dead, Pura Dalem Kauh Tegalalang, during an Odalan in Tegalalang village near Ubud.*

Facing Page: *Elegance and refined beauty during an Odalan ceremony at the village Temple of the Dead, Pura Dalem Kauh Tegalalang, in Tegalalang.*

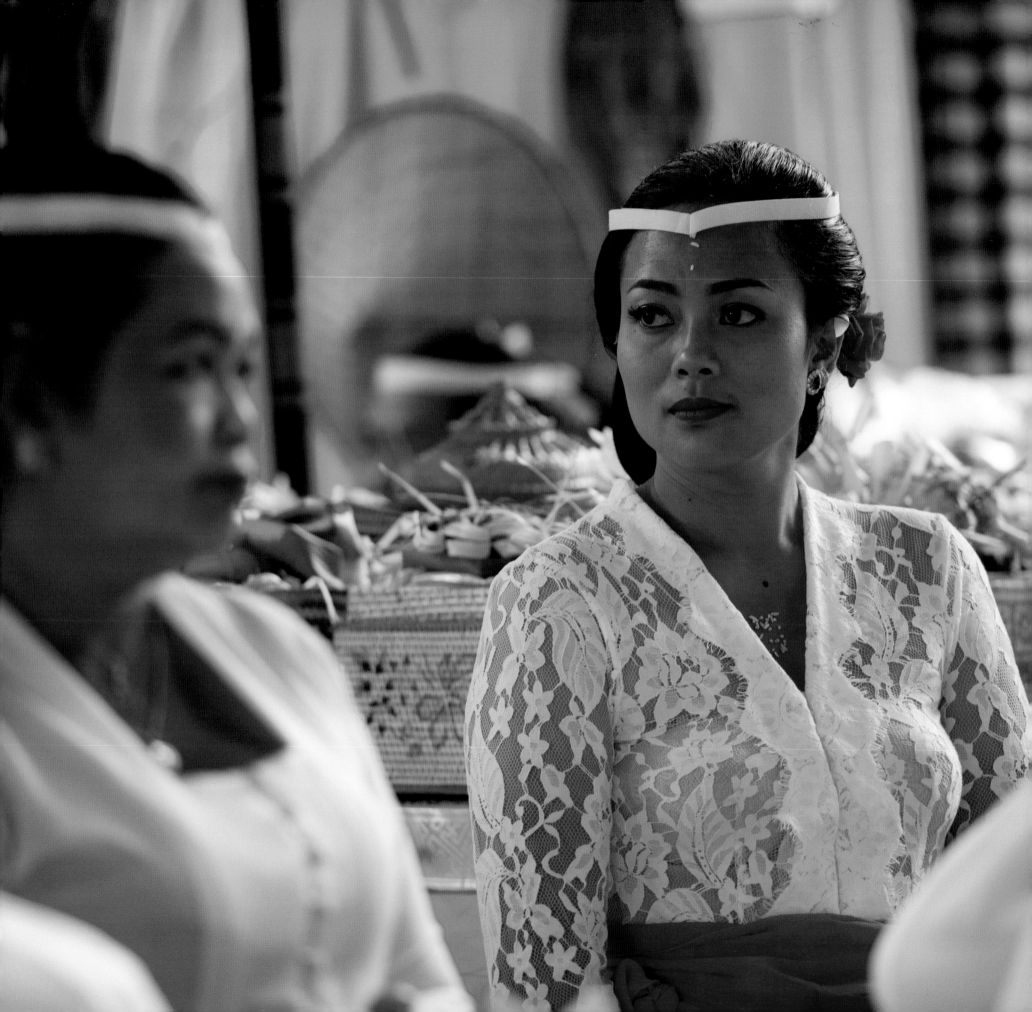

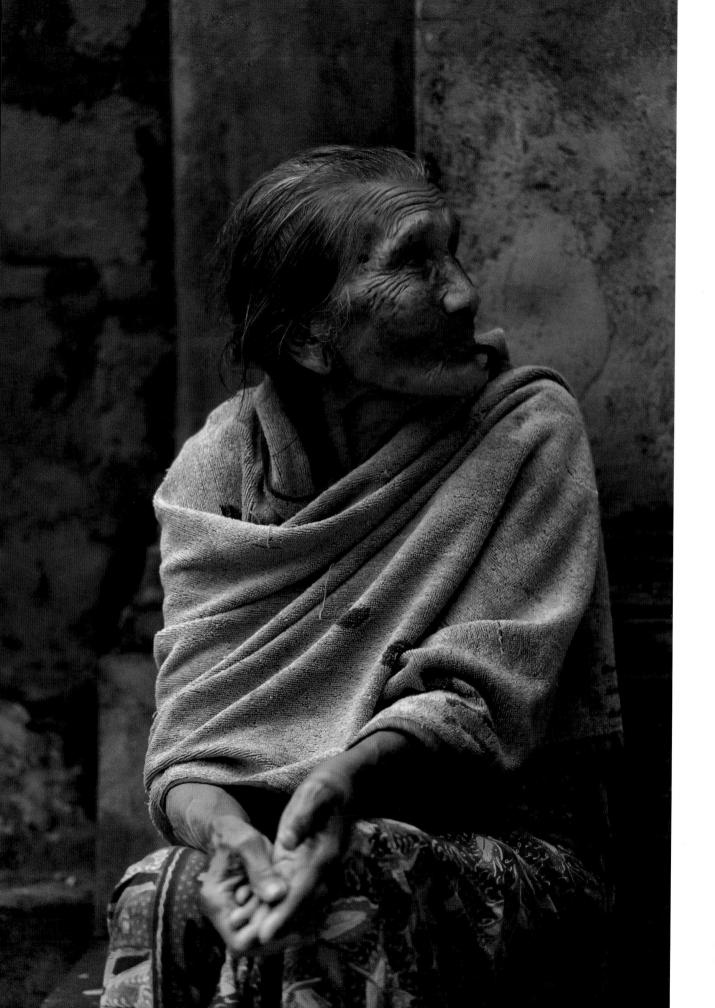

This Page: *A candid street-side portrait in Sukawati, Bali.*

Facing Page: *At Puri Agung Blahbatuh, Palace of the Raja of Blahbatuh village.*

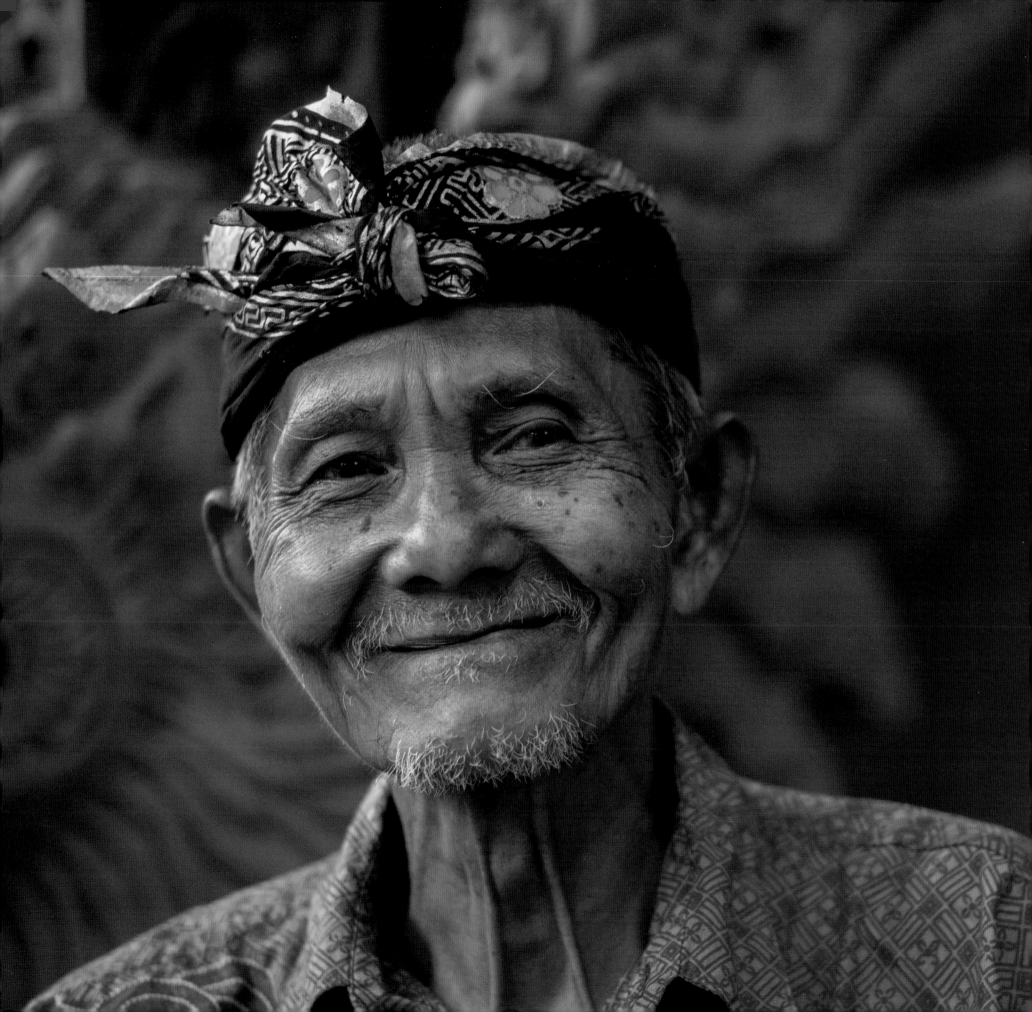

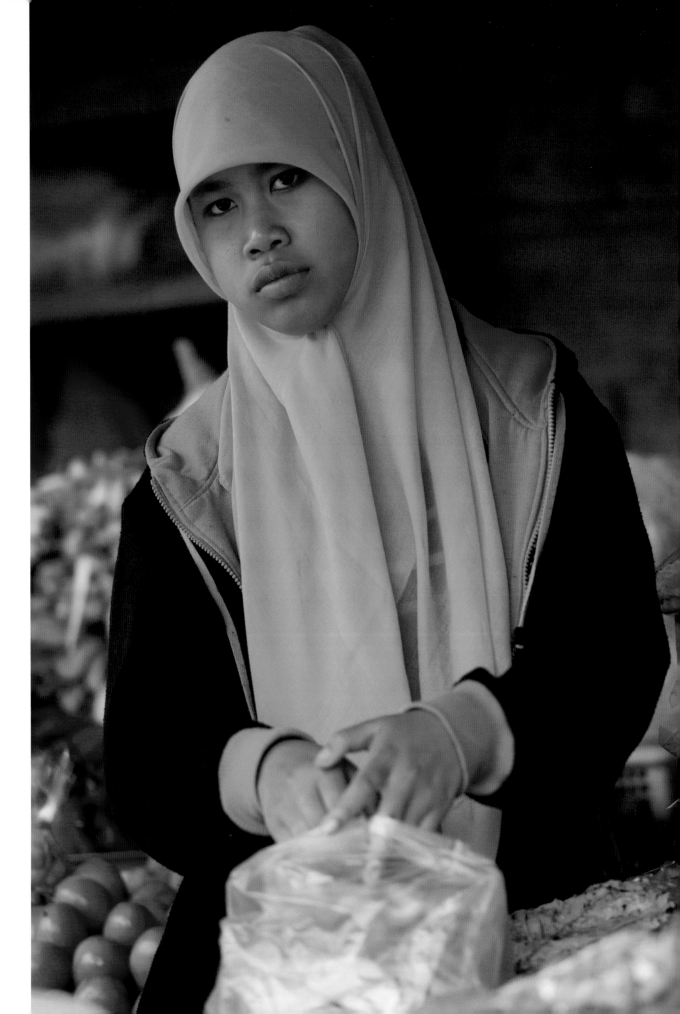

While the residents of Bali predominantly adhere to the Hindu faith, Bali is only one of over 14,000 islands making up the Republic of Indonesia, a country with the largest population of Muslims in the world. Hindus make up 83.5 percent of Bali's population, 13.4 percent practice the Islamic faith, 2.5 percent practice Christianity and 0.5 percent follow Buddhist teachings according to a census conducted in 2014.

Many Indonesians from outside Bali have settled on the island seeking a better life and higher wages in the tourism industry. Mosques have popped up all the island in recent years to meet the spiritual needs of this immigrant population.

Traditionally, these communities have enjoyed friendly relationships throughout Bali. Terrorist bombings in the Kuta resort area and in Jimbaran on the southern tip of the island in 2005 have strained this relationship.

A Muslim girl sells vegetable at the Candikuning Market in the mountain village of Bedugal.

Several years ago while in the main city of Denpasar, wandering the streets in search of photographic subjects, I stumbled upon a flower market. This woman, speaking no English, was in the rear of the shop. Communicating with her through pantomime, I coaxed a handful of frames out of this shy but beautiful woman.

A year or two later, my wife returned to the market with a print of this photograph, found this woman with the infectious smile and handed her the print. She was overjoyed to the point of tears.

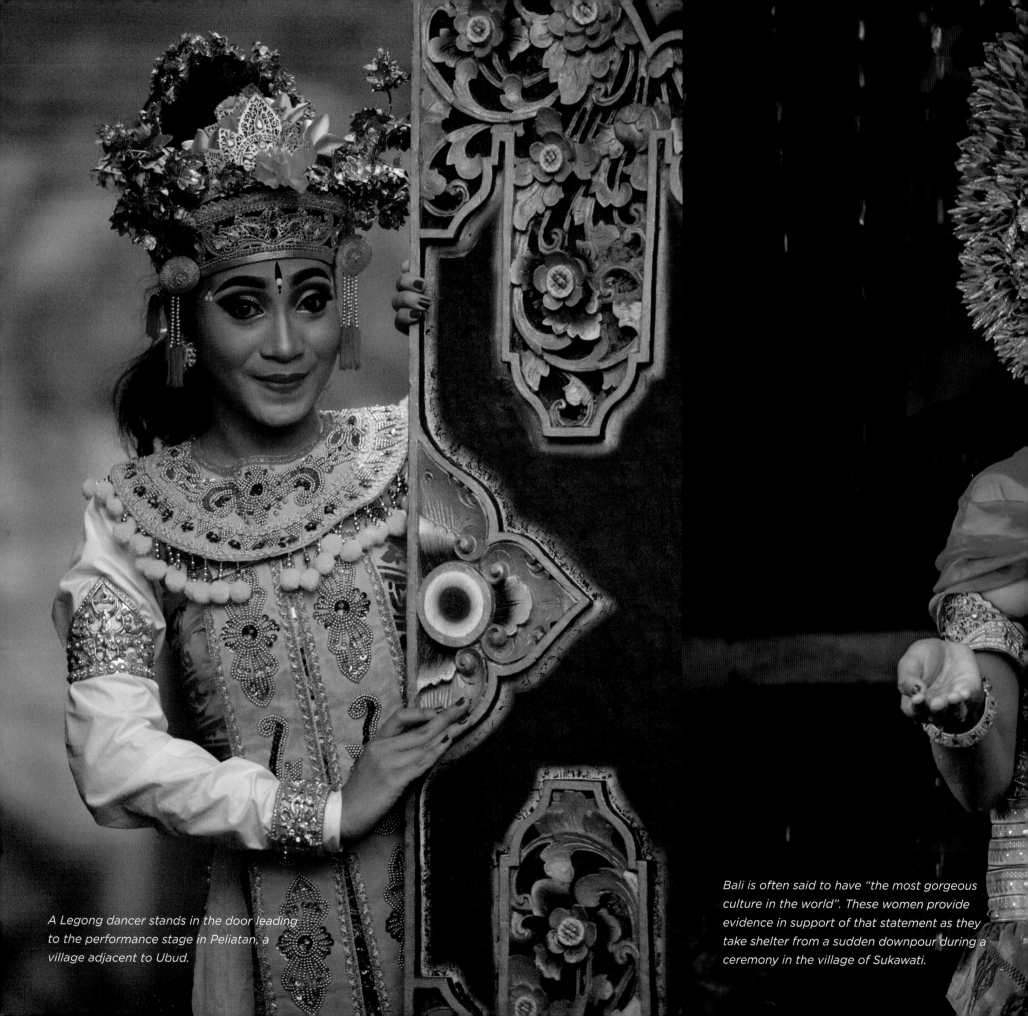

A Legong dancer stands in the door leading to the performance stage in Peliatan, a village adjacent to Ubud.

Bali is often said to have "the most gorgeous culture in the world". These women provide evidence in support of that statement as they take shelter from a sudden downpour during a ceremony in the village of Sukawati.

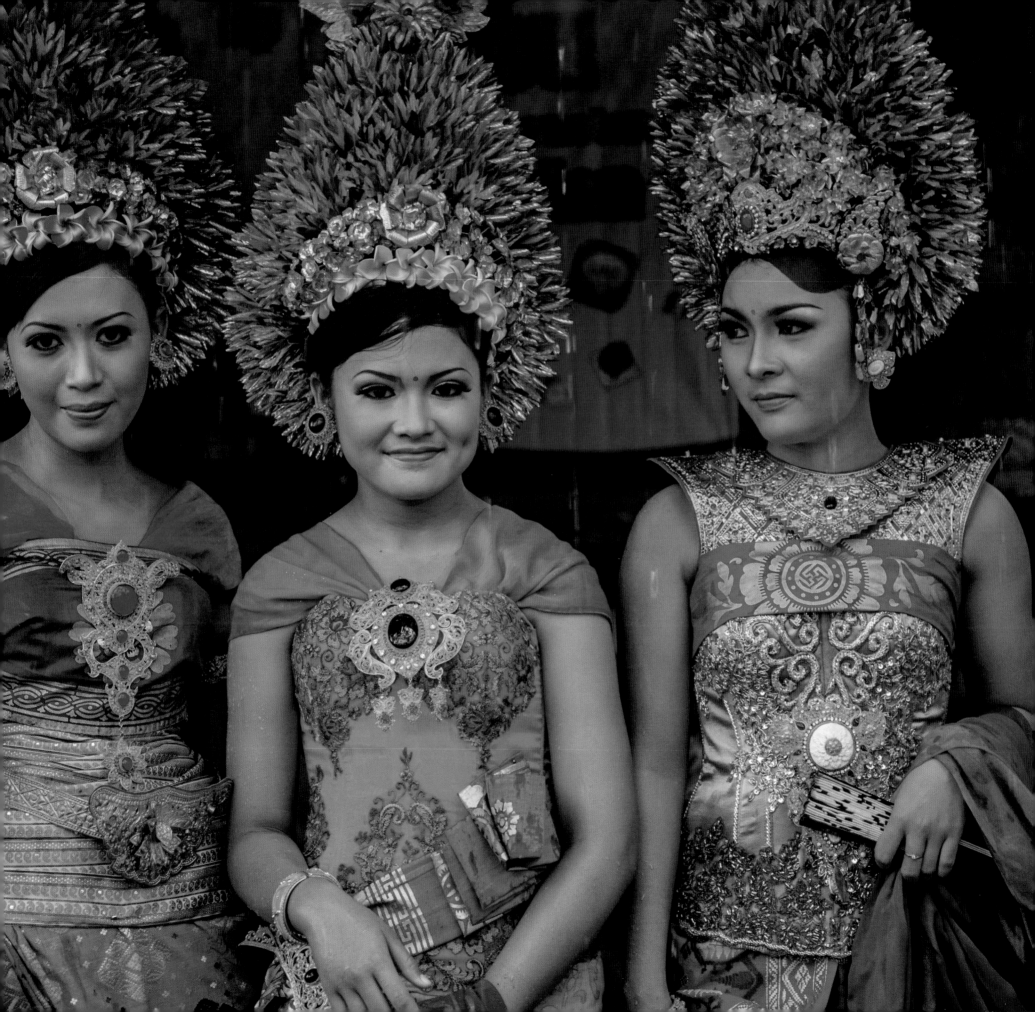

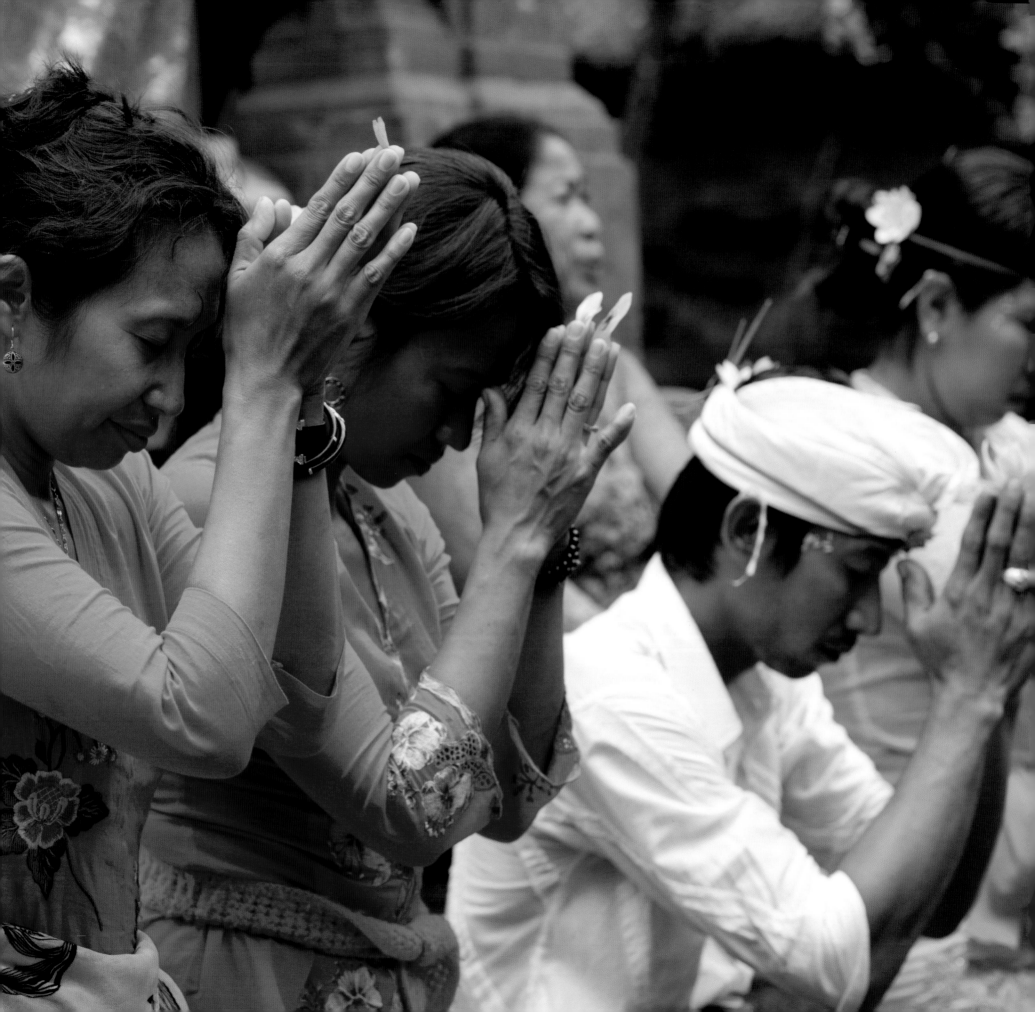

This Page: *The smoke of burning incense carries prayers to the gods during a wedding ceremony in Peliatan, Bali.*

Facing Page: *Family members pray together in their family temple during Otonan ceremonies, Kedewatan, Bali.*

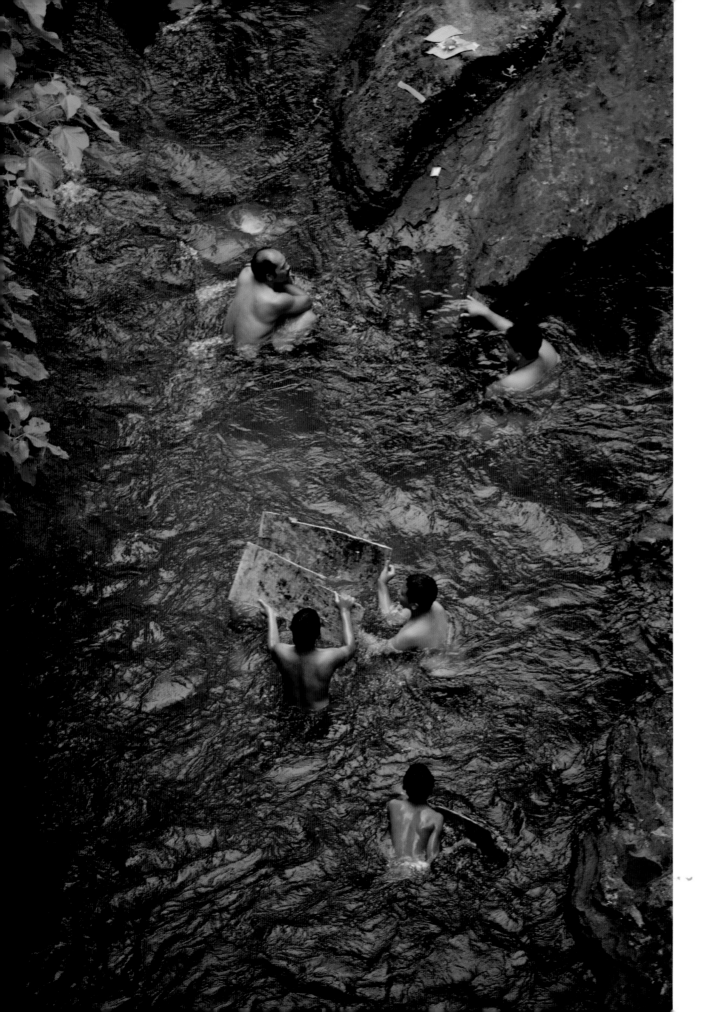

This Page: Beating the tropical afternoon heat in the Tjampuhan River just outside the village of Ubud.

Facing Page: Silhouetted against a brilliant Indian Ocean sunset, Balinese boys strike a totem-like pose on the reflective low-tide sands of Kuta Beach.

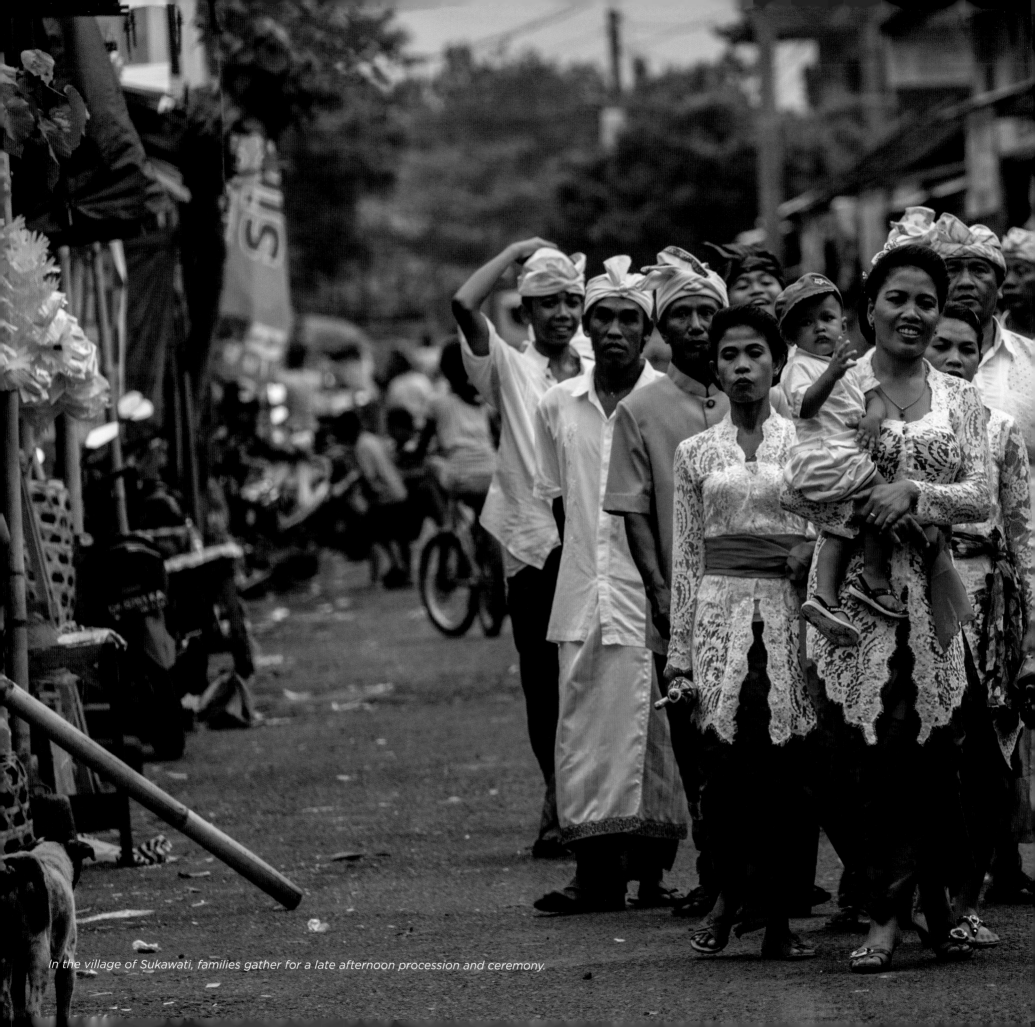

In the village of Sukawati, families gather for a late afternoon procession and ceremony.

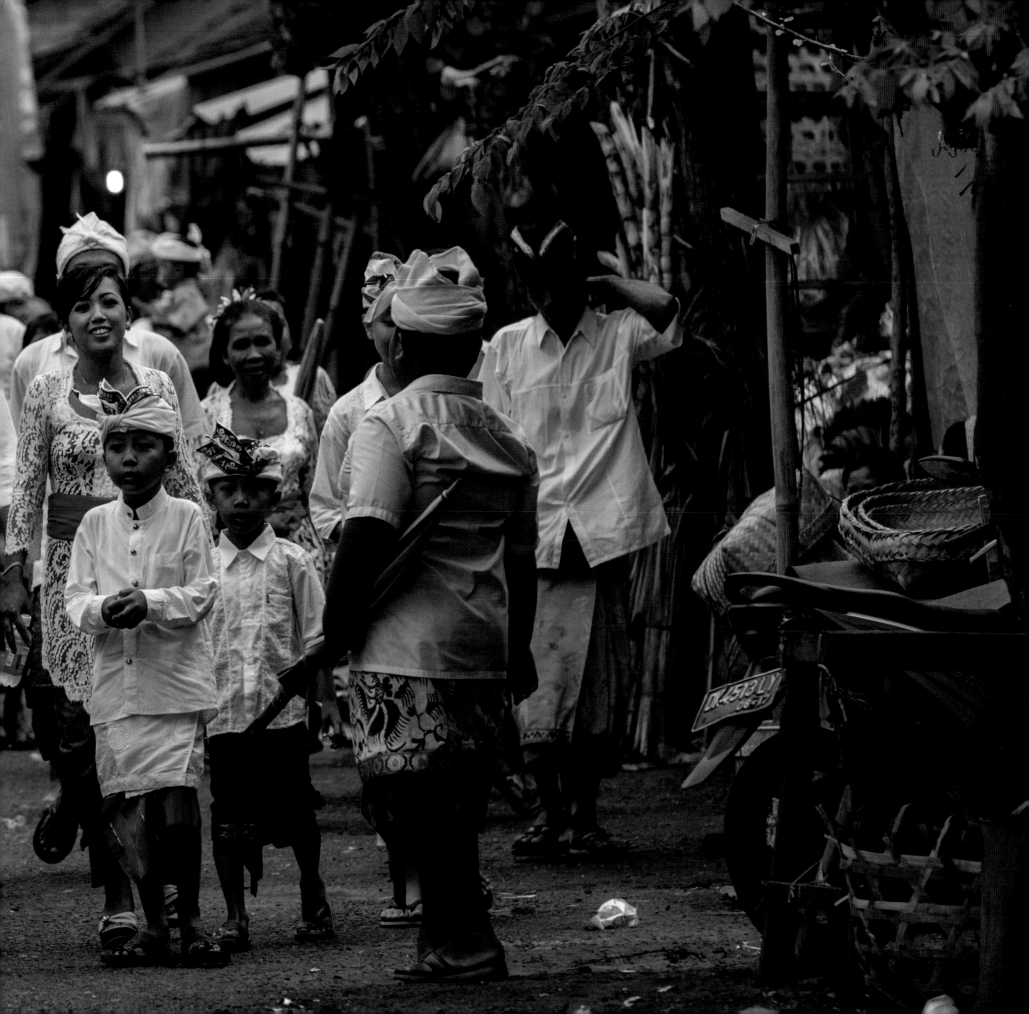

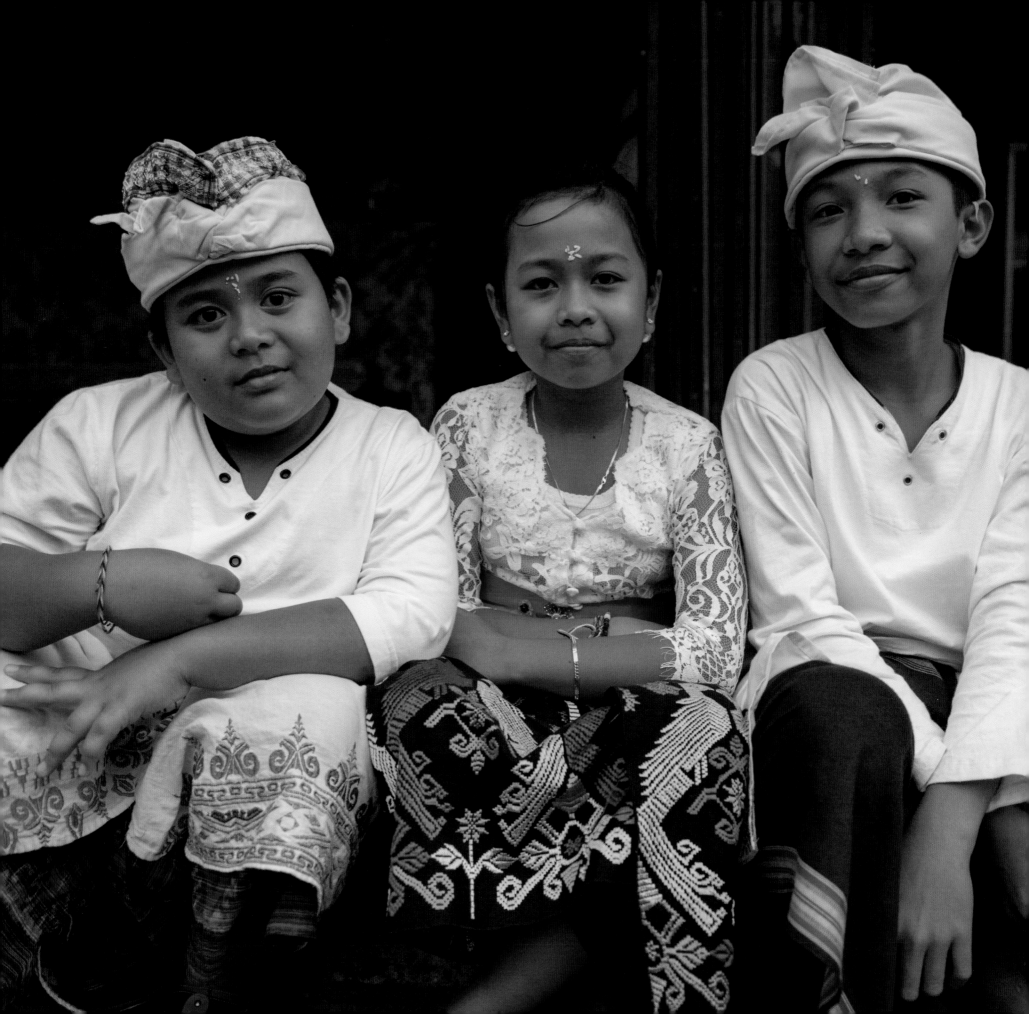

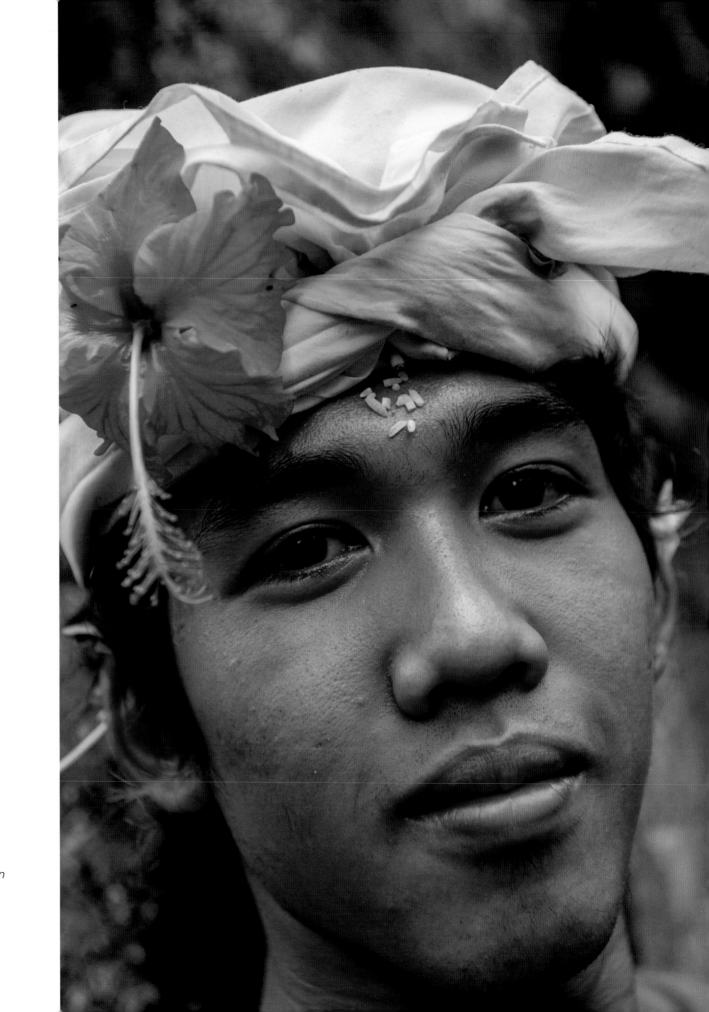

This Page: A portrait of Edi, a young Balinese man who has accompanied me on many adventures around the island of Bali over the years.

Facing Page: Children outside a small warung (café) in Selumbung.

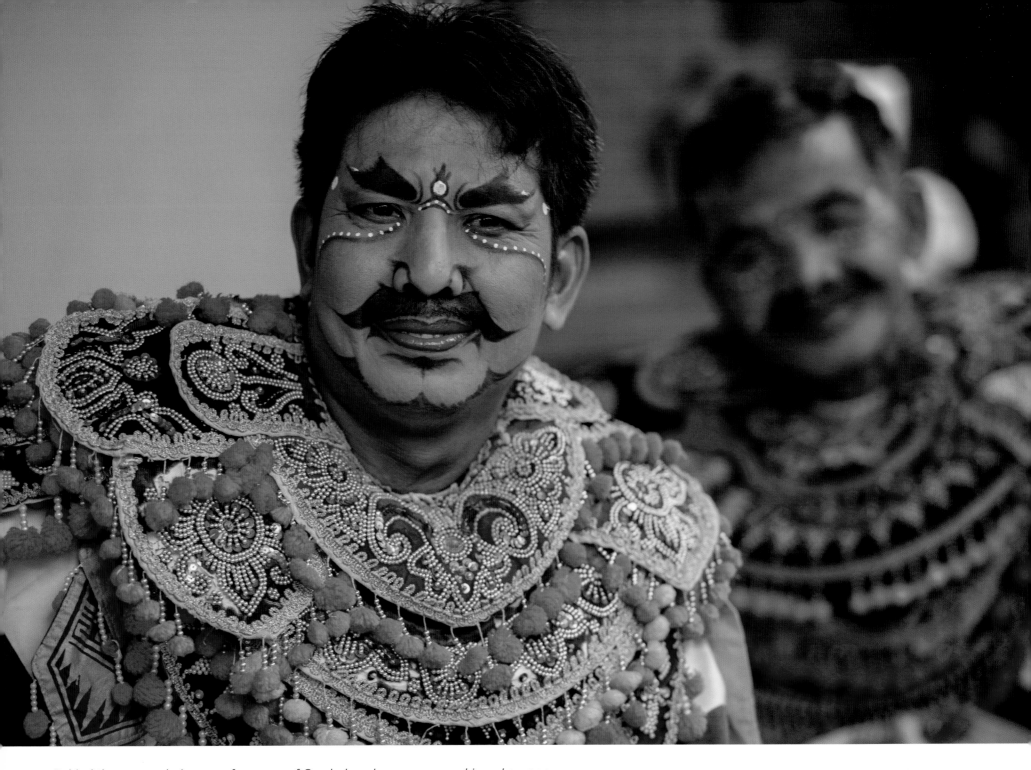

Behind the scenes during a performance of Gambuh, a dancer prepares his make-up as he readies to take the stage at the Blahbatuh palace, Puri Agung Blahbatuh. Gambuh, one of the oldest surviving forms of Balinese performing arts, dates back to the 15th century. A "dance-drama" credited to the late Majapahit era when the royalty and elite of Java resettled in Bali. Gambuh utilizes dance, music, acting, and dialog. The dance and music are technically complex, the dialog requiring a knowledge of the ancient Kawi language. The drama draws from the narrative material of the Malat, a series of poems about a fictional Javanese prince and incarnation of Wisnu, one of the principal Hindu deities, the protector and preserver of worlds.

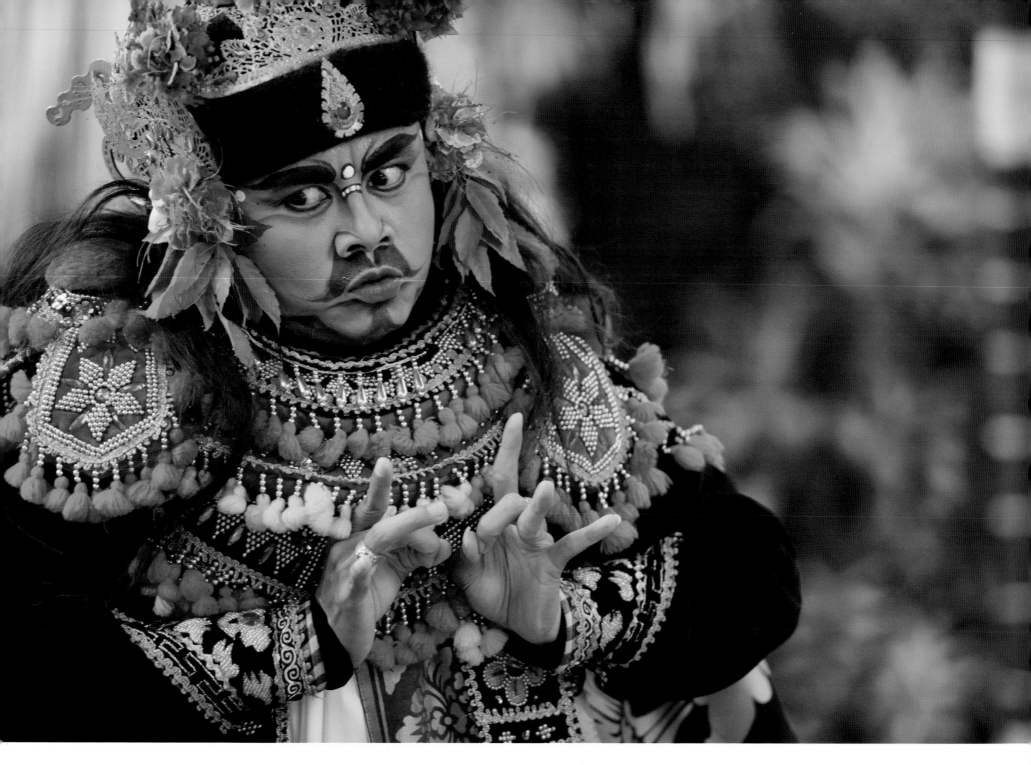

A performance of Gambuh at Puri Agung Blahbatuh, the palace of the Raja of the village of Bahbatuh, near Ubud.

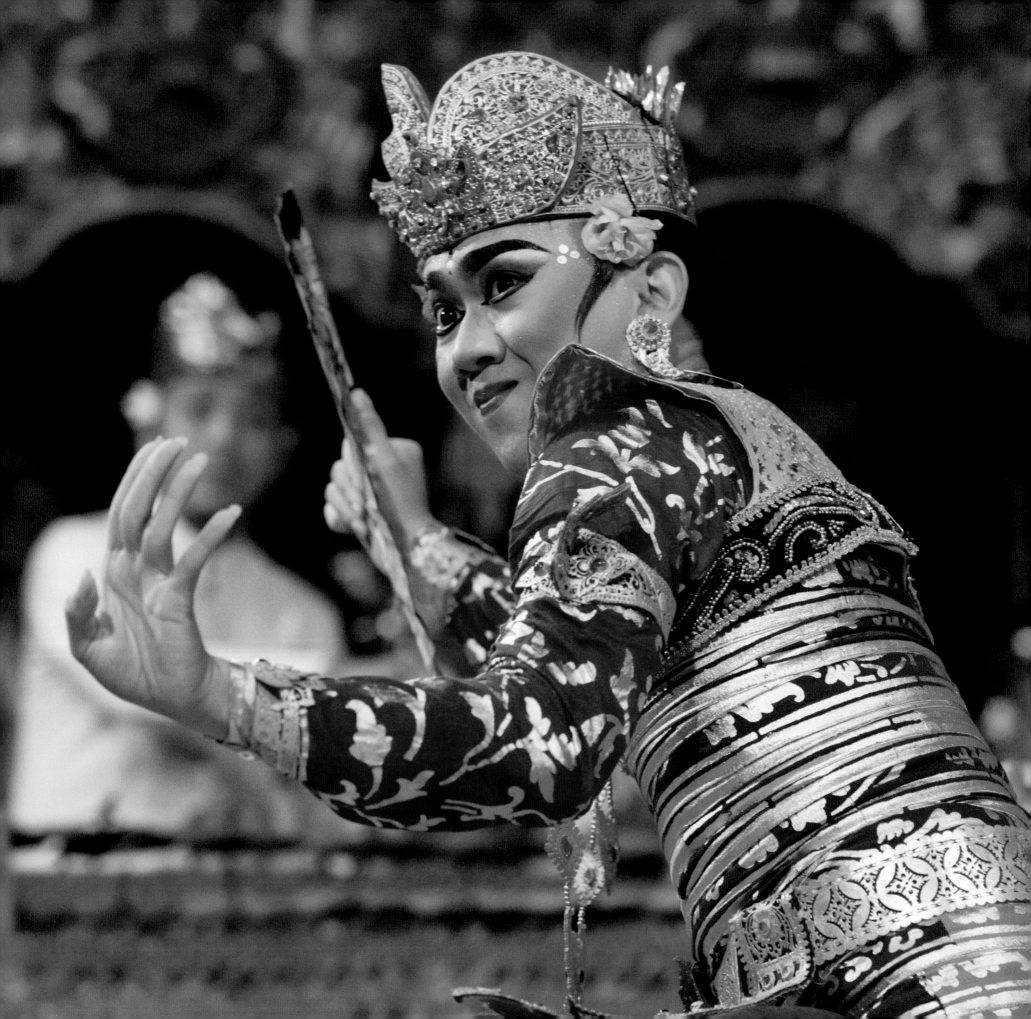

This Page: Complex and intricate finger movements, footwork, expressive facial expressions and eyes are all elements of the refined form of Balinese dance known as Legong. Legend has it that the style developed in the 19th century when a price of the village of Sukawati fell ill and had a feverish dream of two maidens dancing to the music of a gamelan orchestra. Traditionally, Legong is performed by young girls who have not yet reached puberty.

Facing Page: A rare performance of Legong Lanang Nandira "Raja" Bedahulu" in Peliatan, Ubud. Legong is a popular style of dance where the dancers are usually young women. In this special performance, the role of dancers are all performed by men.

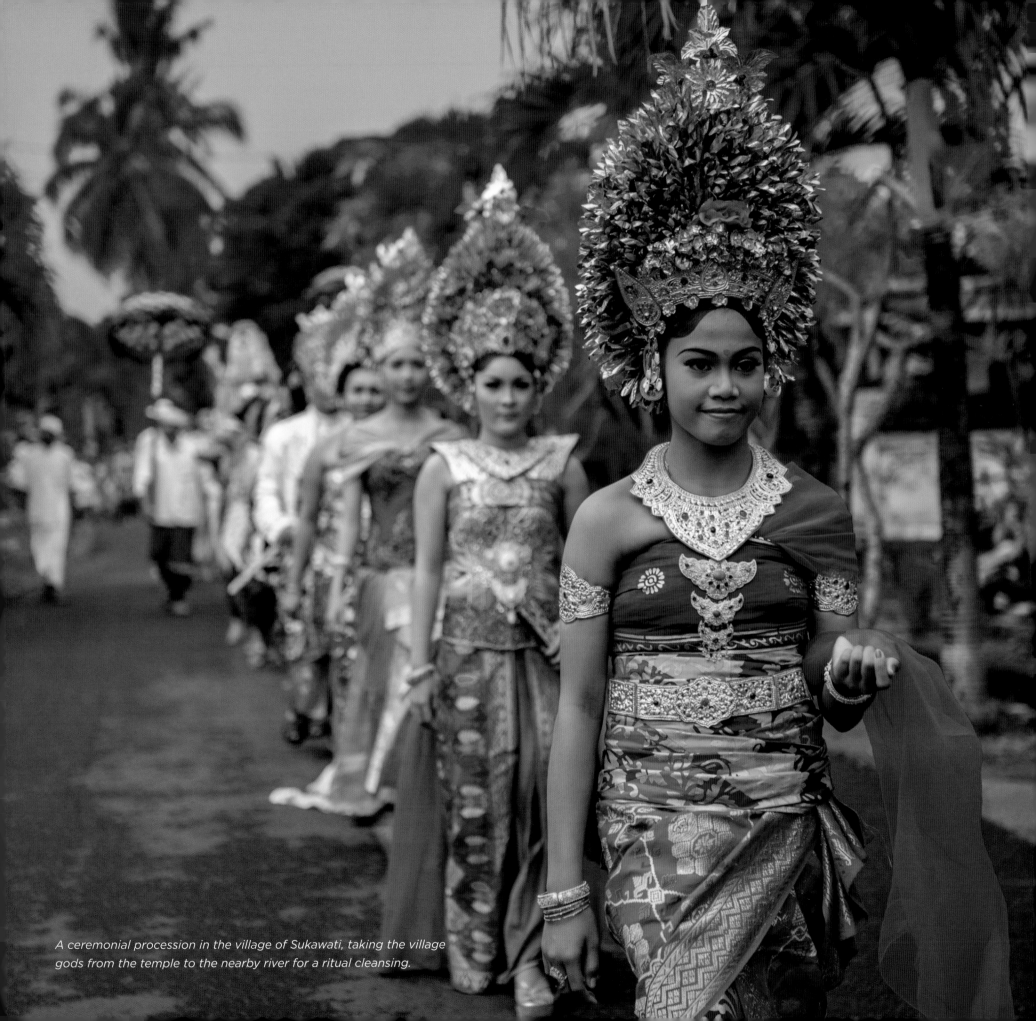

A ceremonial procession in the village of Sukawati, taking the village gods from the temple to the nearby river for a ritual cleansing.

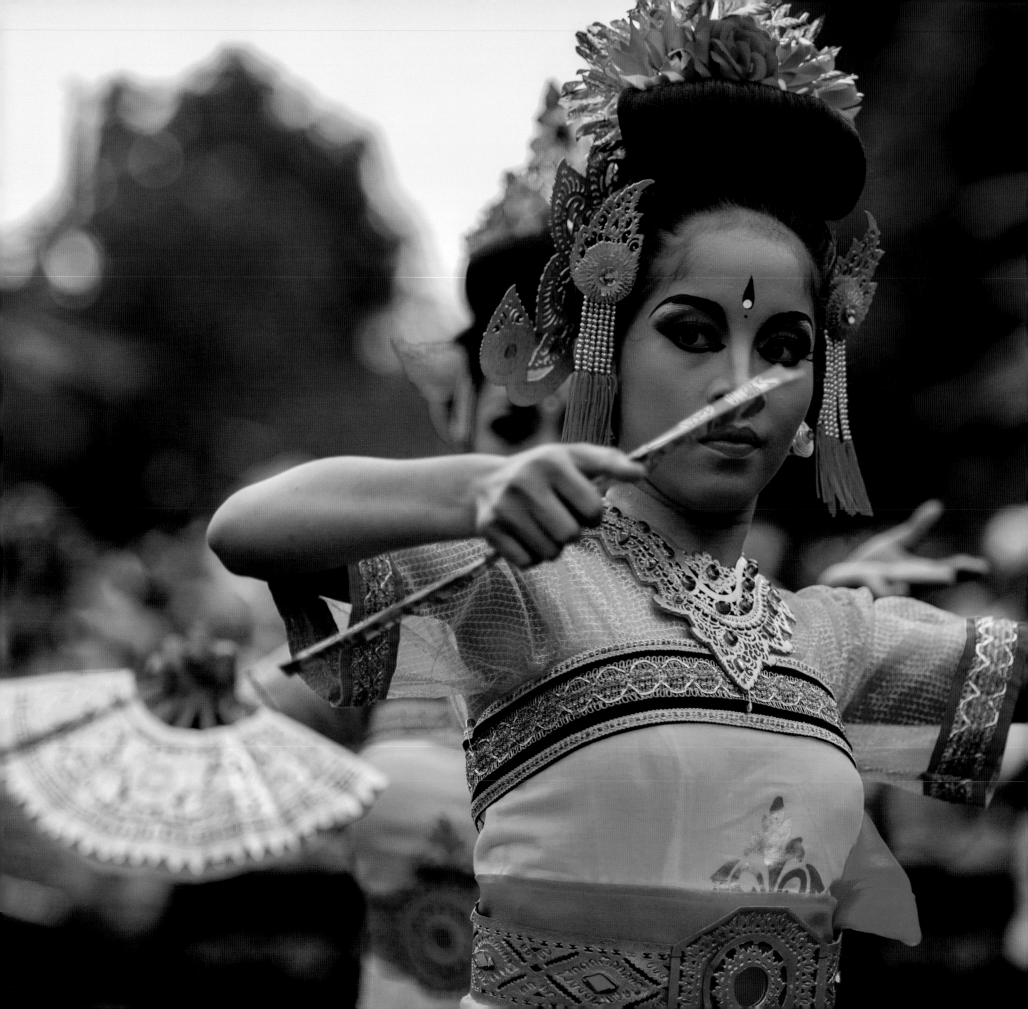

This Page: *A Permangku (temple Priest) looks on during Kris blessing ceremonies at the Bali Governor's Palace in Denpasar.*

Facing Page: *Surrounded by a sea of white lace, a young boy is escorted by his mother during a Hindu ceremony in Sukawati village.*

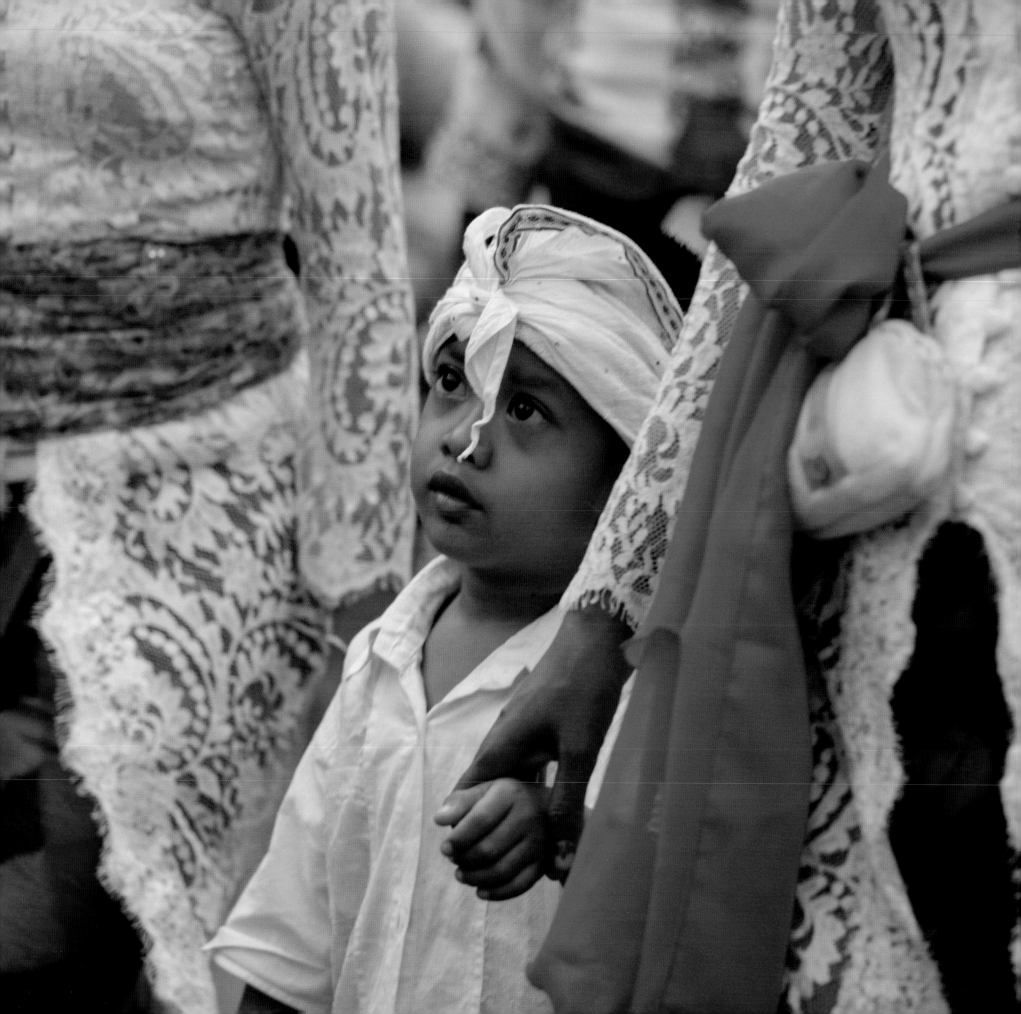

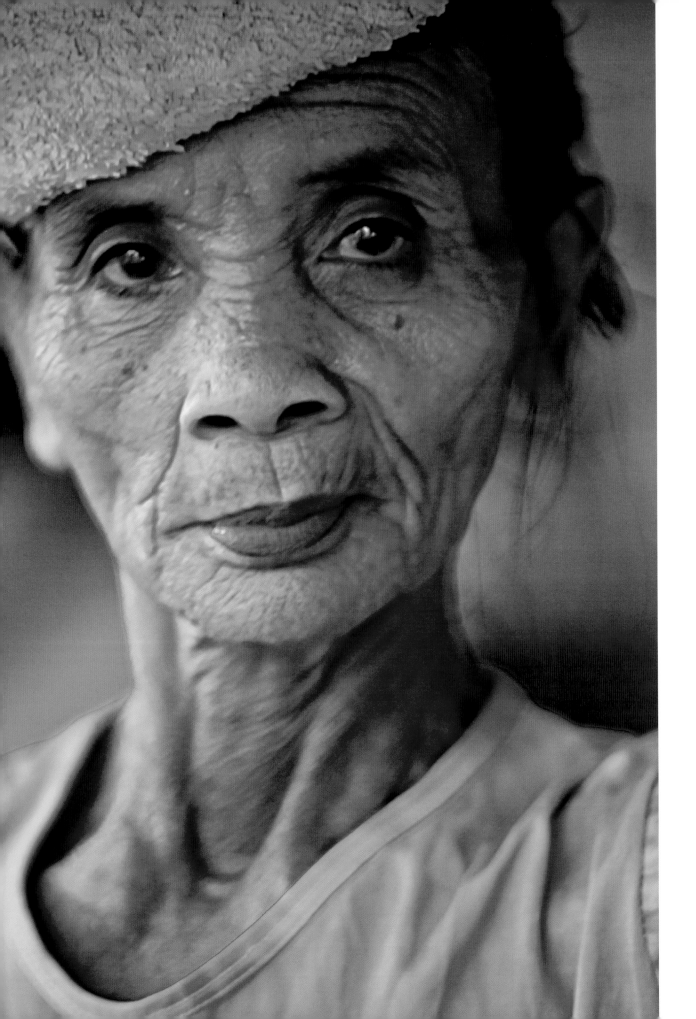

This Page: "Wayan", a wiry woman with a steely gaze, is a familiar face around the main shopping district surrounding the Kumbasari Market in central Denpasar. There she can be found hustling for rupiah by carrying the purchases of shoppers in the area.

Facing Page: A young boy peers from behind the doors to his family home in Kedewatan, near the central Bali resort area of Sayan.

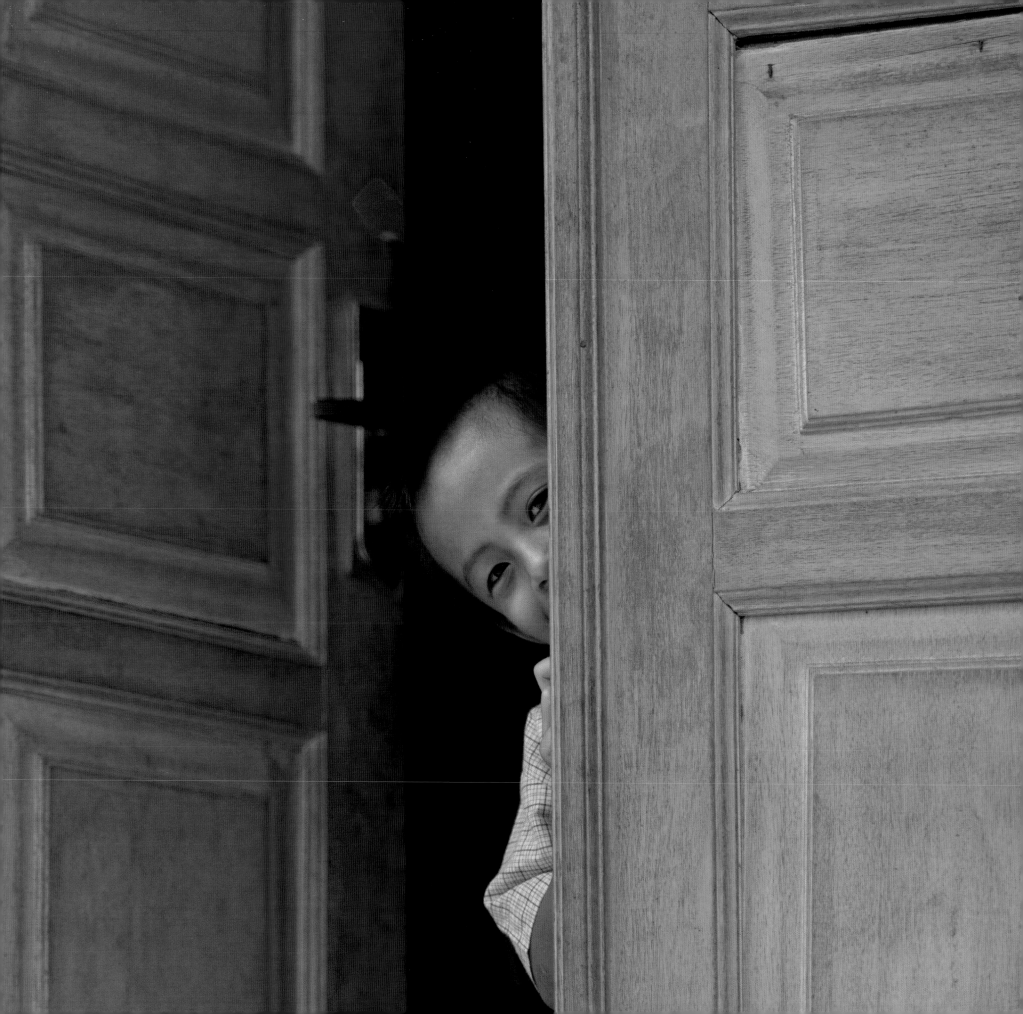

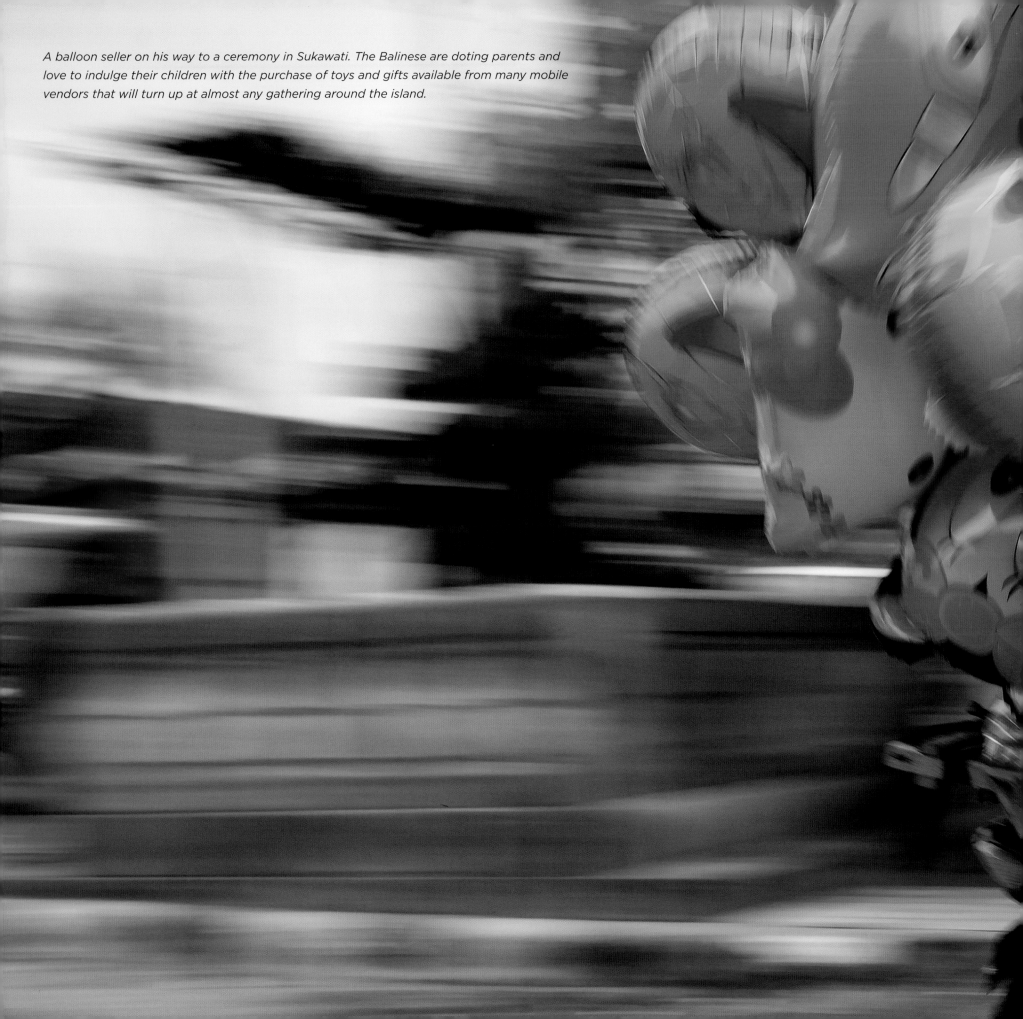

A balloon seller on his way to a ceremony in Sukawati. The Balinese are doting parents and love to indulge their children with the purchase of toys and gifts available from many mobile vendors that will turn up at almost any gathering around the island.

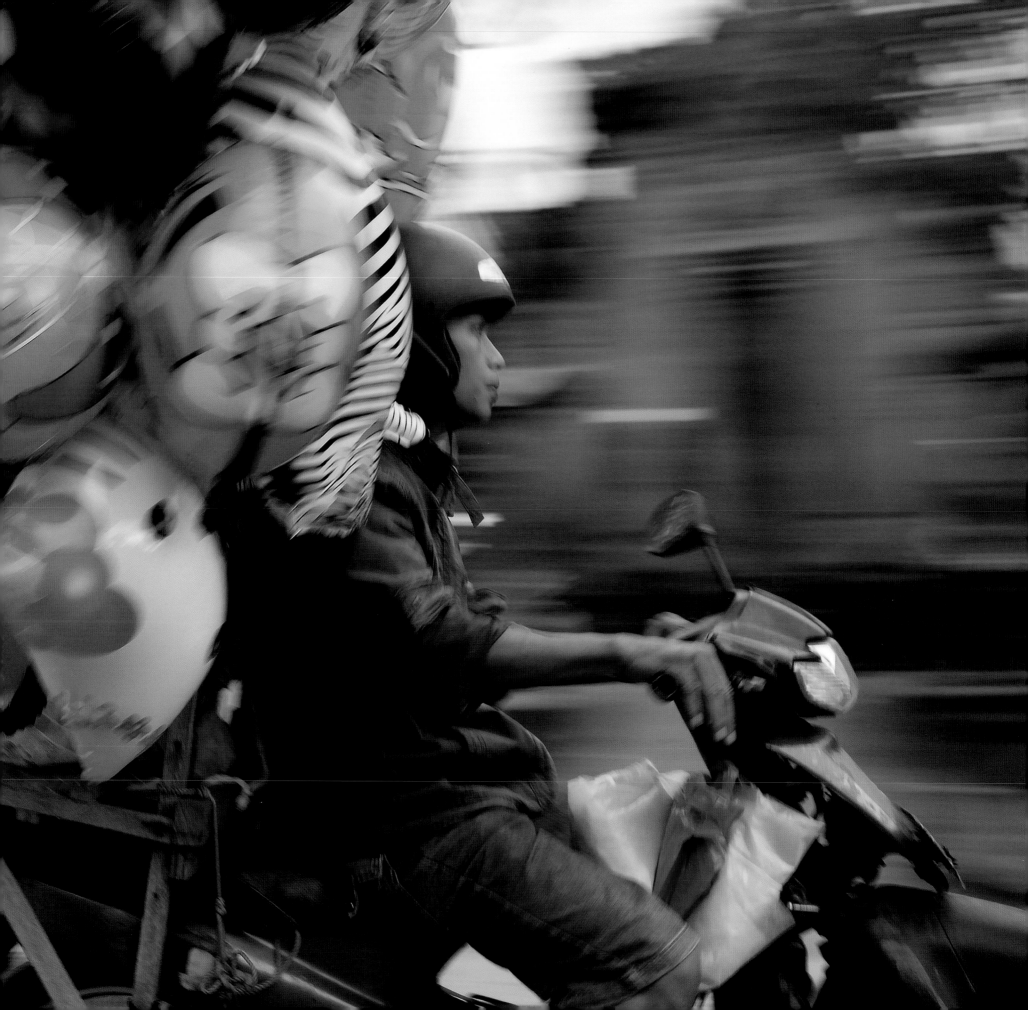

Temple Life

Centers of Spiritual Life in the Balinese Community

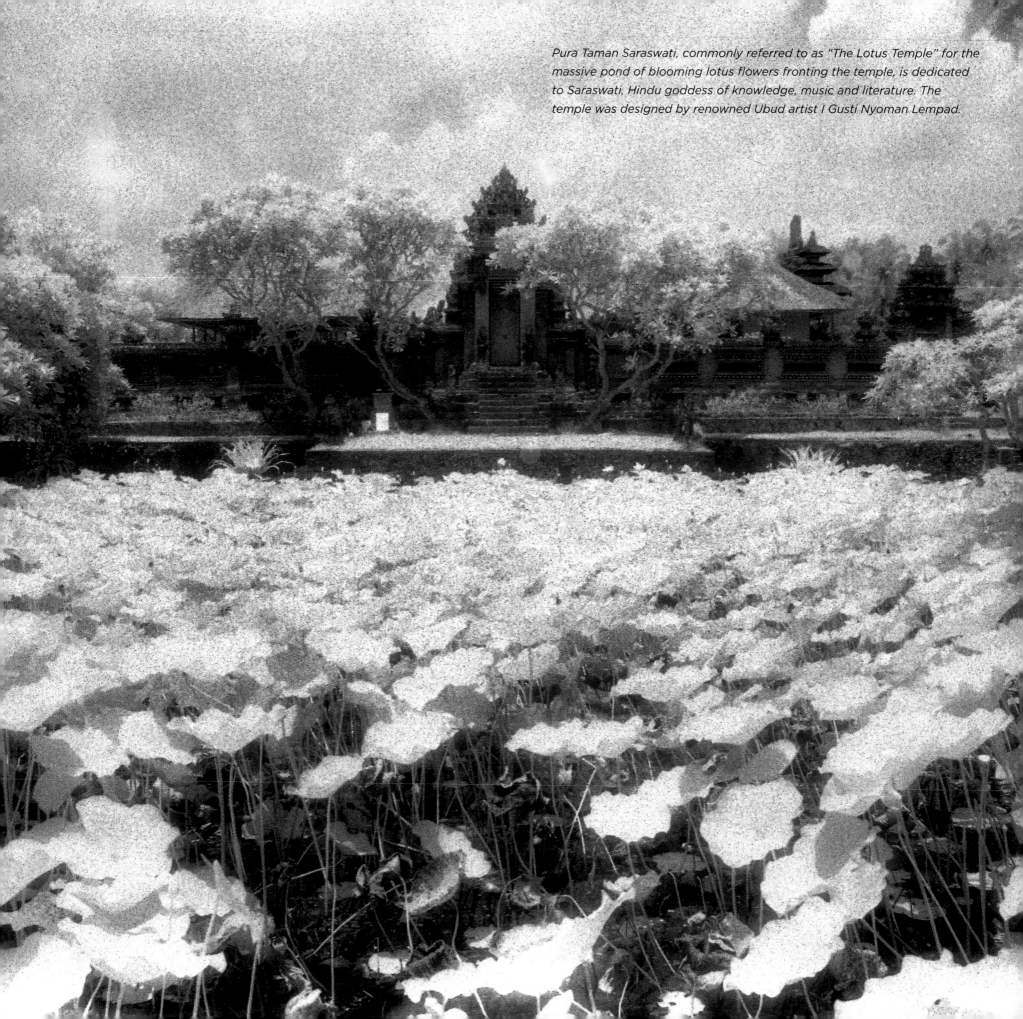

Pura Taman Saraswati, commonly referred to as "The Lotus Temple" for the massive pond of blooming lotus flowers fronting the temple, is dedicated to Saraswati, Hindu goddess of knowledge, music and literature. The temple was designed by renowned Ubud artist I Gusti Nyoman Lempad.

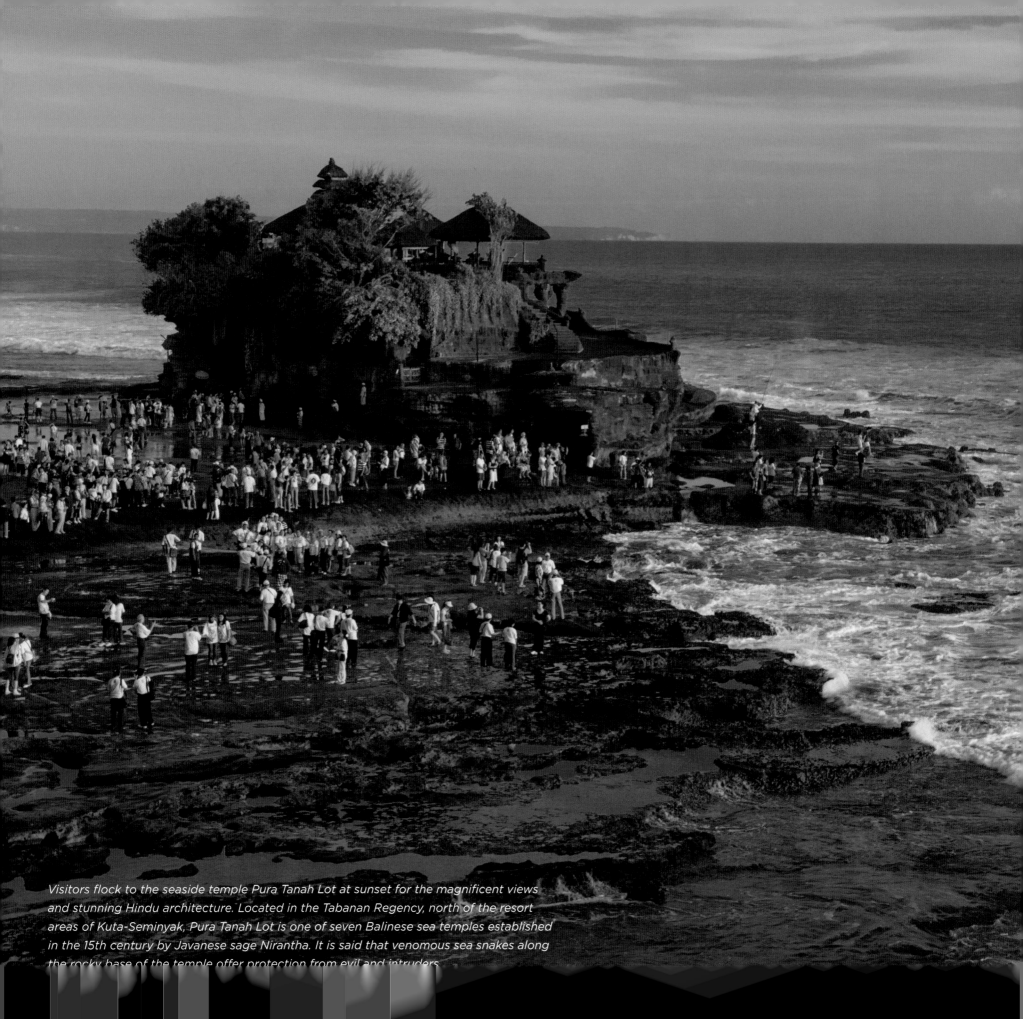

Visitors flock to the seaside temple Pura Tanah Lot at sunset for the magnificent views and stunning Hindu architecture. Located in the Tabanan Regency, north of the resort areas of Kuta-Seminyak, Pura Tanah Lot is one of seven Balinese sea temples established in the 15th century by Javanese sage Nirantha. It is said that venomous sea snakes along the rocky base of the temple offer protection from evil and intruders.

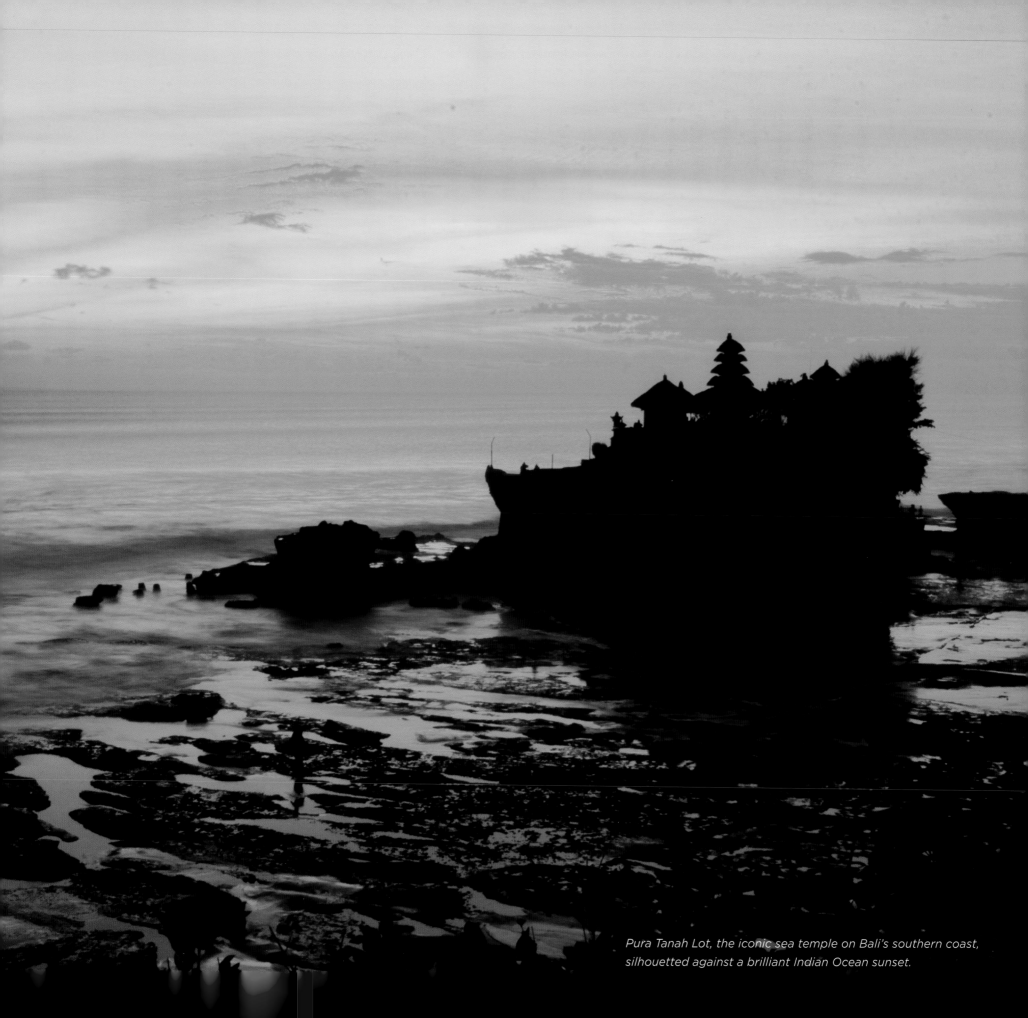

Pura Tanah Lot, the iconic sea temple on Bali's southern coast, silhouetted against a brilliant Indian Ocean sunset.

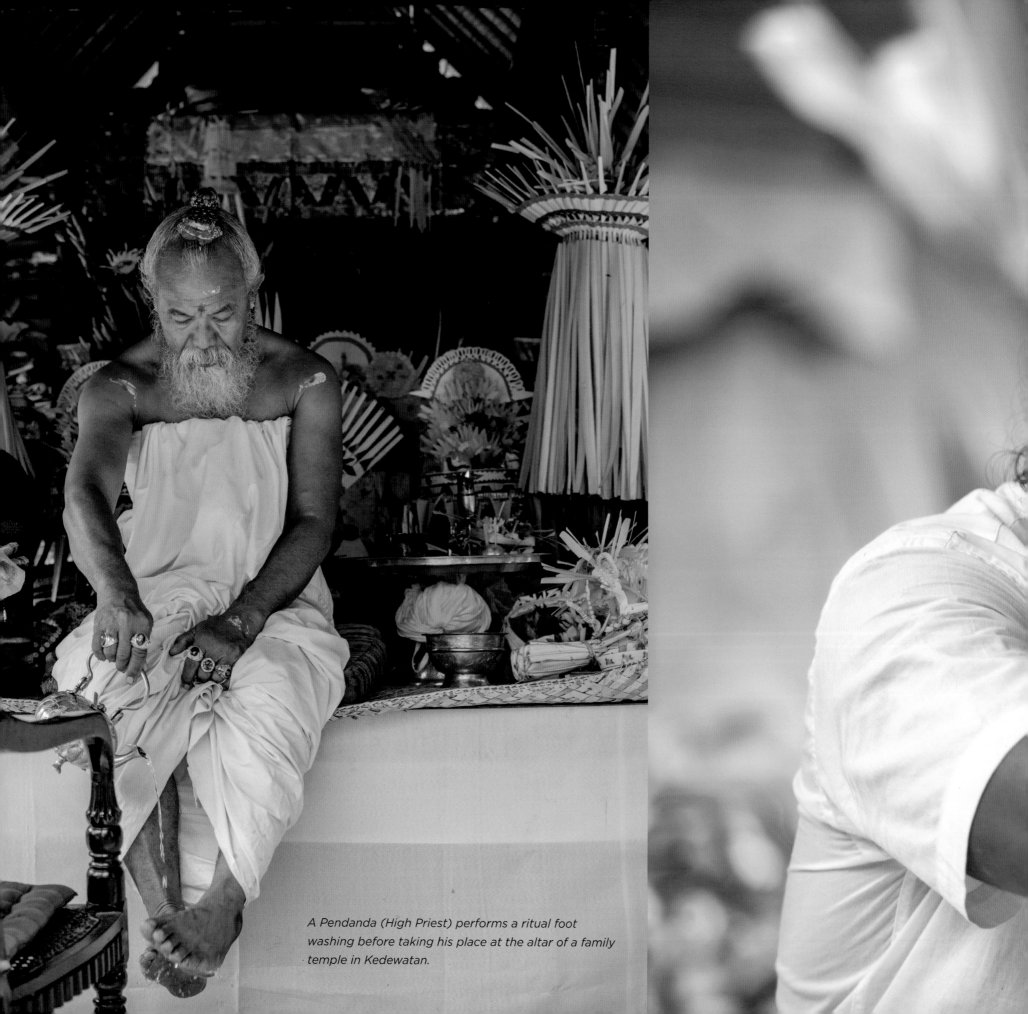

A Pendanda (High Priest) performs a ritual foot washing before taking his place at the altar of a family temple in Kedewatan.

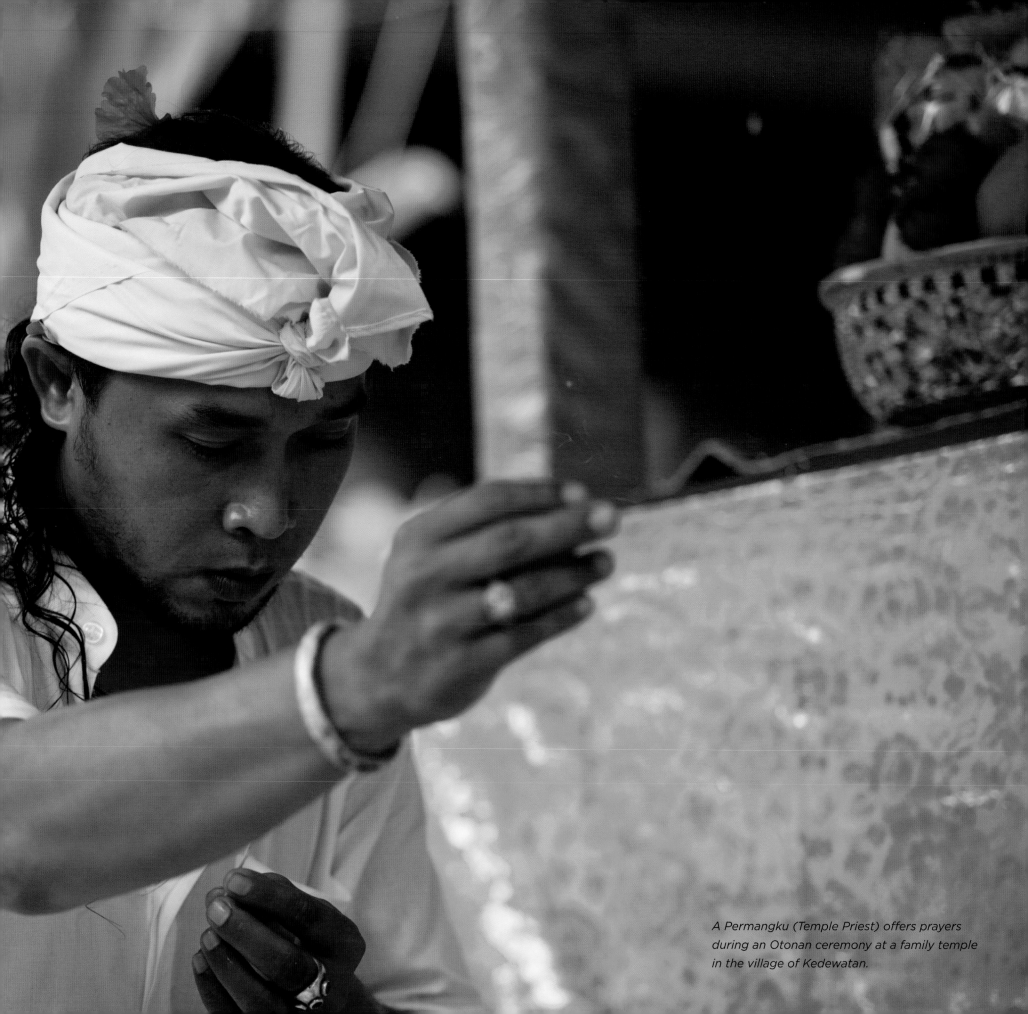

A Permangku (Temple Priest) offers prayers during an Otonan ceremony at a family temple in the village of Kedewatan.

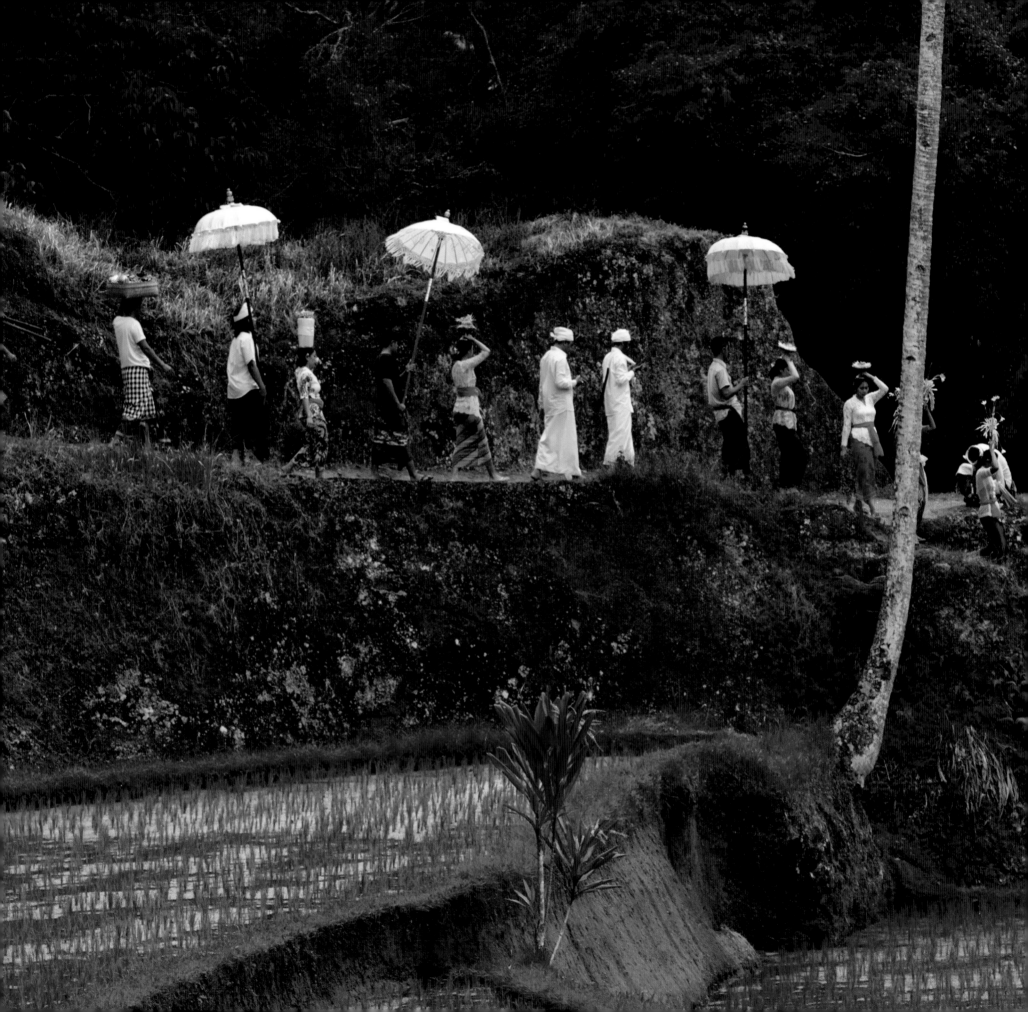

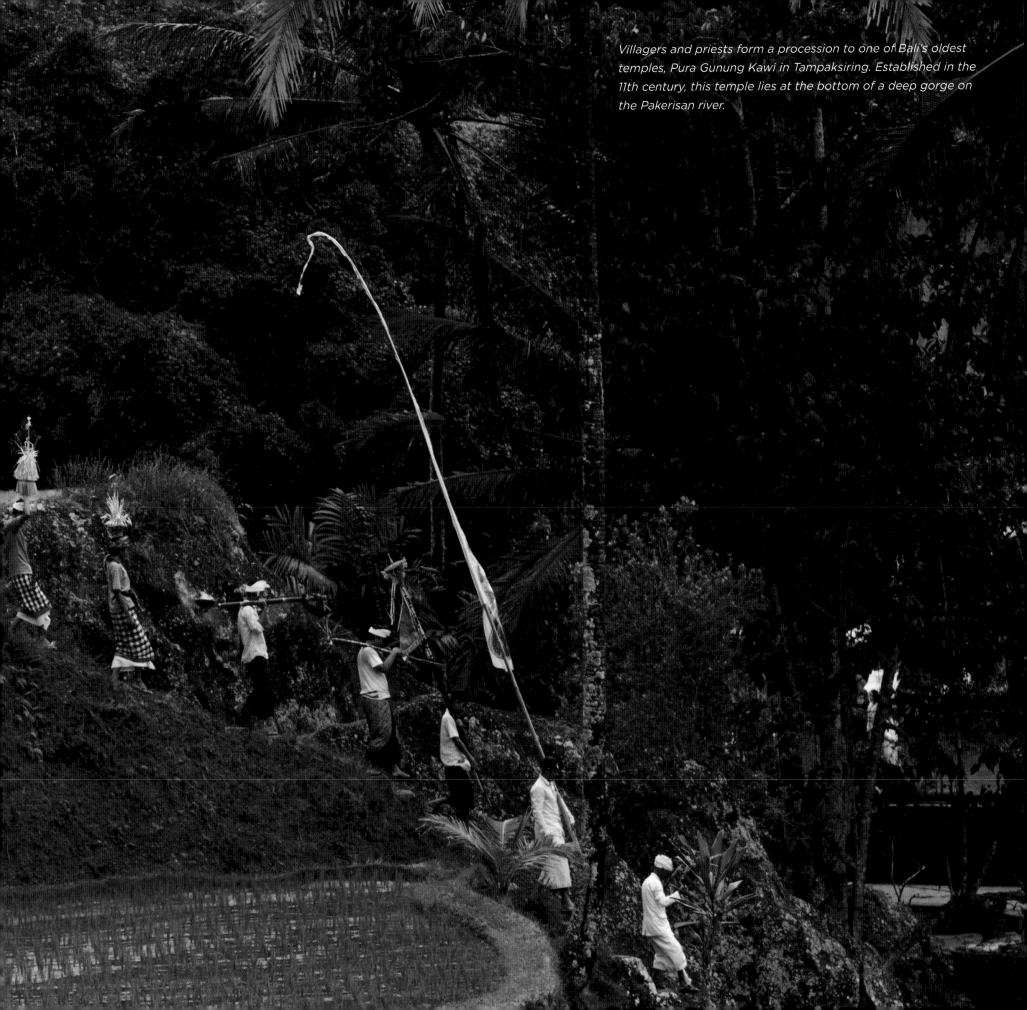

Villagers and priests form a procession to one of Bali's oldest temples, Pura Gunung Kawi in Tampaksiring. Established in the 11th century, this temple lies at the bottom of a deep gorge on the Pakerisan river.

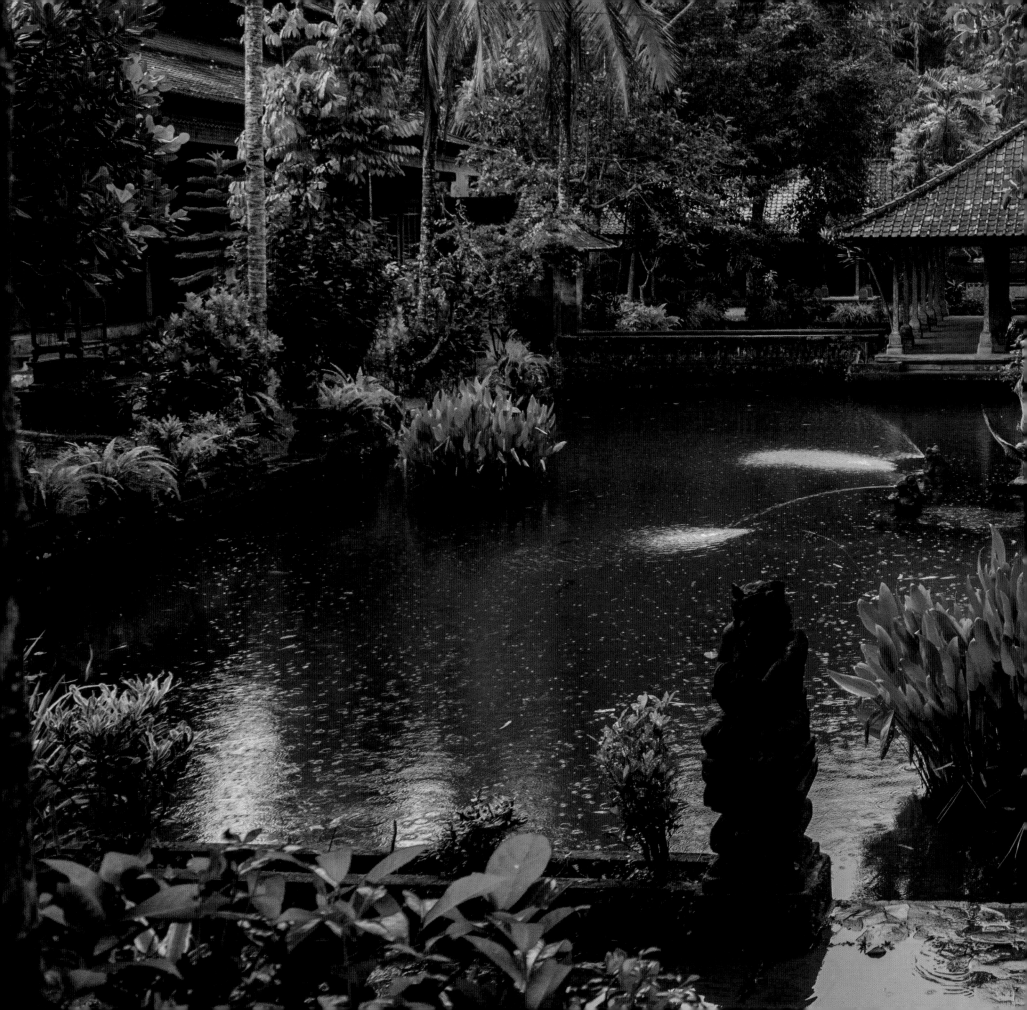

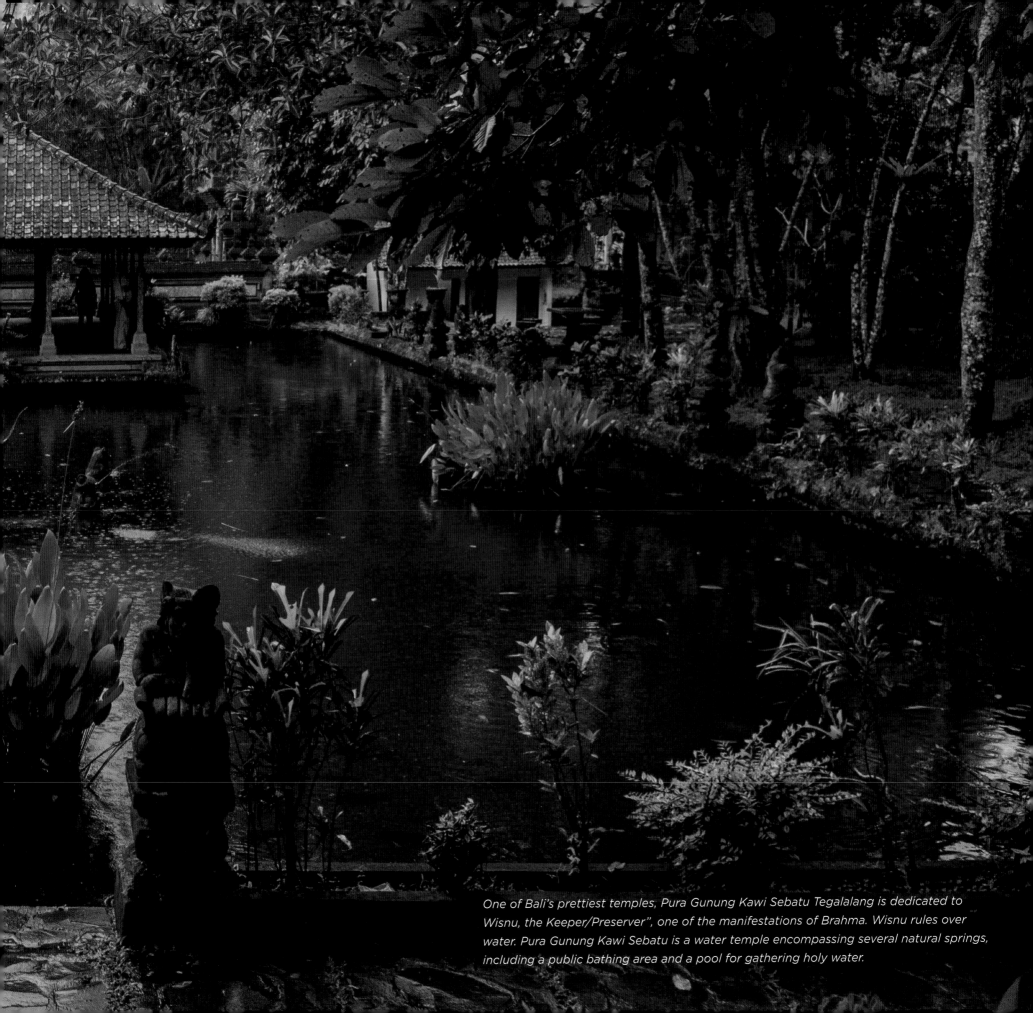

One of Bali's prettiest temples, Pura Gunung Kawi Sebatu Tegalalang is dedicated to Wisnu, the Keeper/Preserver", one of the manifestations of Brahma. Wisnu rules over water. Pura Gunung Kawi Sebatu is a water temple encompassing several natural springs, including a public bathing area and a pool for gathering holy water.

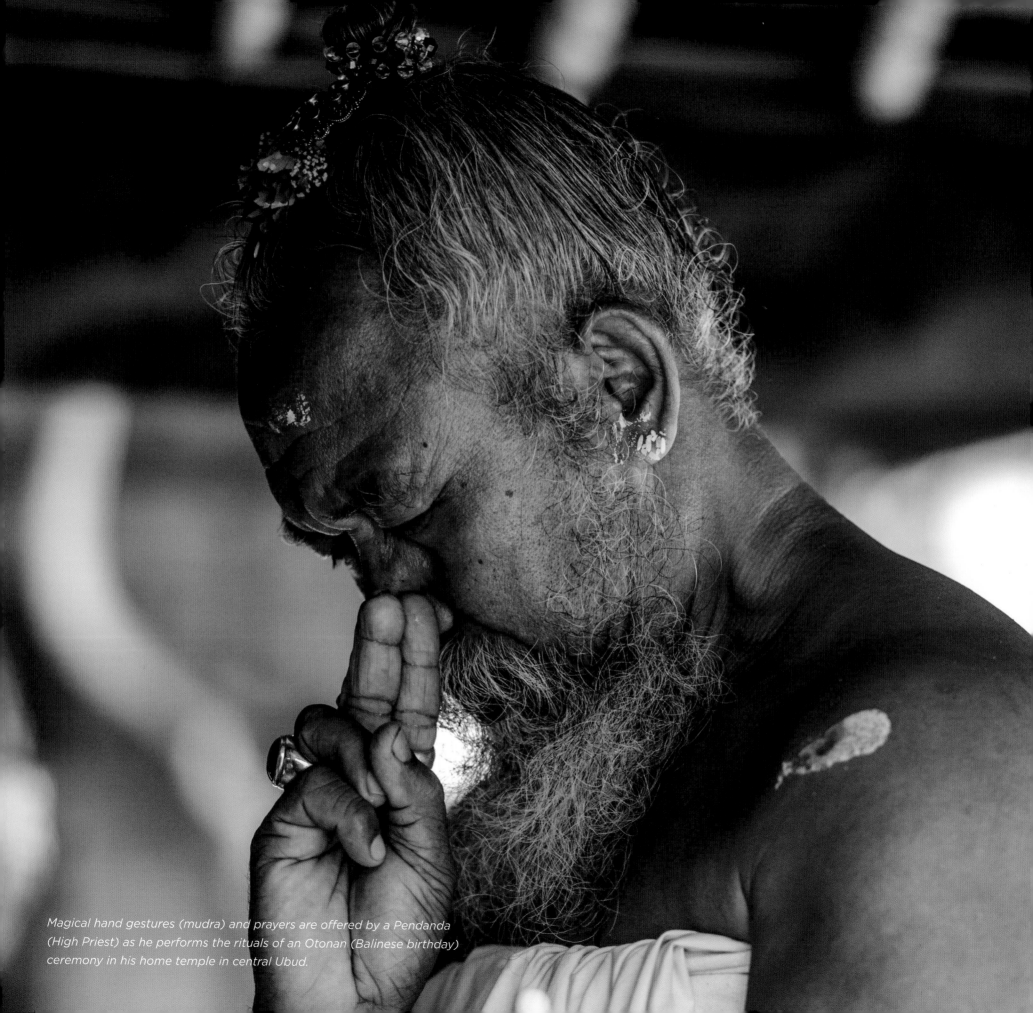

Magical hand gestures (mudra) and prayers are offered by a Pendanda (High Priest) as he performs the rituals of an Otonan (Balinese birthday) ceremony in his home temple in central Ubud.

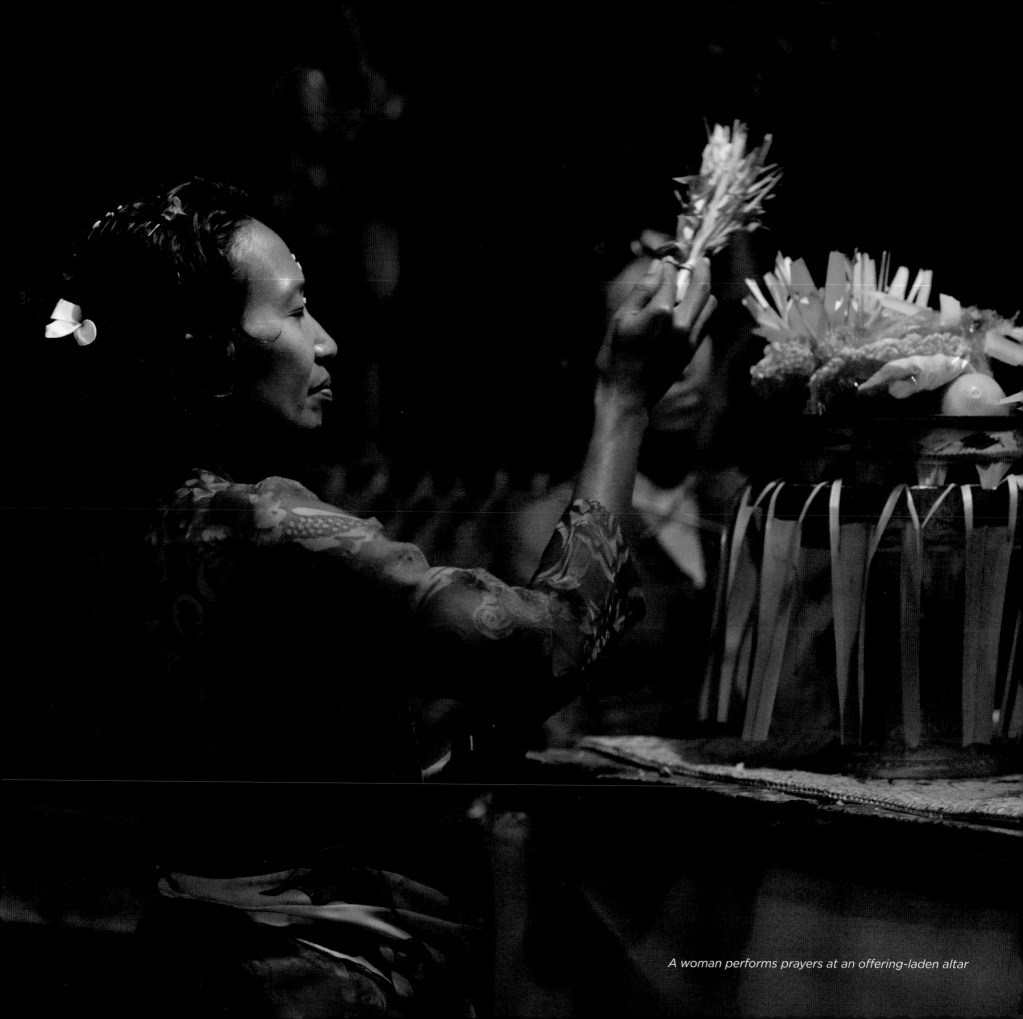

A woman performs prayers at an offering-laden altar

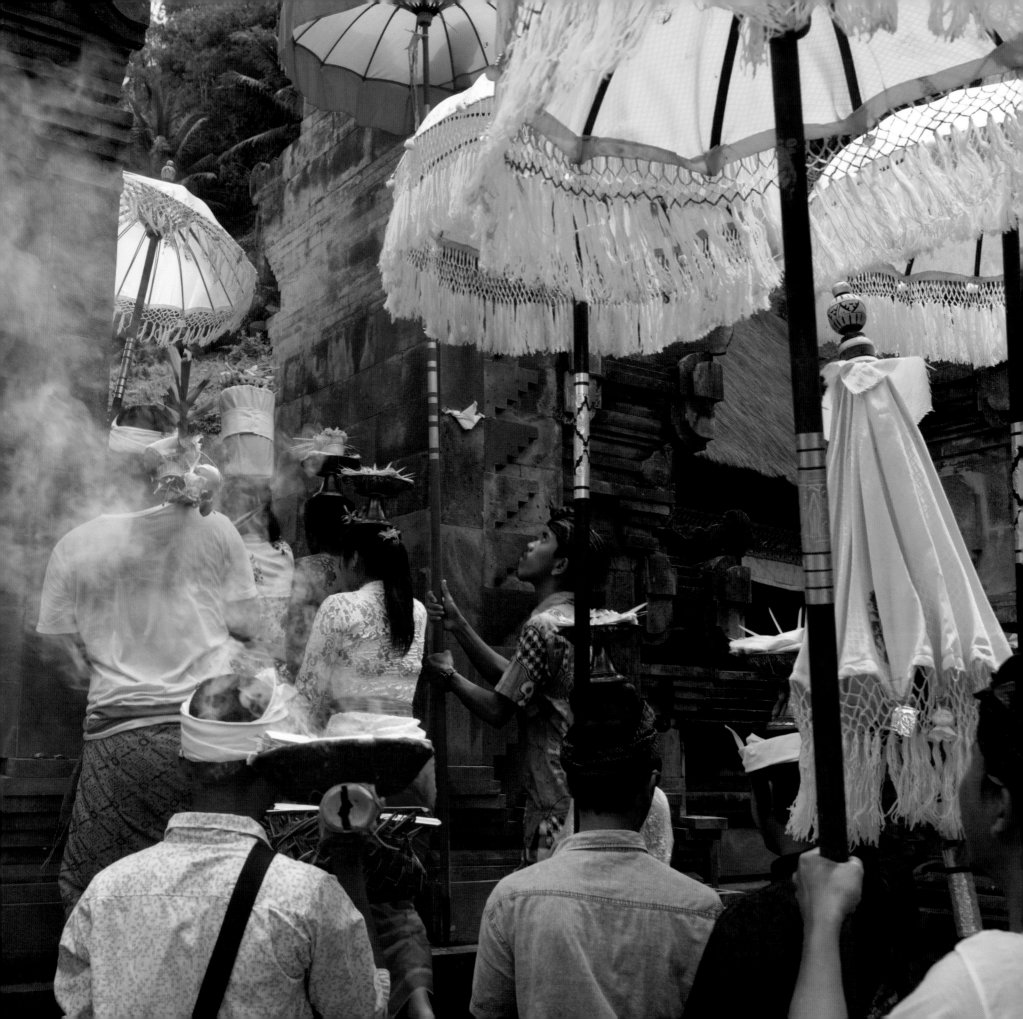

This Page: A High Priest (Pendanda) recites prayers and magical incantations (Mantra) during Otonan ceremonies in Ubud. The "Otonan" is a ceremony conducted by each Hindu Balinese twice each year celebrating the individual's "spiritual" birthday. During Otonan ceremonies, participants seek forgiveness for past sins and dedicate themselves to living a better spiritual life moving forward.

Facing Page: Bearing offerings, smoking braziers of incense, and colorful ceremonial umbrellas, the Hindu faithful enter the gates into the main temple courtyard at Pura Gunung Kawi in Tampaksiring during the temple's annual anniversary (Odalan) rituals.

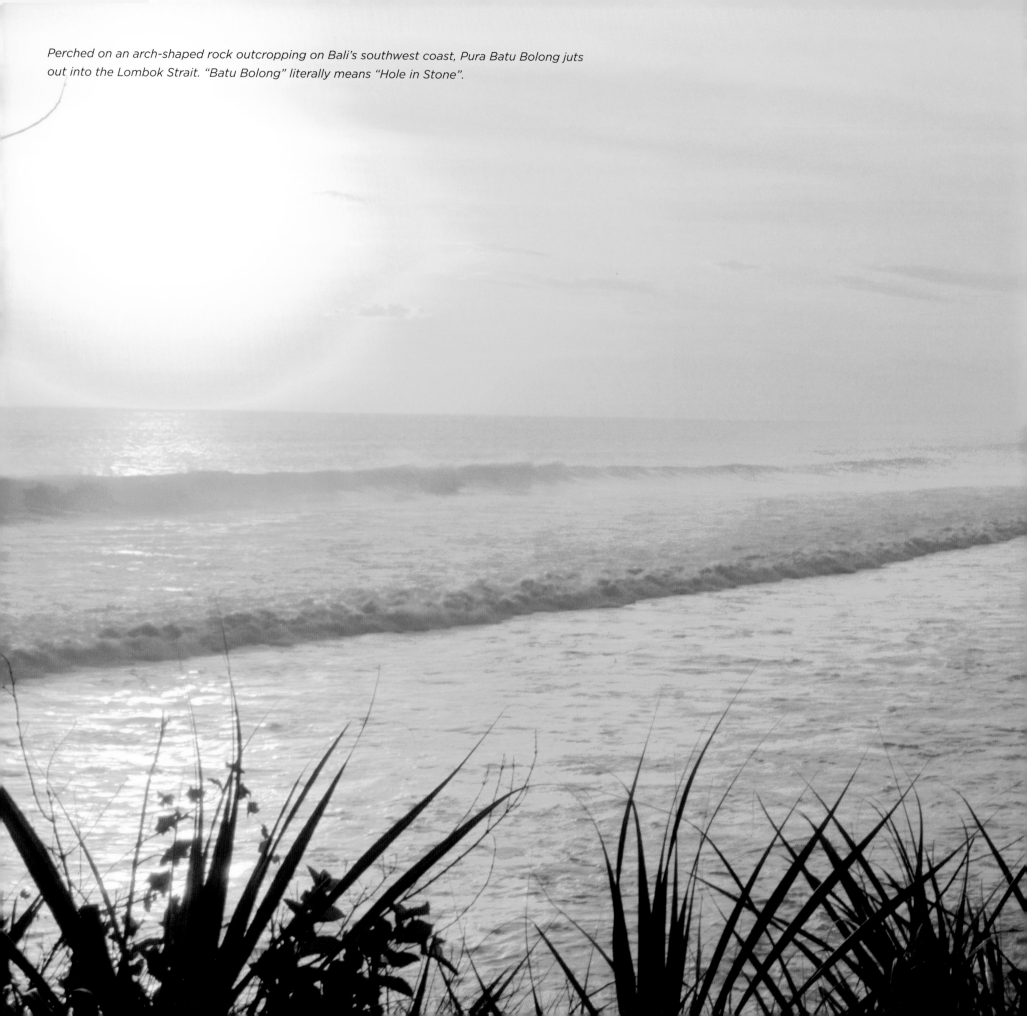

Perched on an arch-shaped rock outcropping on Bali's southwest coast, Pura Batu Bolong juts out into the Lombok Strait. "Batu Bolong" literally means "Hole in Stone".

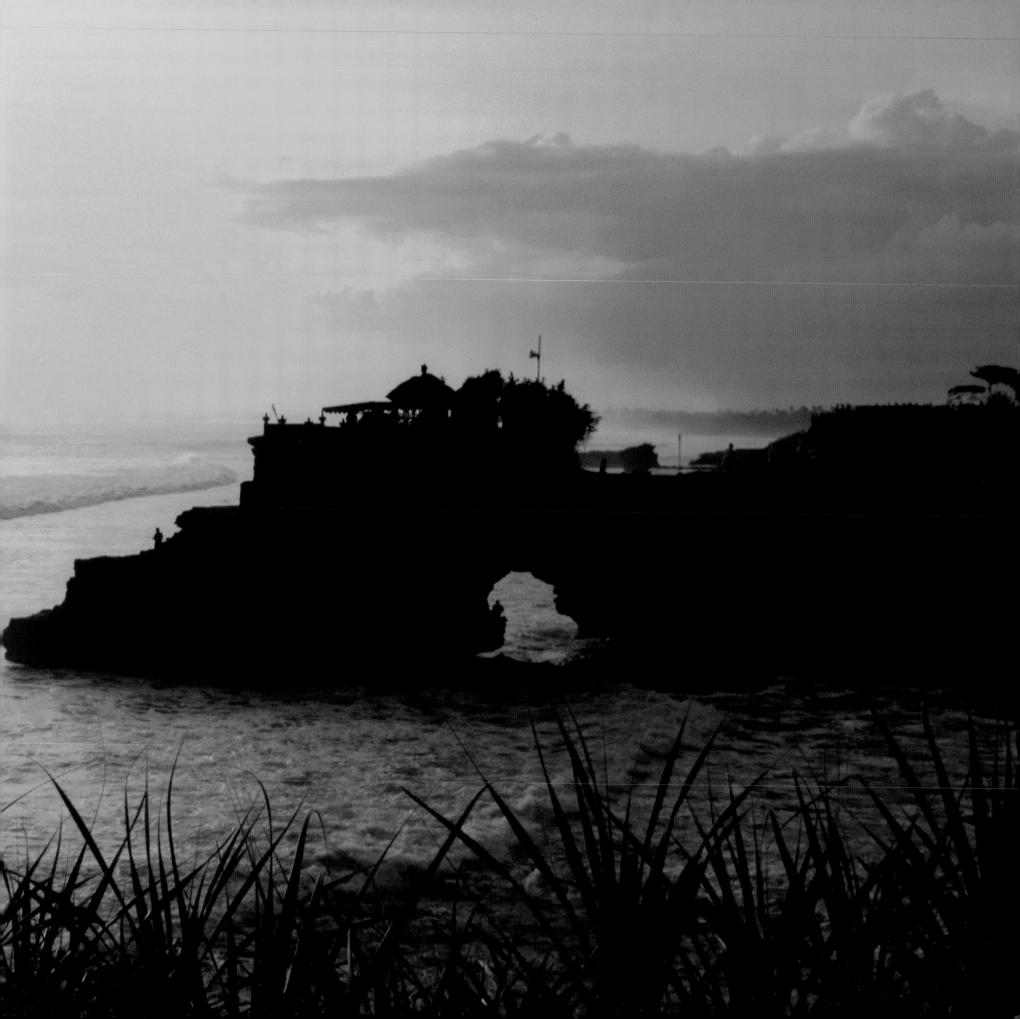

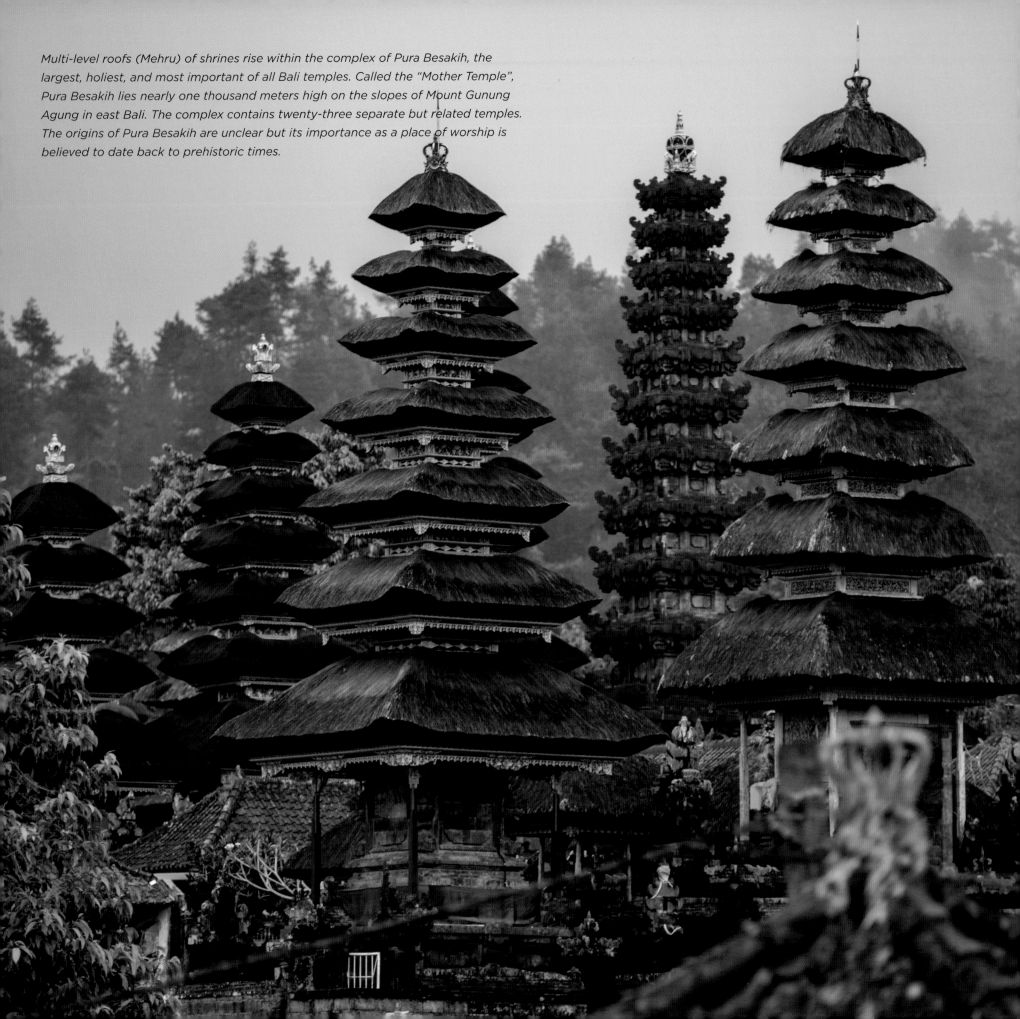

Multi-level roofs (Mehru) of shrines rise within the complex of Pura Besakih, the largest, holiest, and most important of all Bali temples. Called the "Mother Temple", Pura Besakih lies nearly one thousand meters high on the slopes of Mount Gunung Agung in east Bali. The complex contains twenty-three separate but related temples. The origins of Pura Besakih are unclear but its importance as a place of worship is believed to date back to prehistoric times.

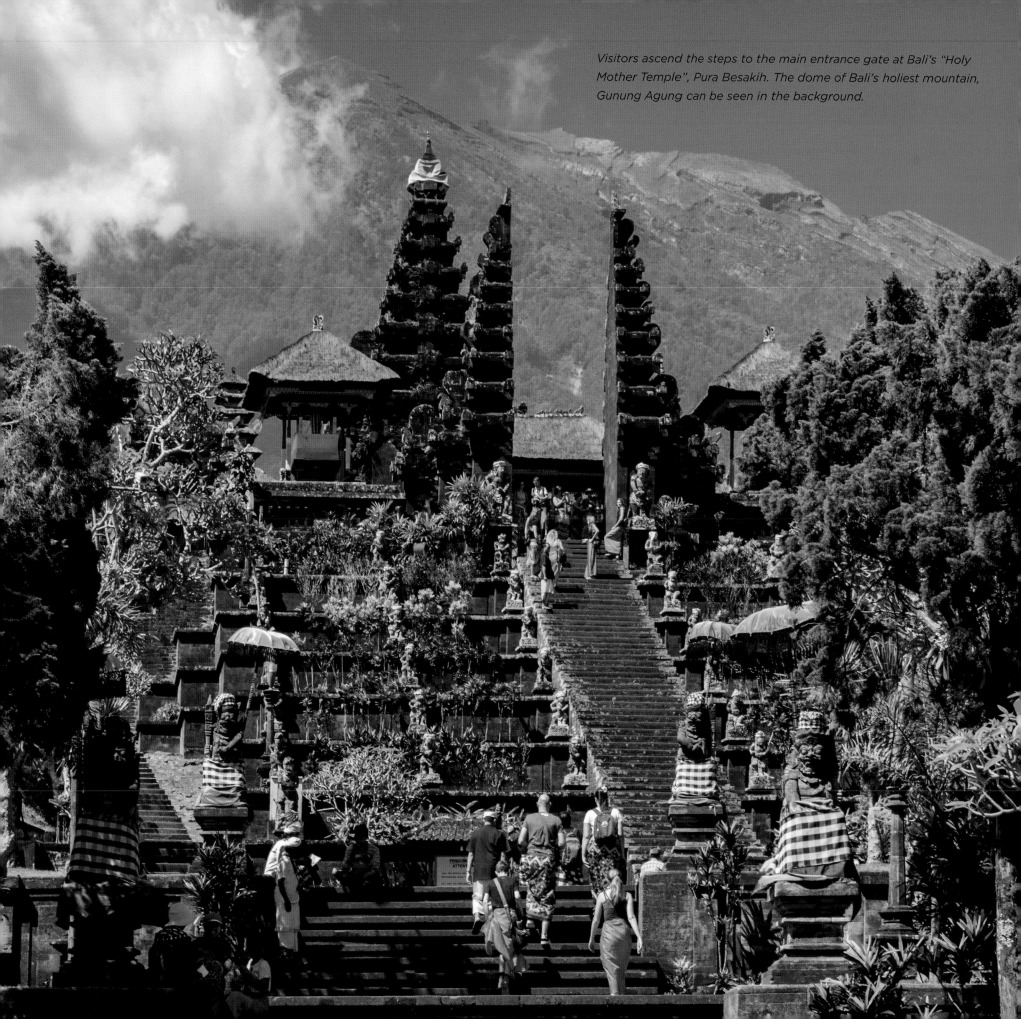

Visitors ascend the steps to the main entrance gate at Bali's "Holy Mother Temple", Pura Besakih. The dome of Bali's holiest mountain, Gunung Agung can be seen in the background.

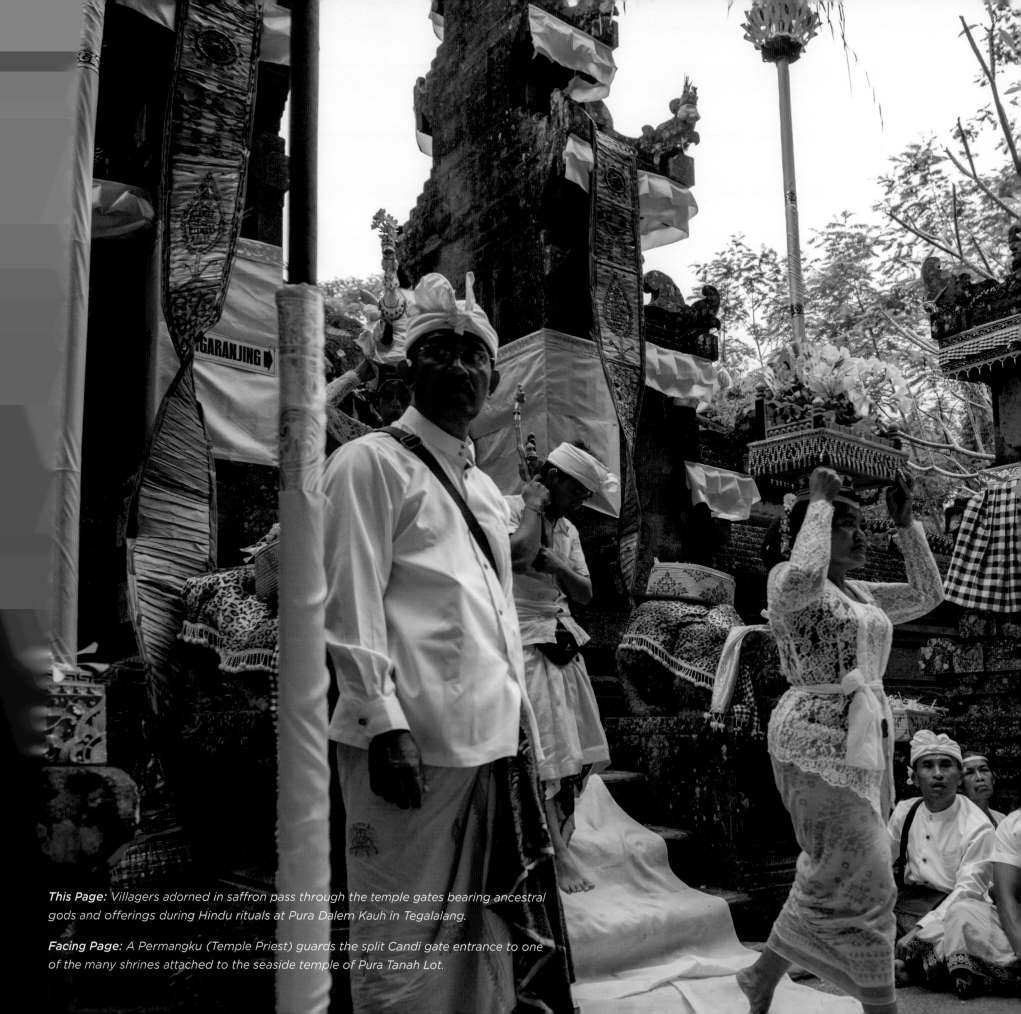

This Page: *Villagers adorned in saffron pass through the temple gates bearing ancestral gods and offerings during Hindu rituals at Pura Dalem Kauh in Tegalalang.*

Facing Page: *A Permangku (Temple Priest) guards the split Candi gate entrance to one of the many shrines attached to the seaside temple of Pura Tanah Lot.*

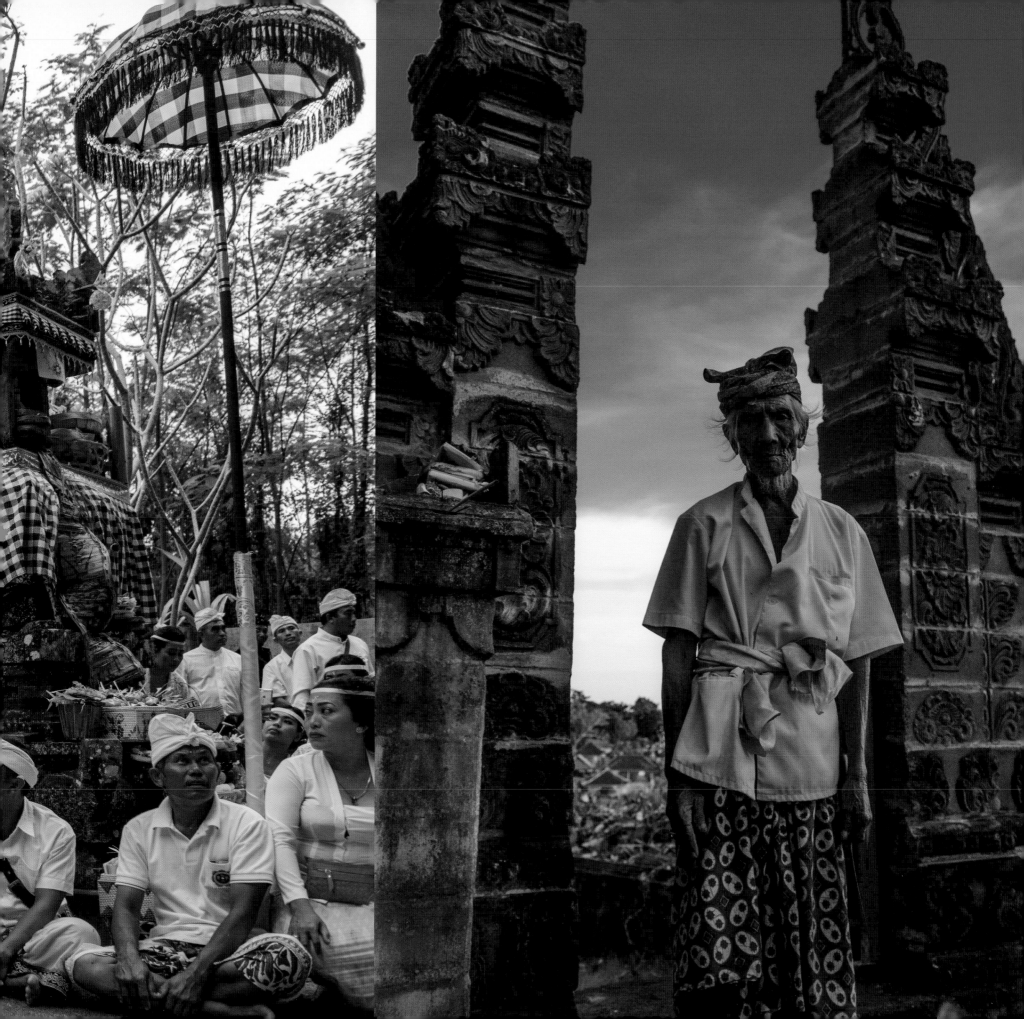

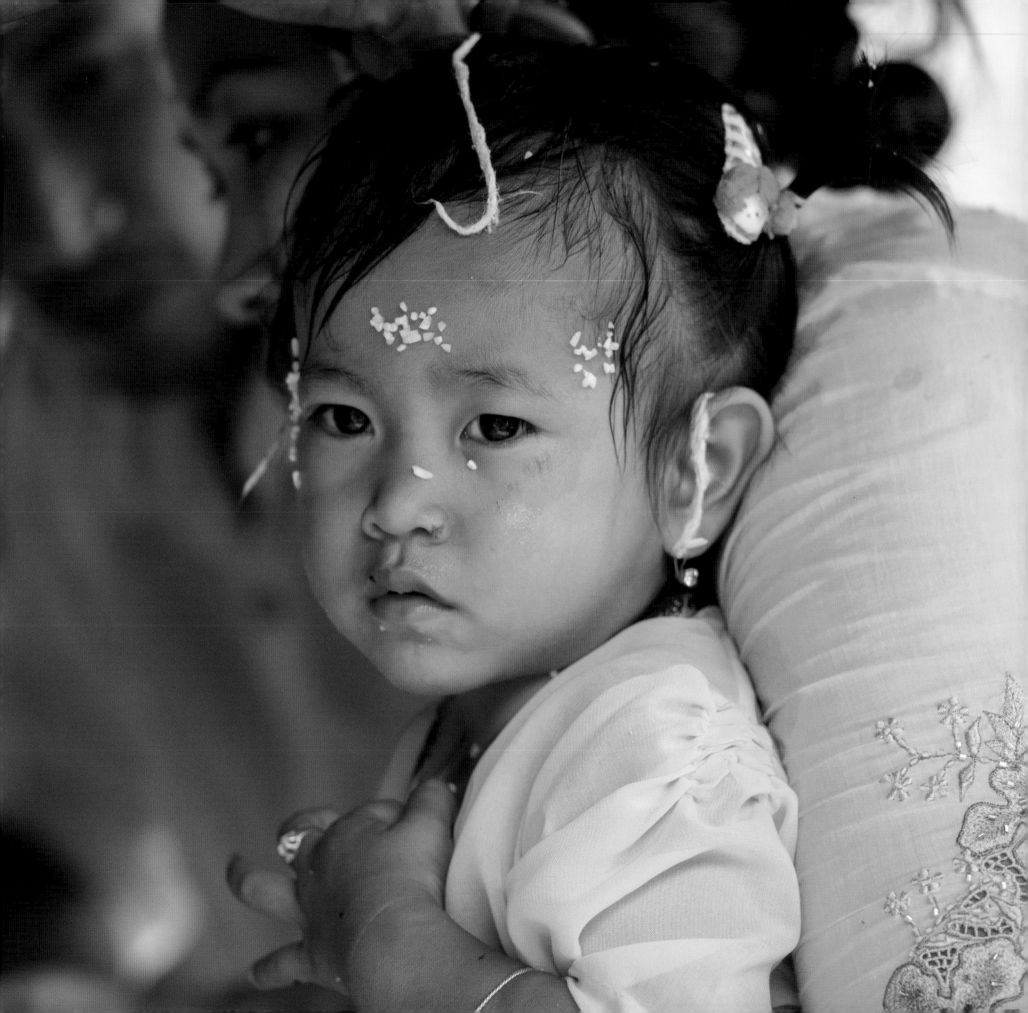

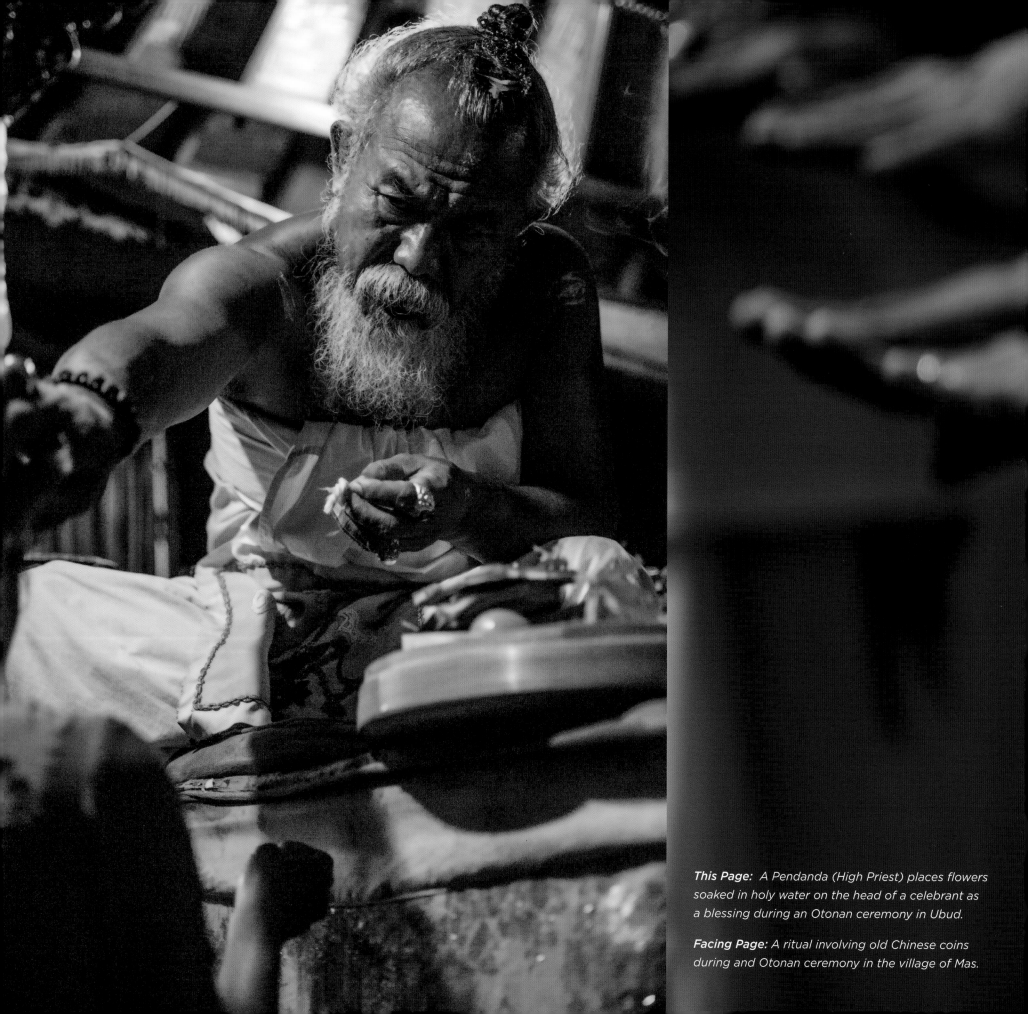

This Page: A Pendanda (High Priest) places flowers soaked in holy water on the head of a celebrant as a blessing during an Otonan ceremony in Ubud.

Facing Page: A ritual involving old Chinese coins during and Otonan ceremony in the village of Mas.

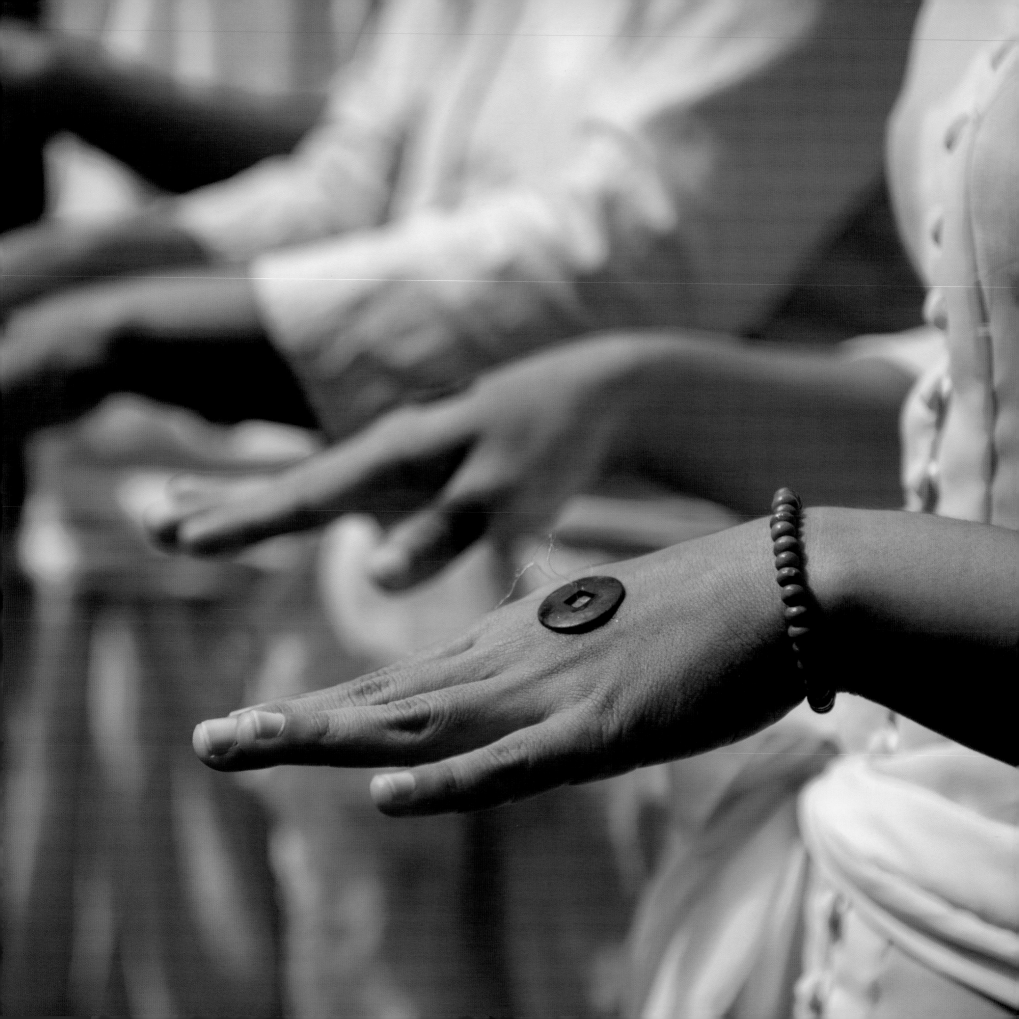

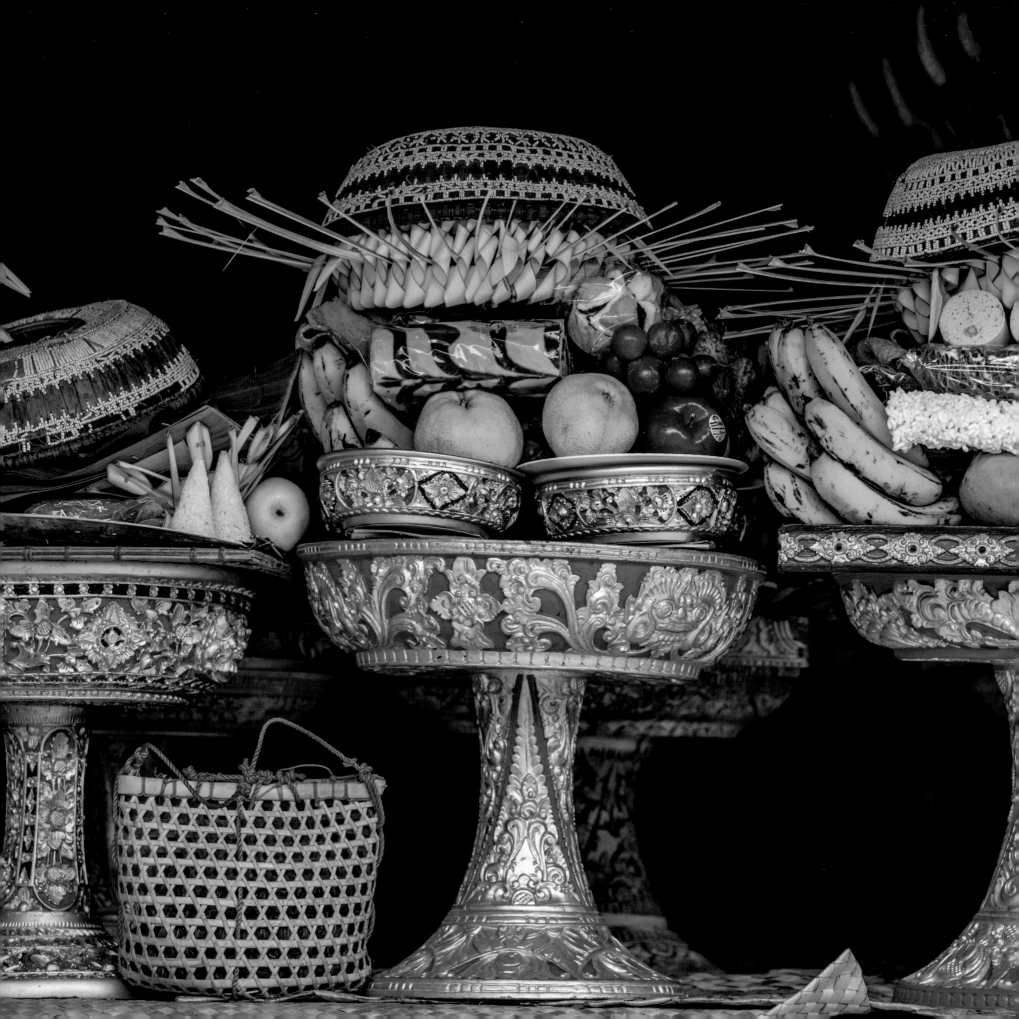

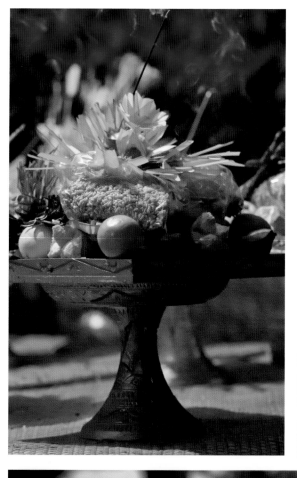

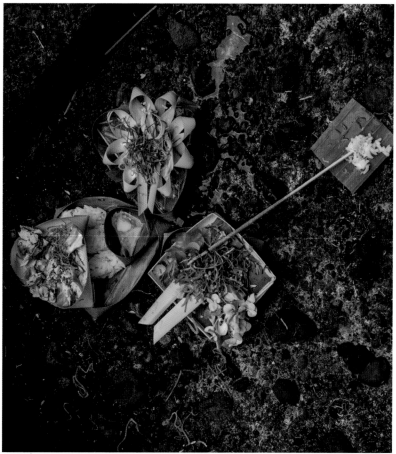

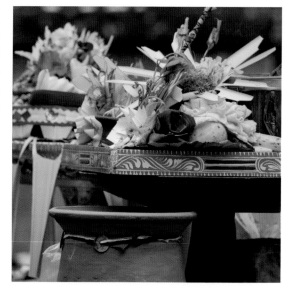

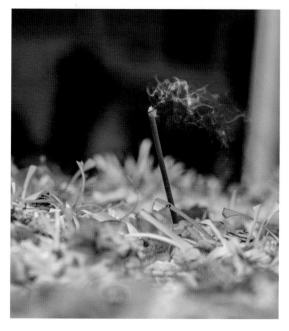

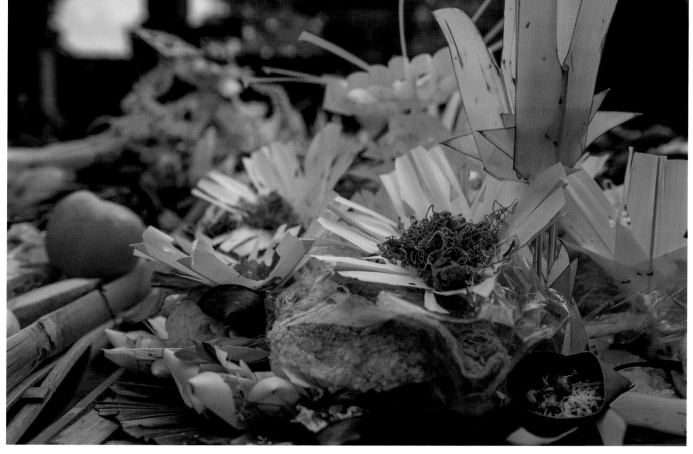

A few of the myriad styles of offerings used in Balinese religious rituals. Hours go into the preparation of these artful presentation of devotion. Intricate weaving of palm leaf and bamboo, flowers, rice, sticks of smoldering incense, and rice wine (Brem) are used depending on the ritual or occasion. Often smoked chicken or duck, roast suckling pig, crackers, and other foodstuffs, and the occasional live sacrifice all make up these offerings meant to appease and placate a pantheon of gods, ancestral spirits, demons and harmful spirits.

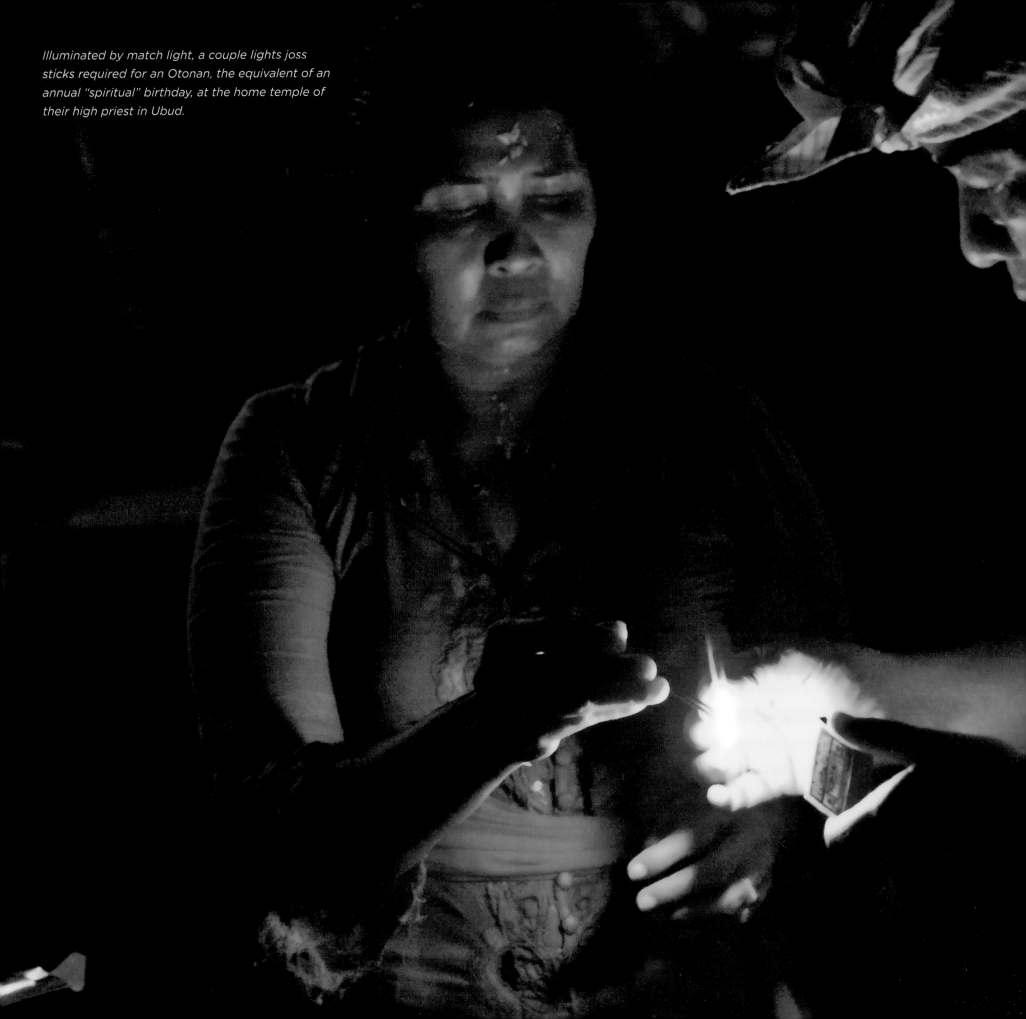

Illuminated by match light, a couple lights joss sticks required for an Otonan, the equivalent of an annual "spiritual" birthday, at the home temple of their high priest in Ubud.

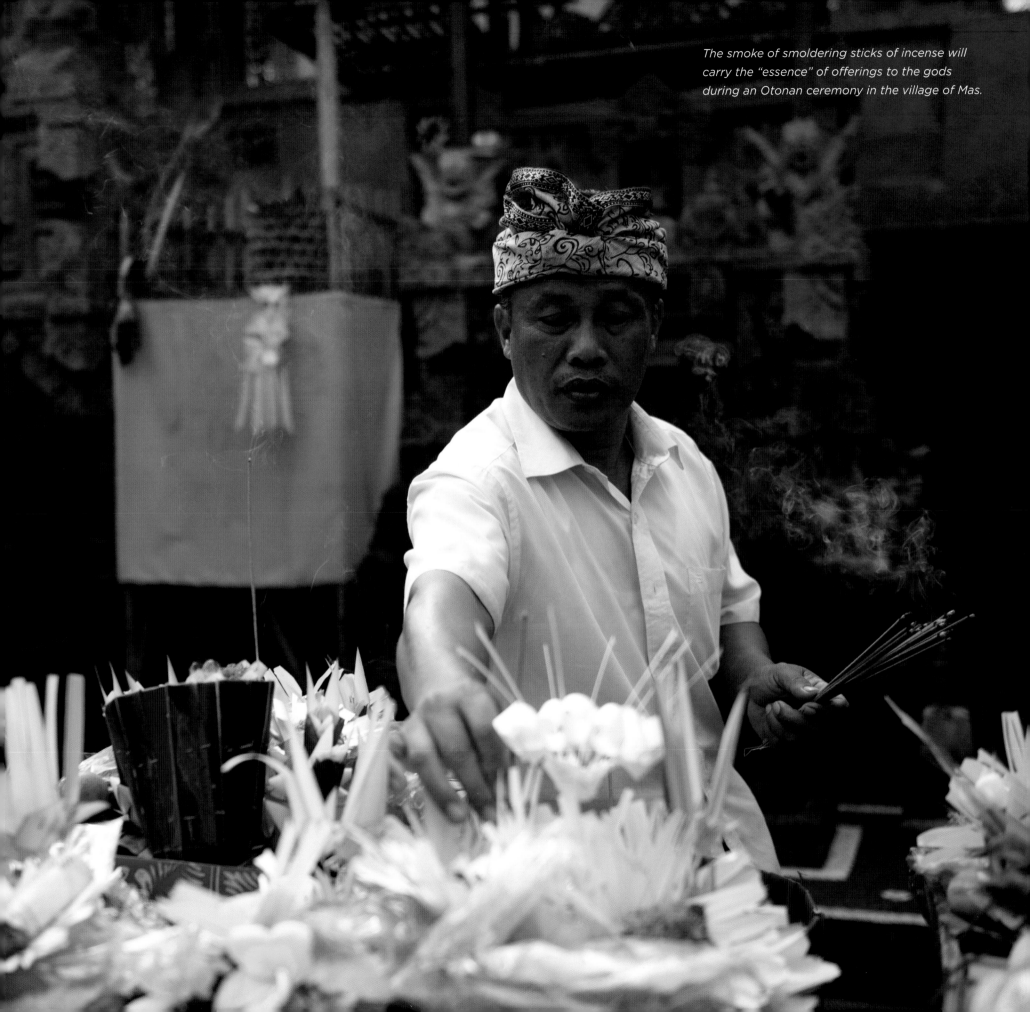

The smoke of smoldering sticks of incense will carry the "essence" of offerings to the gods during an Otonan ceremony in the village of Mas.

Cremation Rituals

The Final Rites of Passage

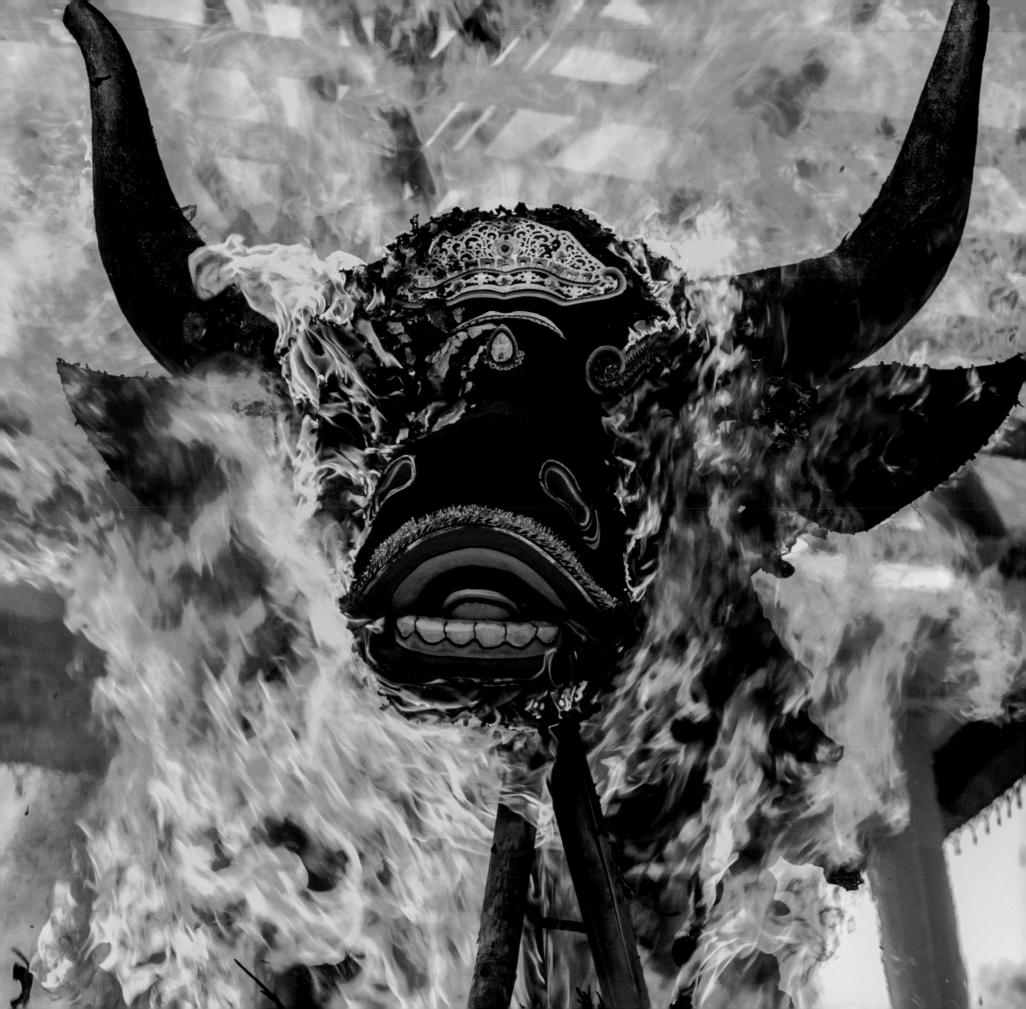

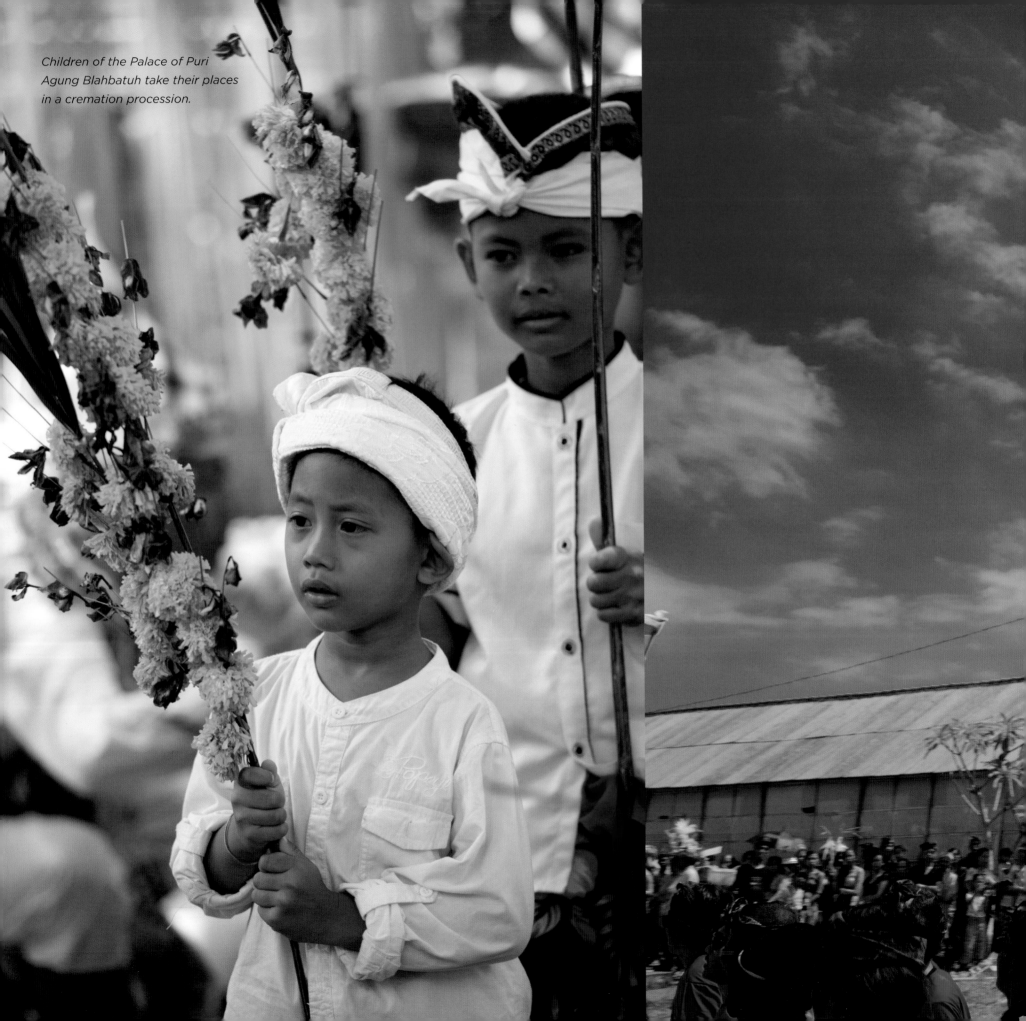

Children of the Palace of Puri Agung Blahbatuh take their places in a cremation procession.

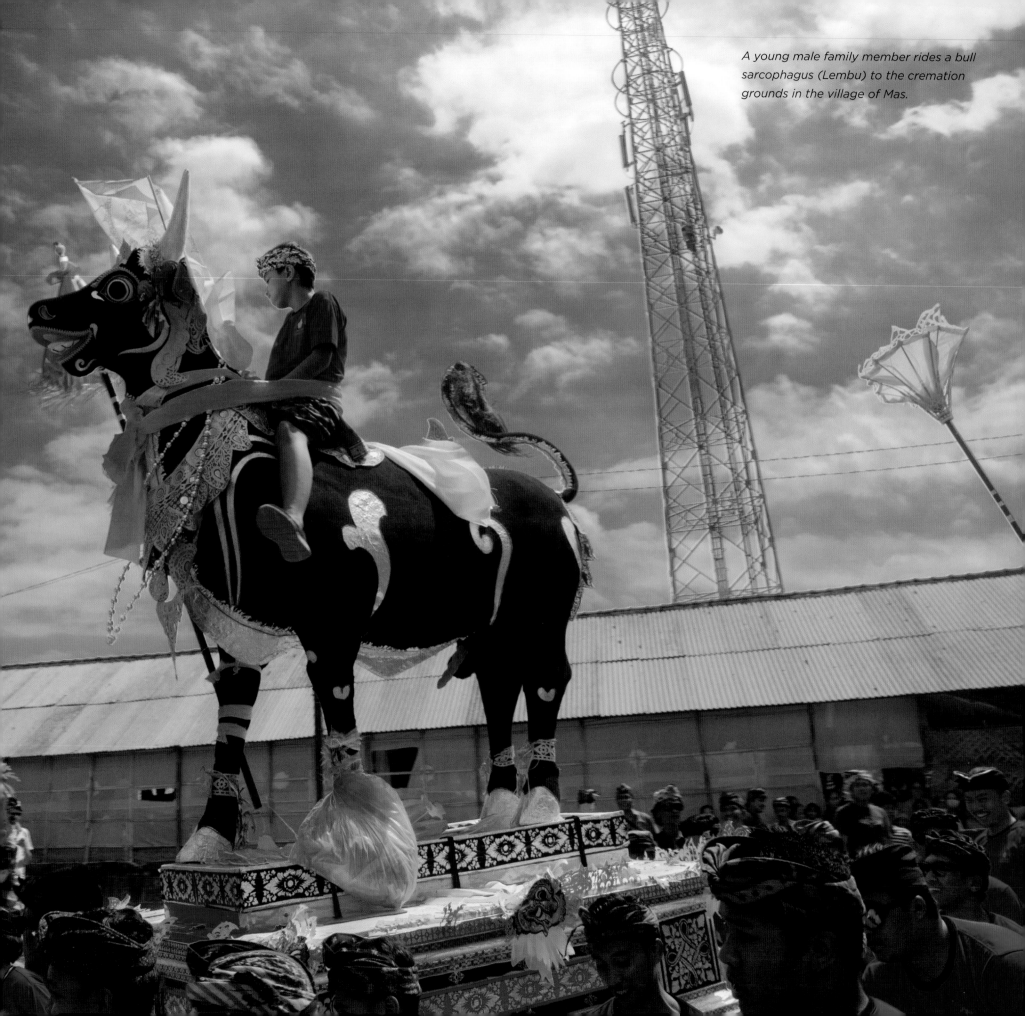

A young male family member rides a bull sarcophagus (Lembu) to the cremation grounds in the village of Mas.

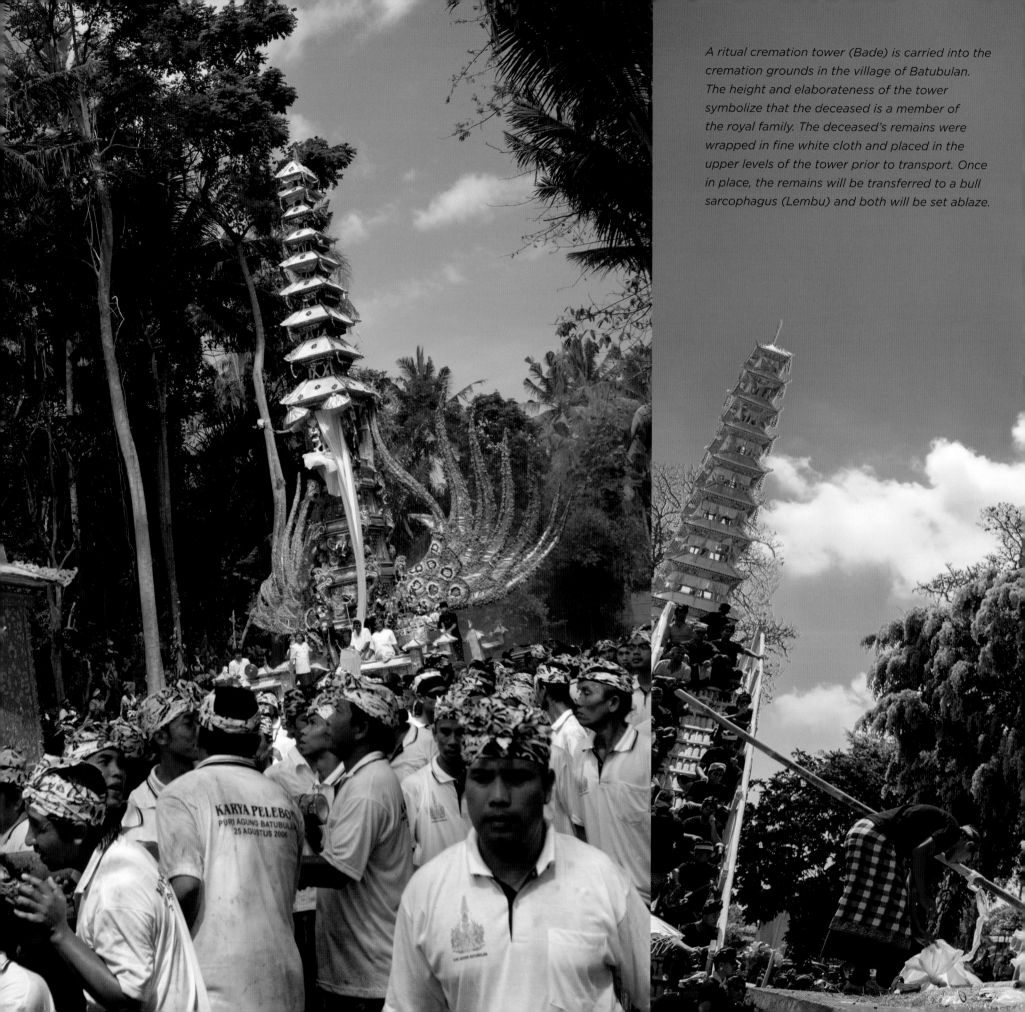

A ritual cremation tower (Bade) is carried into the cremation grounds in the village of Batubulan. The height and elaborateness of the tower symbolize that the deceased is a member of the royal family. The deceased's remains were wrapped in fine white cloth and placed in the upper levels of the tower prior to transport. Once in place, the remains will be transferred to a bull sarcophagus (Lembu) and both will be set ablaze.

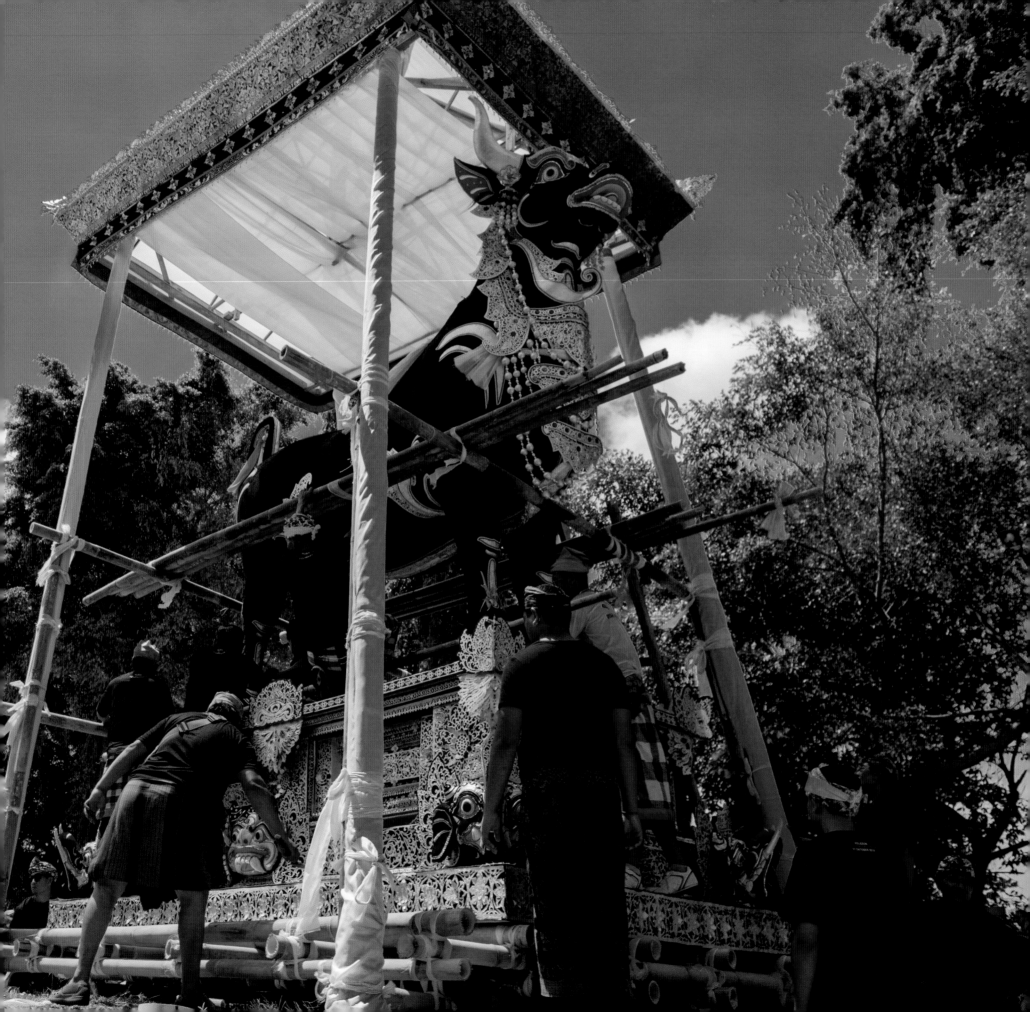

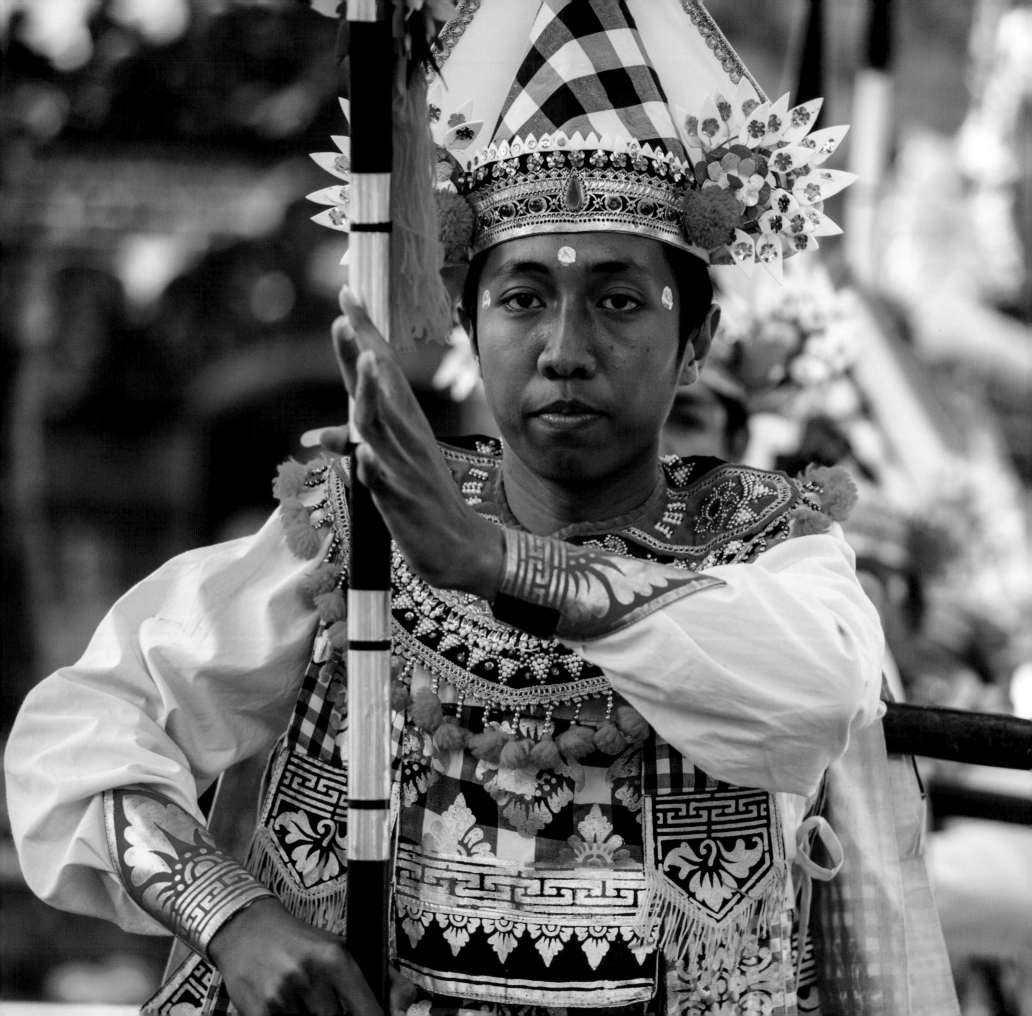

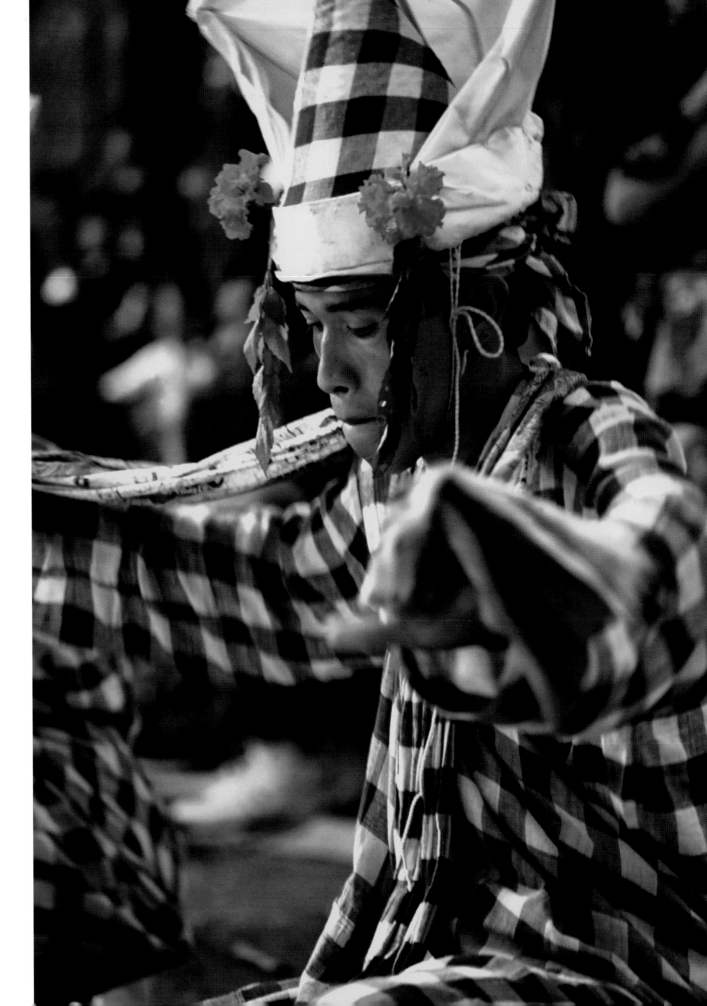

This Page: During a cremation in the village of Kuta, a young man performs a solemn Baris Gede. The dance, commonly performed at cremation rites, is associated with the rituals of war and is considered an offering to the gods.

Facing Page: Baris Gede dancers perform at Puri Agung Blahbatuh prior to the procession to the cremation grounds.

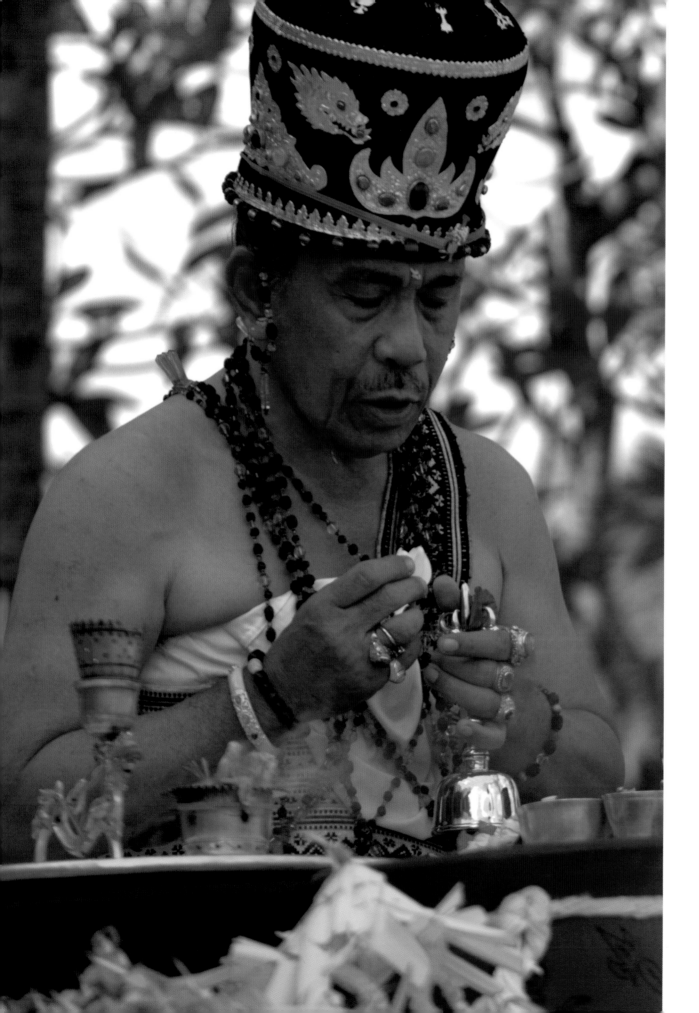

This Page: A Balinese High Priest (Pendanda) chants magical incantations (Mantra) and prayers to ensure the deceased's soul (Atman) enjoys safe and speedy passage to its ethereal form during a royal cremation ritual in Batubulan.

Facing Page: A charred ceremonial umbrella lies at the base of a cremation pyre emblazoned with the face of Hindu deity Kala Boma following a cremation in Peliatan. Boma represents the earth goddess through who's mouth all spirits must pass for symbolic death and cleansing prior to union with the gods.

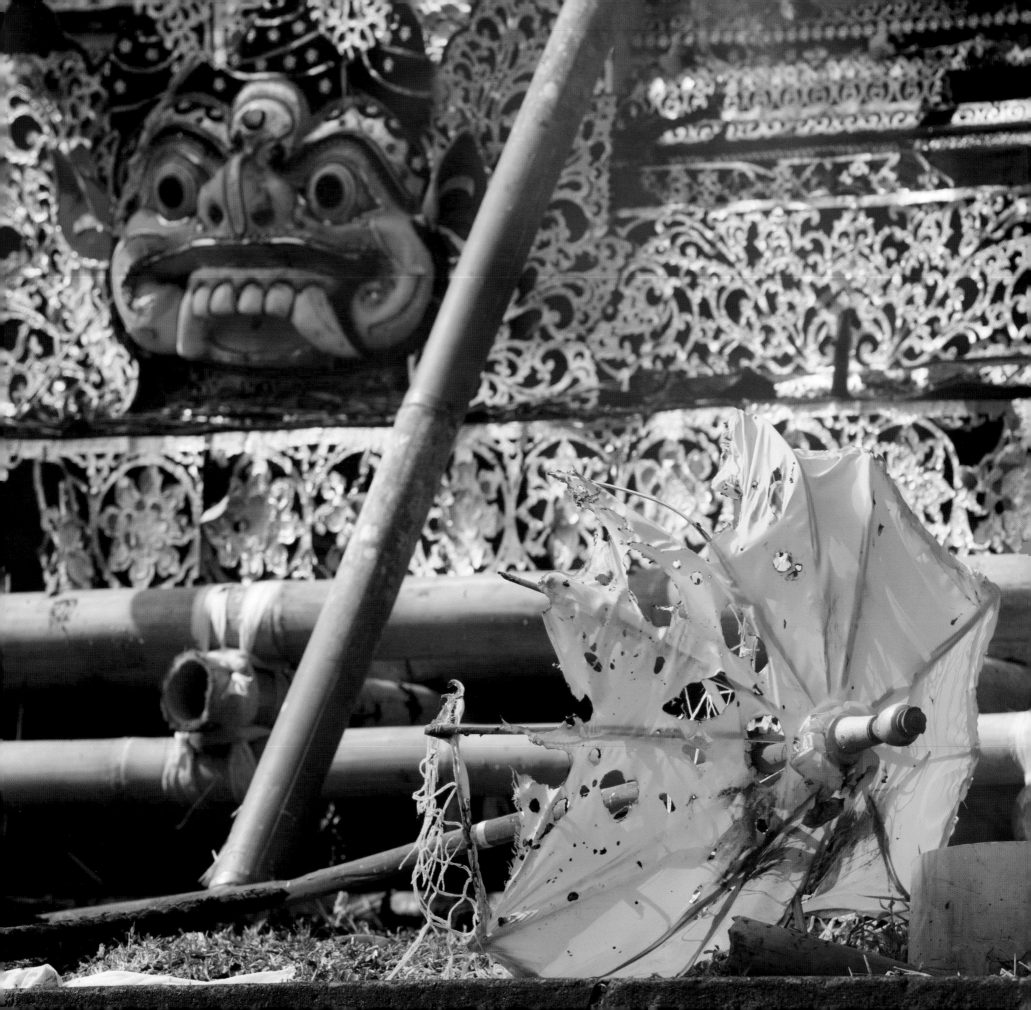

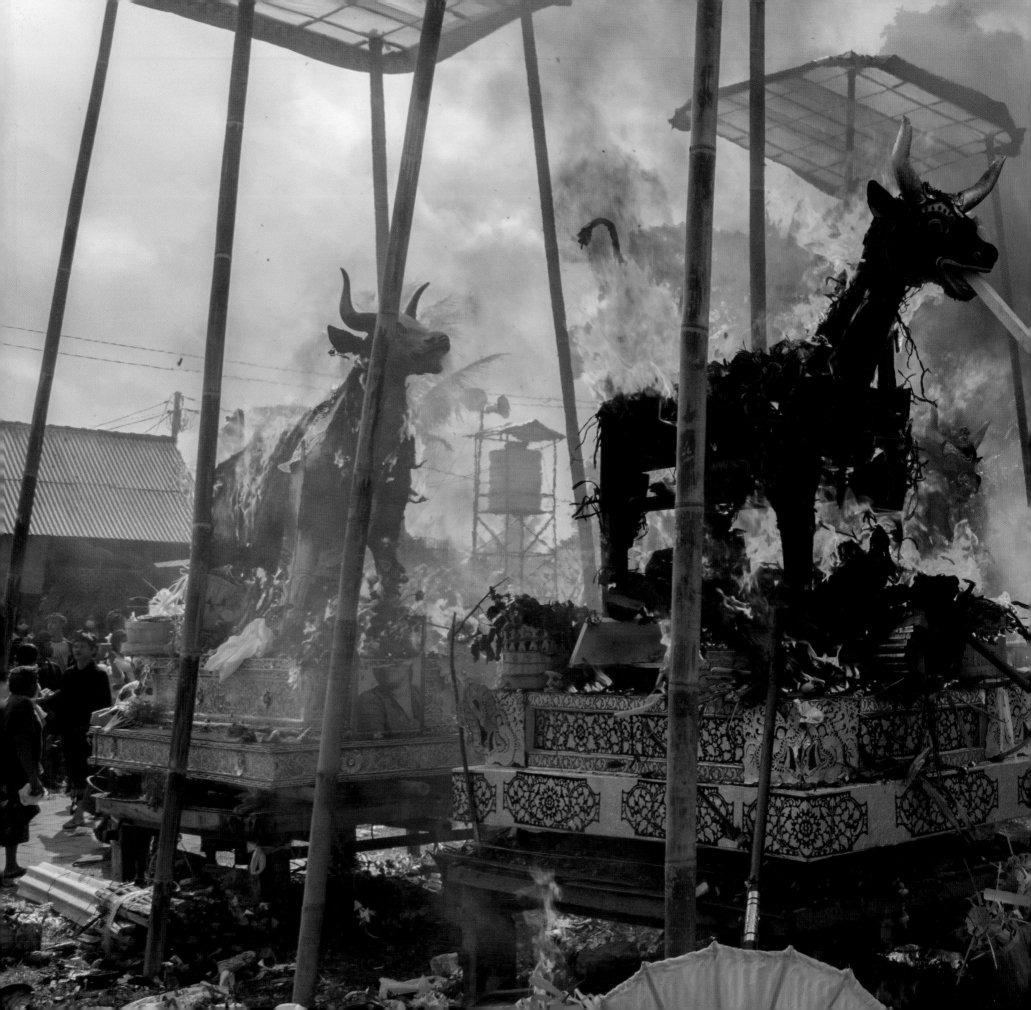

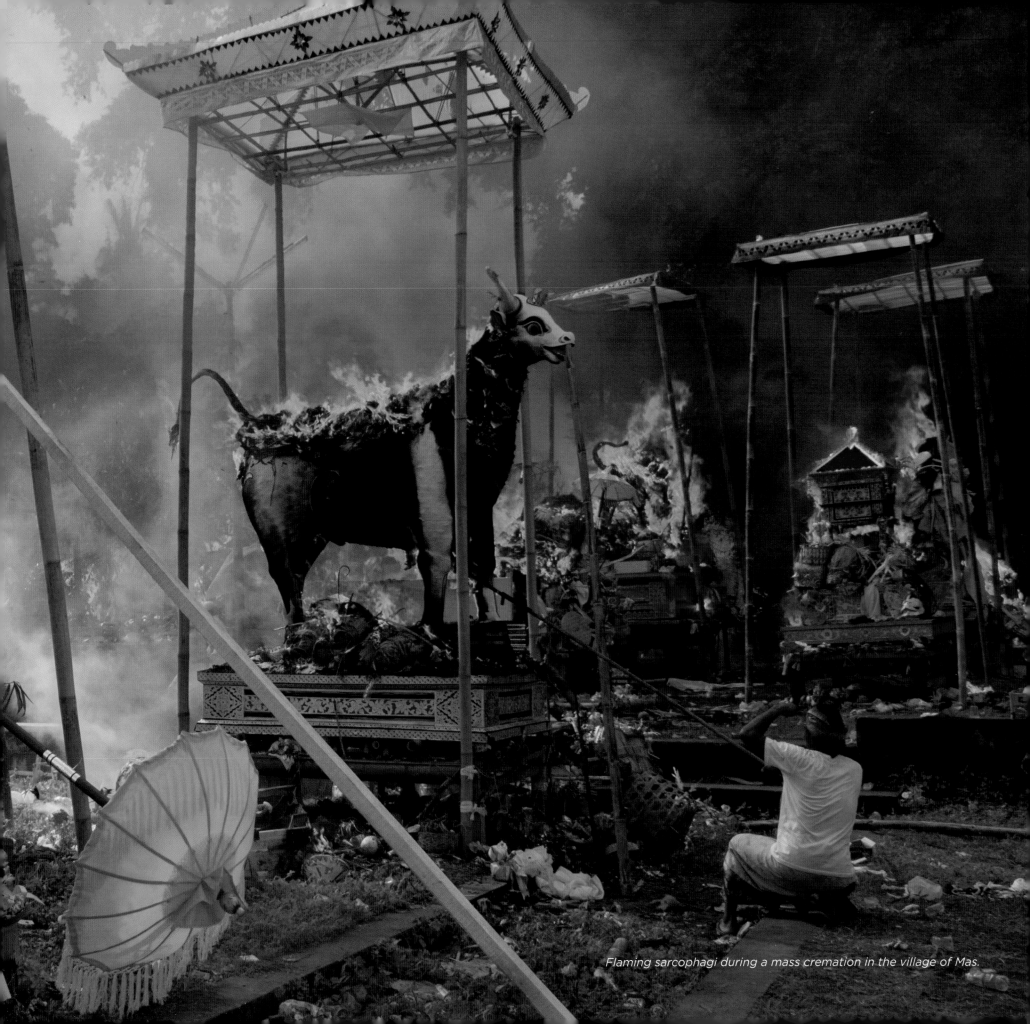

Flaming sarcophagi during a mass cremation in the village of Mas.

This Page: *During a royal cremation ritual in Batubulan, the bull sarcophagus holding the remains of the deceased is set ablaze. Behind can be seen a giant snake or dragon effigy also in flames. Known as "Naga Banda", the snake effigy is reserved for the cremation of royalty only and also serves as a vehicle to carry the departed's soul to heaven*

Facing Page: *The charred skull of a sacrificial water buffalo and broken clay pots used for holding holy water smolder following a royal cremation in Batubulan. All implements used during cremation rites are considered unclean and must be burned after use.*

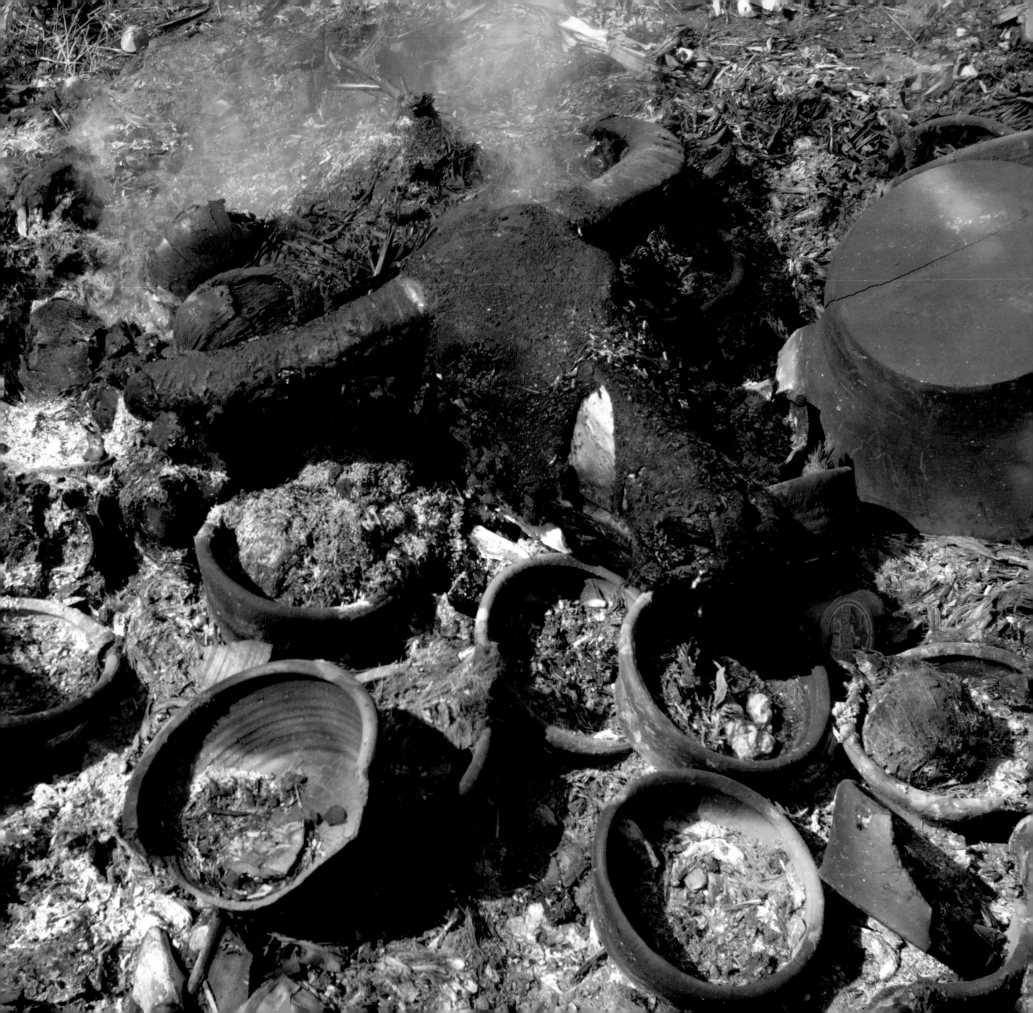

Tamblingan

A Volcanic Lake Shrouded in Mist and Mystery

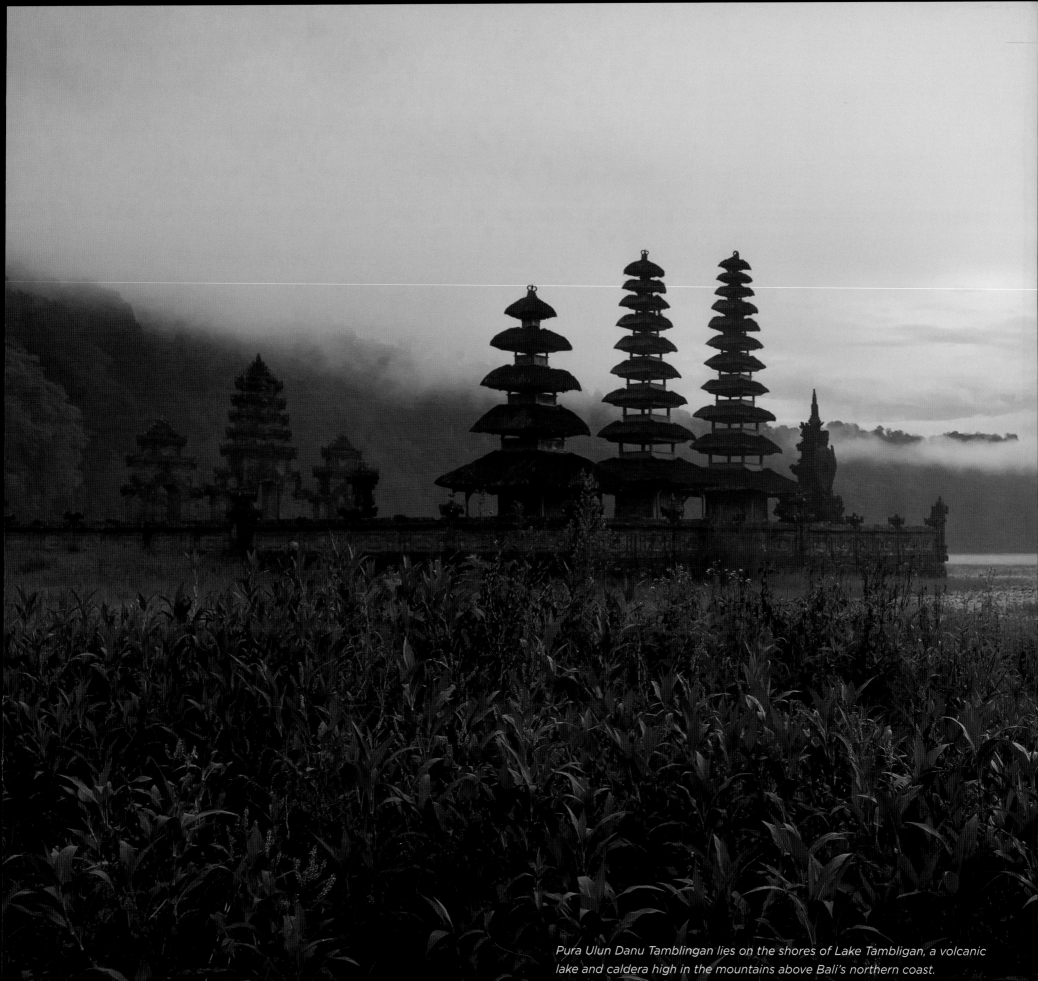

Pura Ulun Danu Tamblingan lies on the shores of Lake Tambligan, a volcanic lake and caldera high in the mountains above Bali's northern coast.

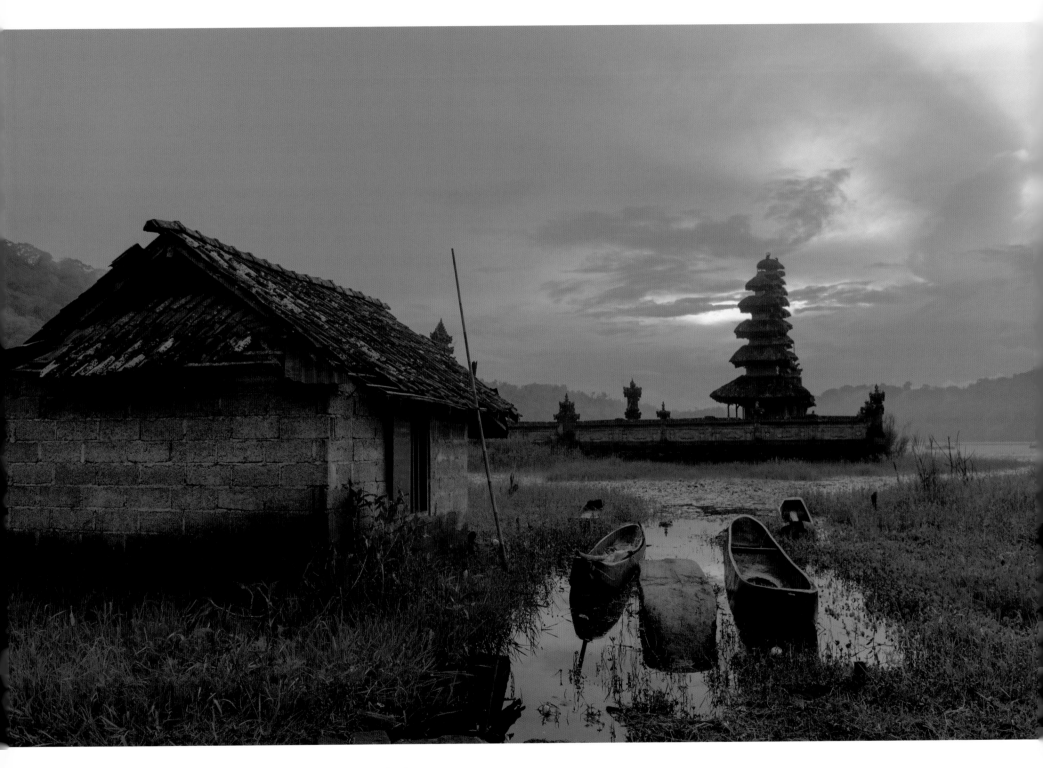

The water level of Lake Tamblingan rises with the seasonal rains, encroaching upon homes built by the lake's edge. Here, dugout canoes and an abandoned home lie on a flooded patch of ground. Pura Ulun Danu Tamblingan, the village temple, is silhouetted against the sunrise.

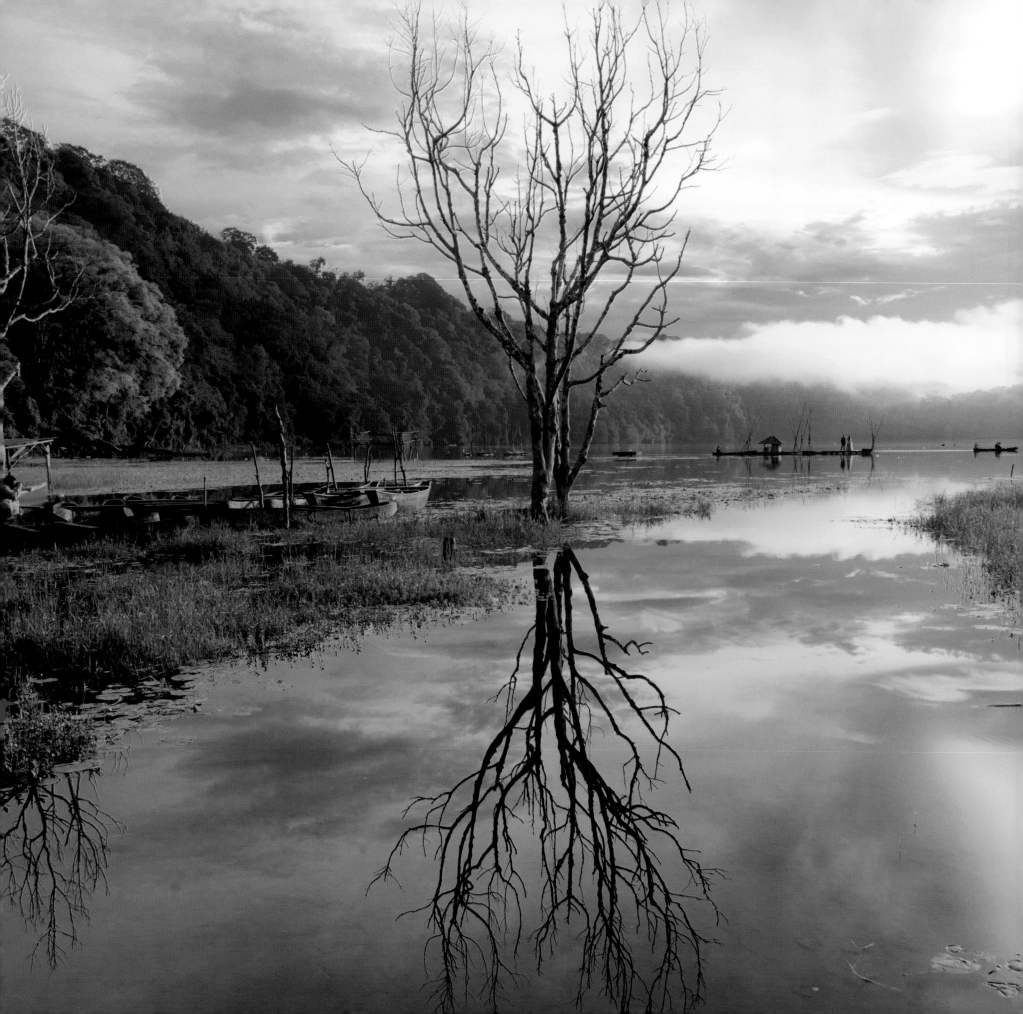

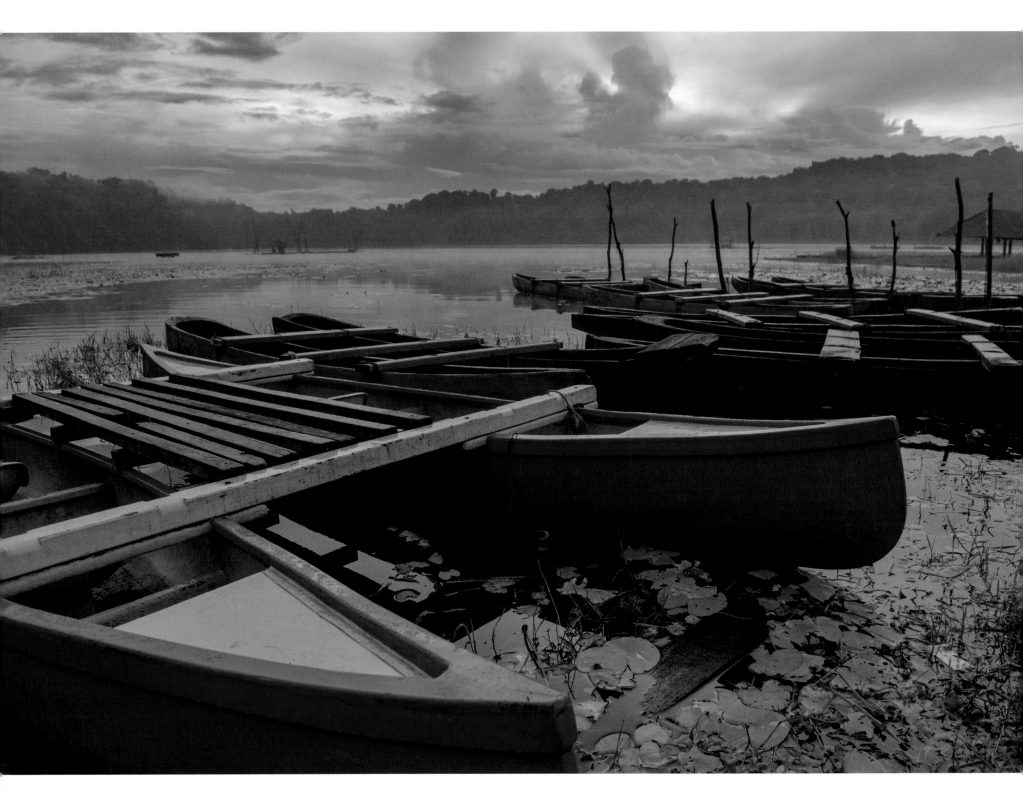

Canoes, both modern and traditional dugout, line the shore of Lake Tamblingan.
Shortly after sunrise, they will be put to use transporting visitors to the floating raft
anchored in the center of the lake.

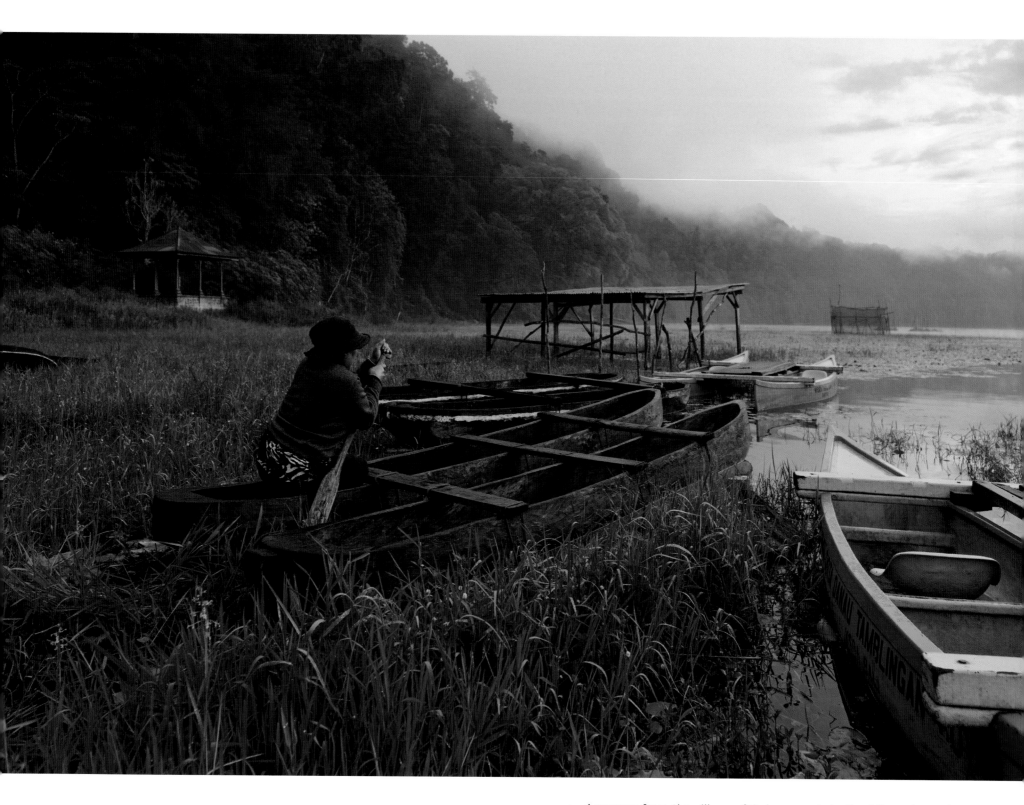

A woman from the village of Gubung on Lake Tamblingan's southern shore launches her canoe into the lake's misty waters at daybreak.

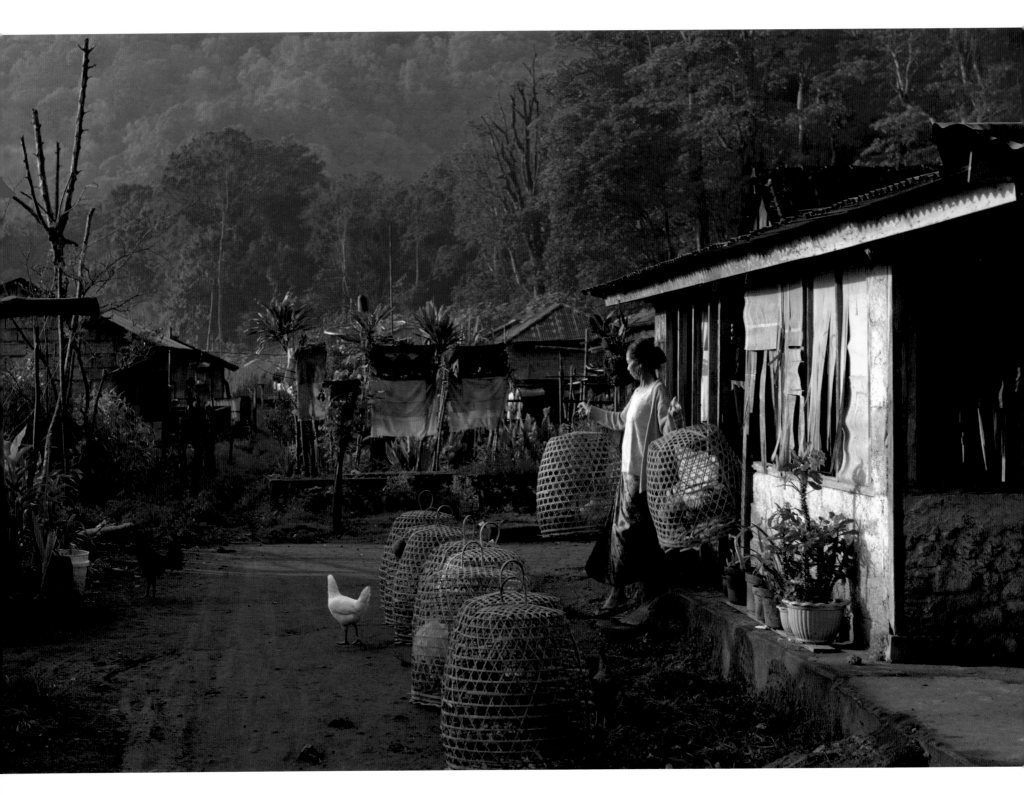

*A woman of Gubung village on Lake Tamblingan's shore brings
out baskets of fighting cocks to air in the morning sunlight.*

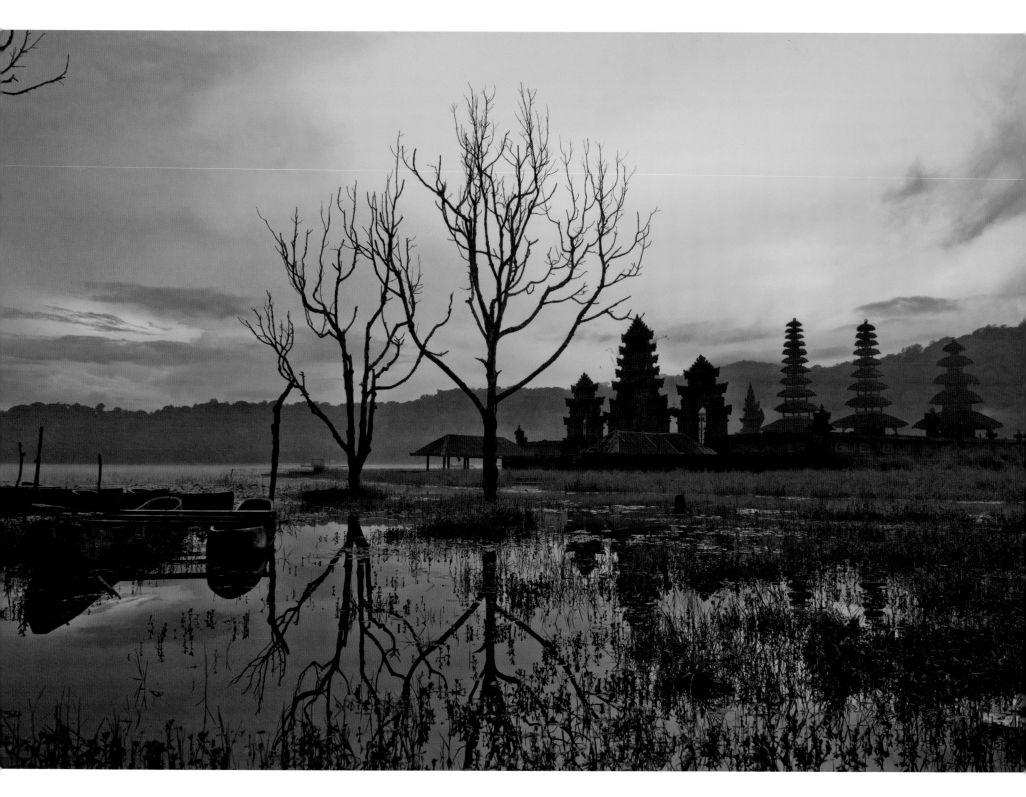

The lake and adjacent temple are bathed in an ethereal glow as sunrise creeps over the caldera rim.

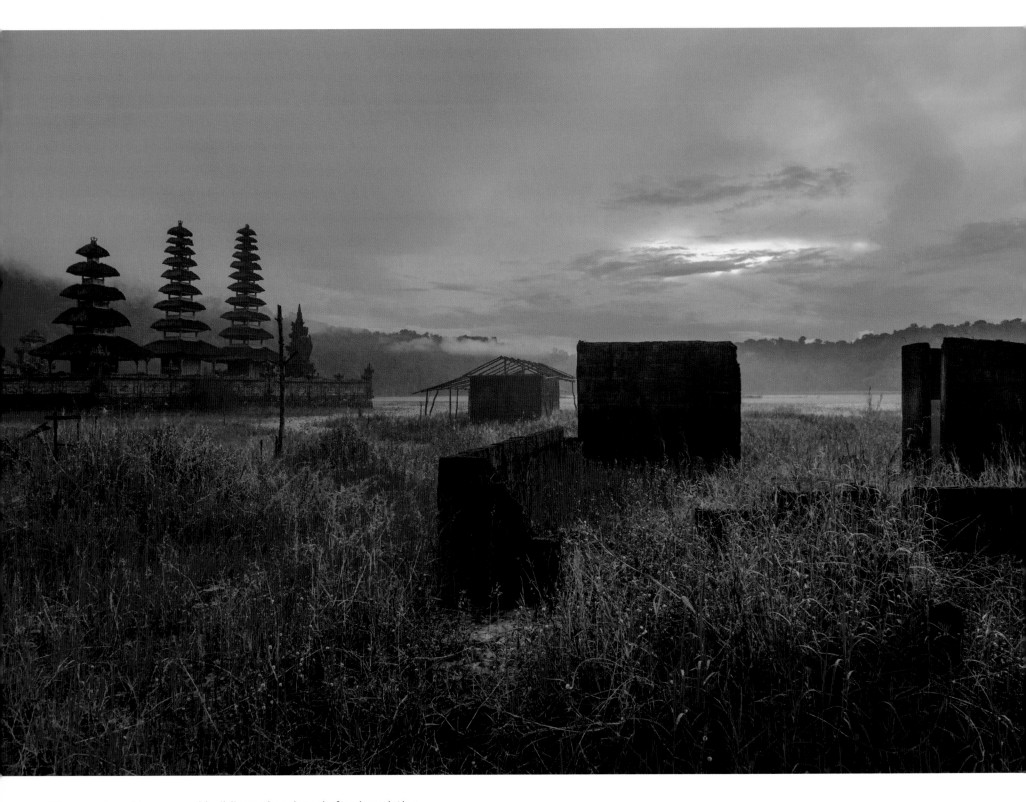

The remains of homes and buildings abandoned after inundation by rising lake waters rise like ancient monoliths from the marshes surrounding Pura Ulun Danu Tamblingan.

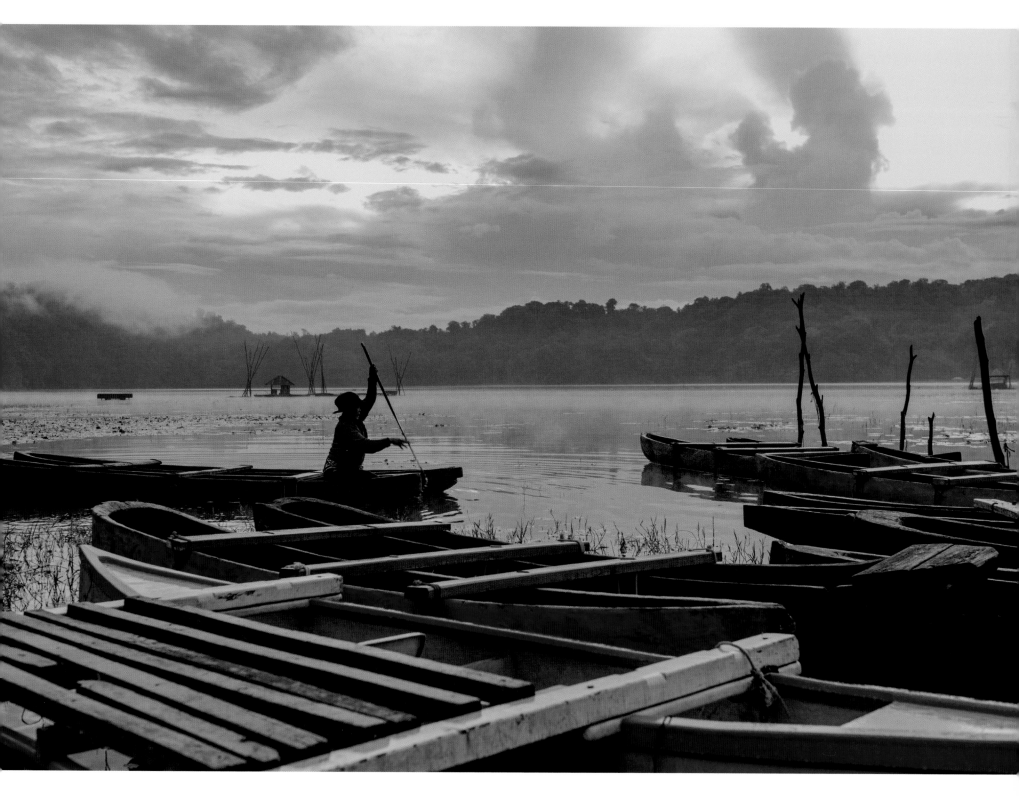

Using a pole to negotiate the shallow lake waters, a woman prepares for a busy morning of transporting passengers to the lake's center.

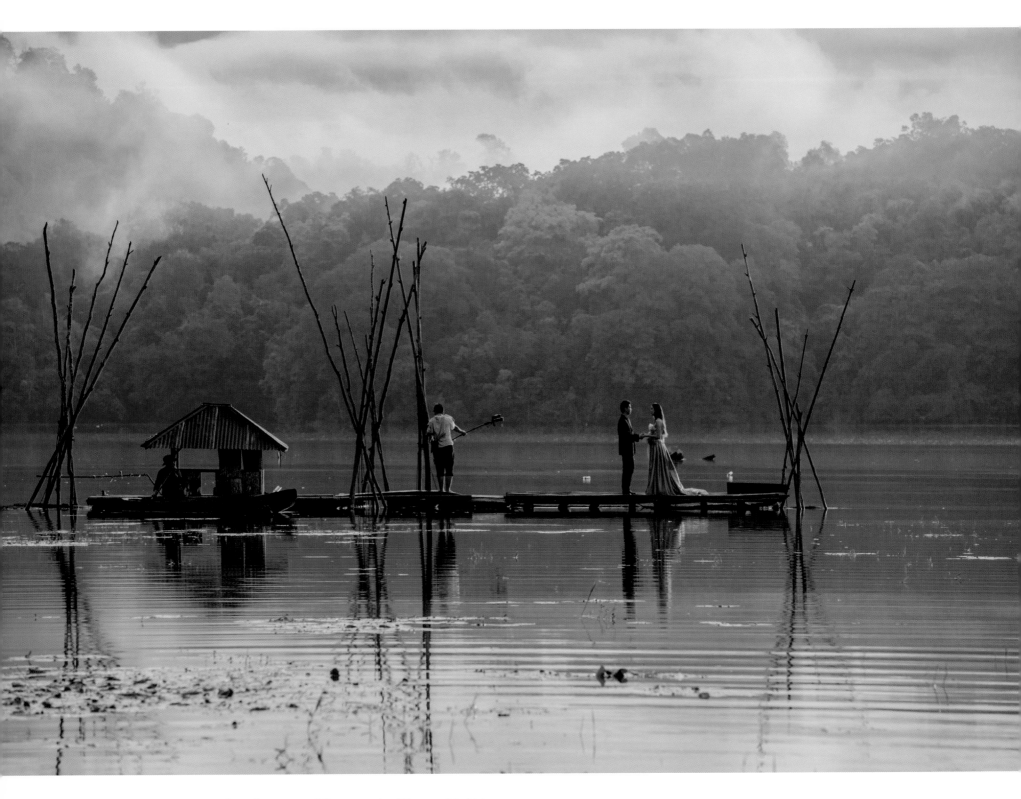

A couple and their film crew take advantage of the surreal setting and light to make their pre-wedding video on the floating platform anchored in the center of Lake Tamblingan.

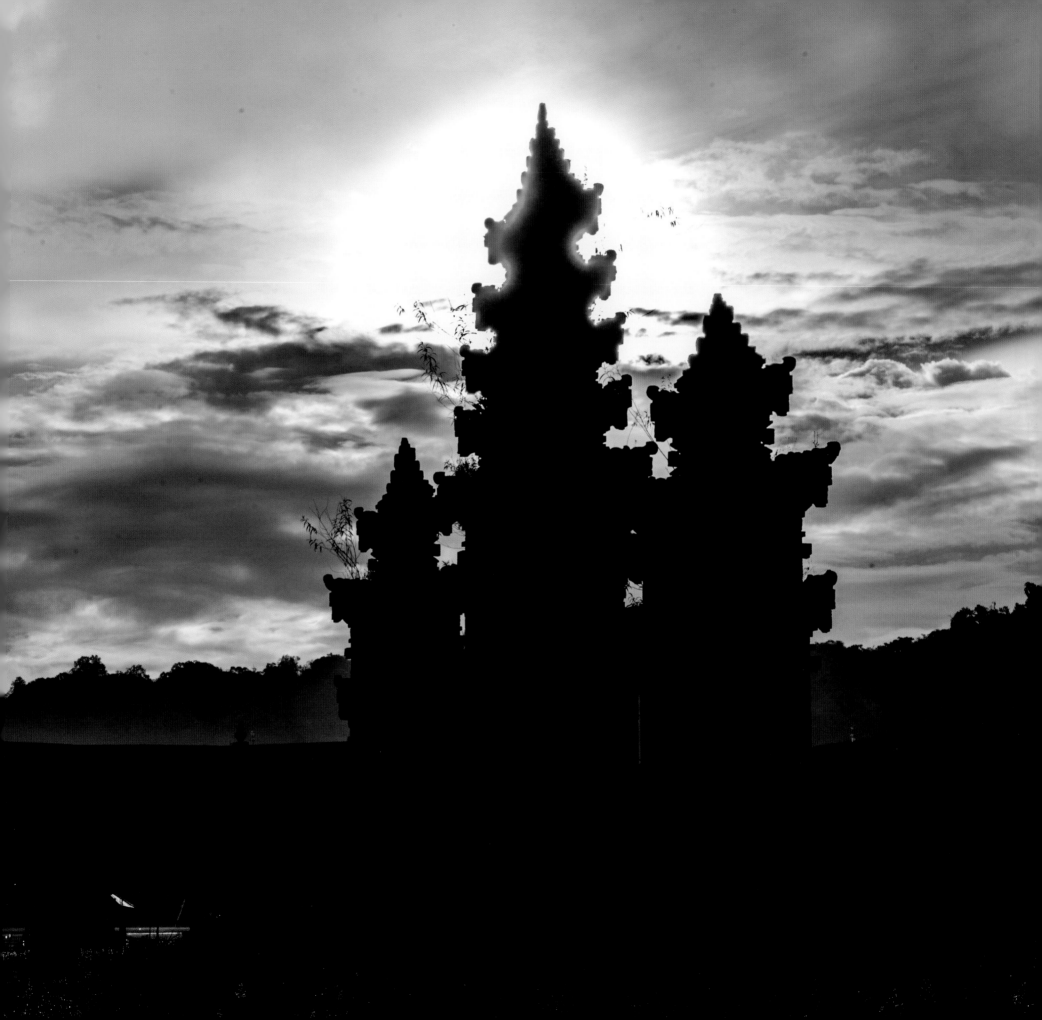

Trance

The Phenomenon of Spirit Possession

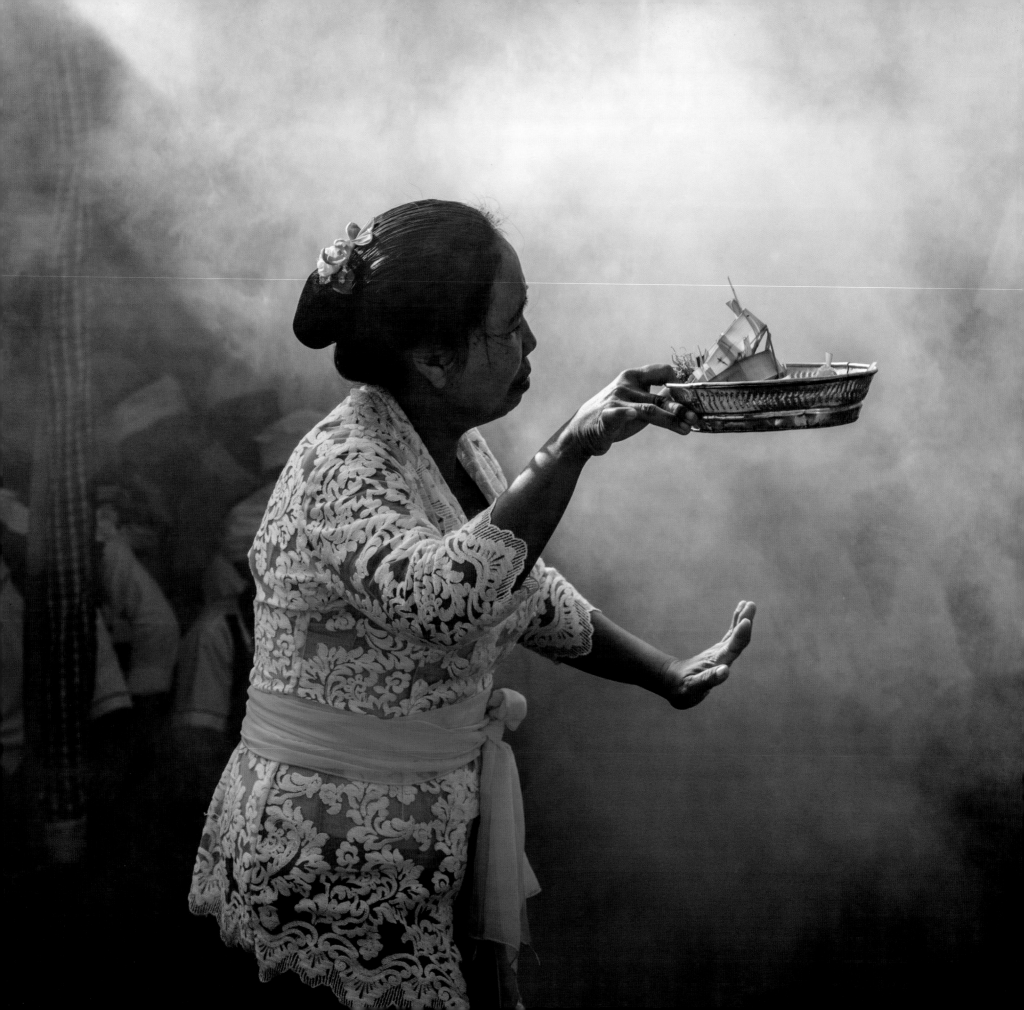

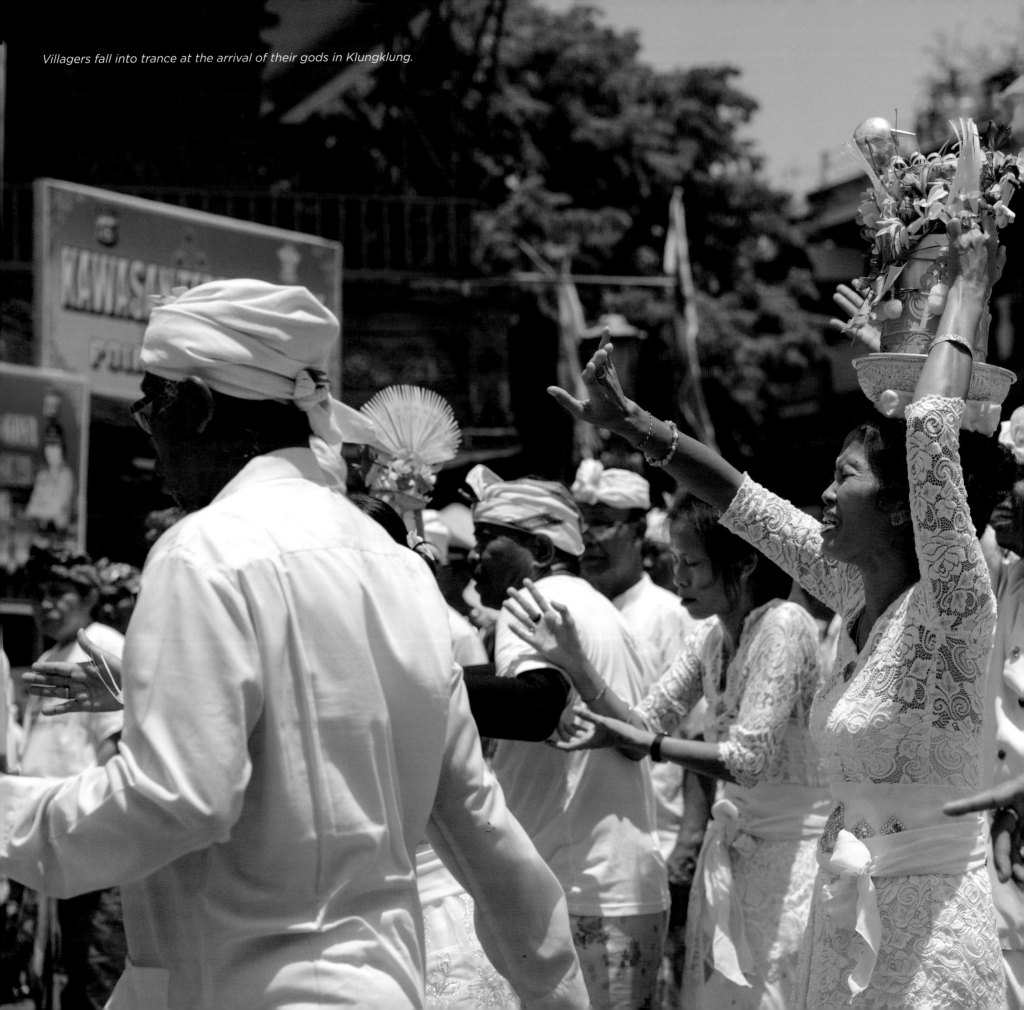

Villagers fall into trance at the arrival of their gods in Klungklung.

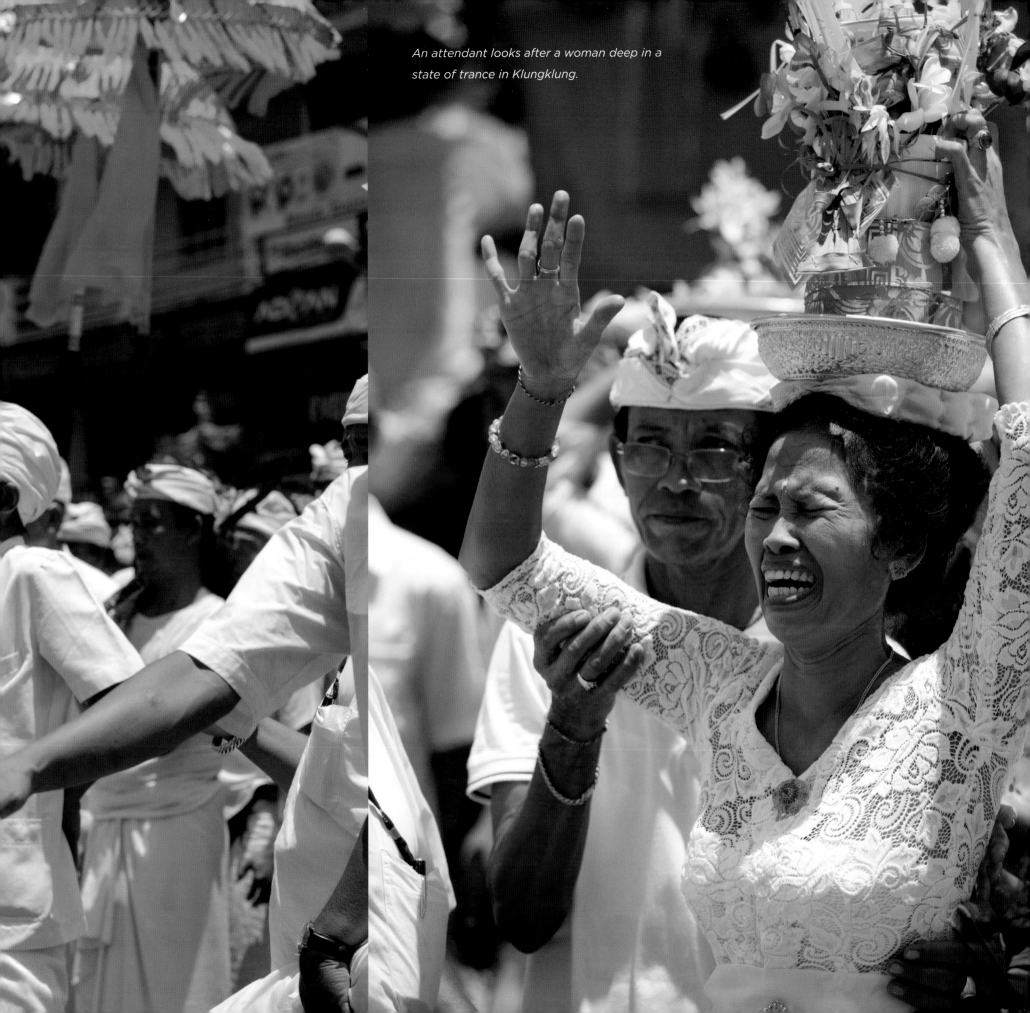

An attendant looks after a woman deep in a state of trance in Klungklung.

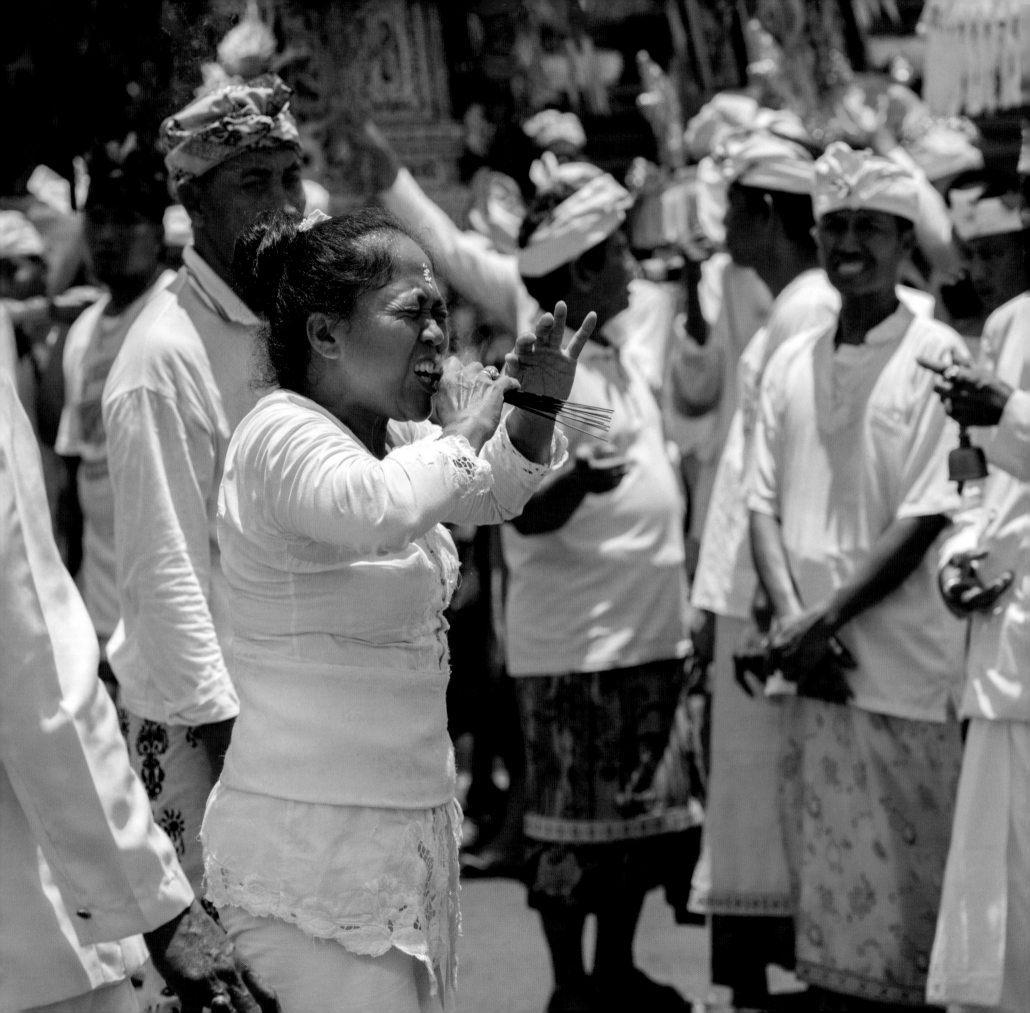

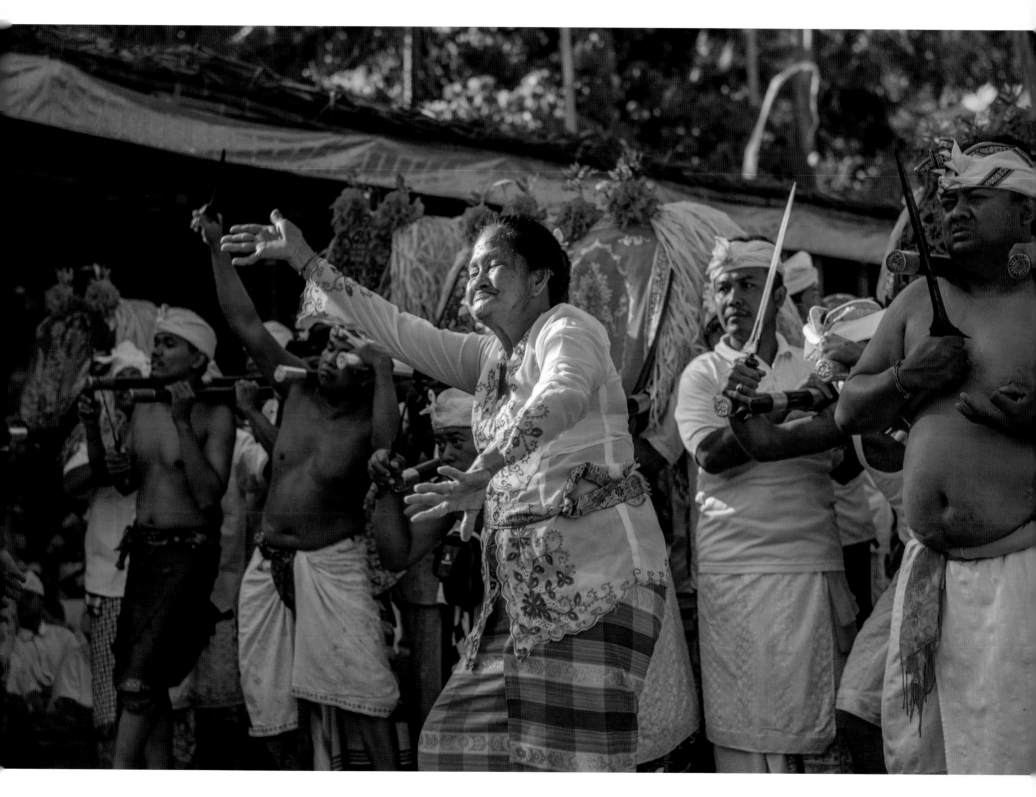

This Page: *Mass trance ceremony in the village of Selumbung, Karangasem Regency.*

Facing Page: *During a massive ceremony in the city of Klungklung, a woman in trance bites off the burning tips of joss sticks yet remains unharmed.*

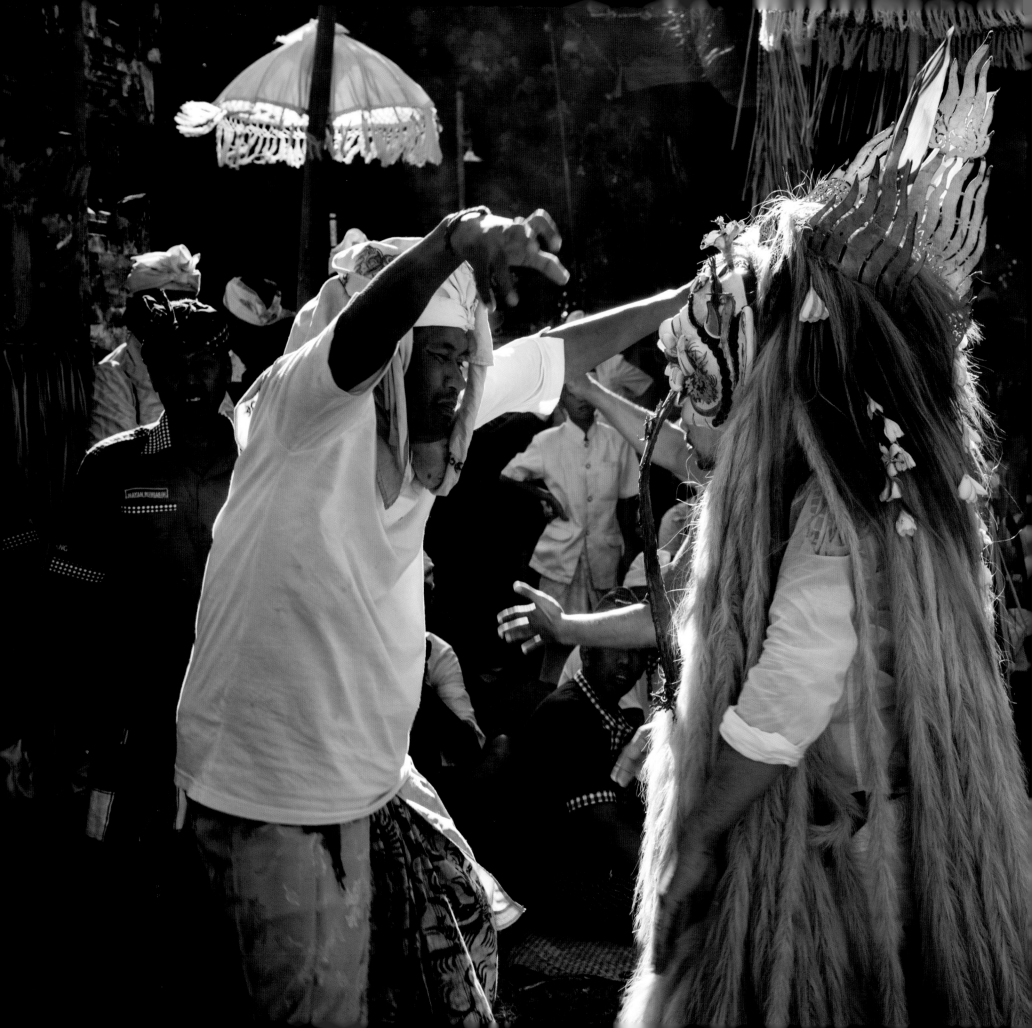

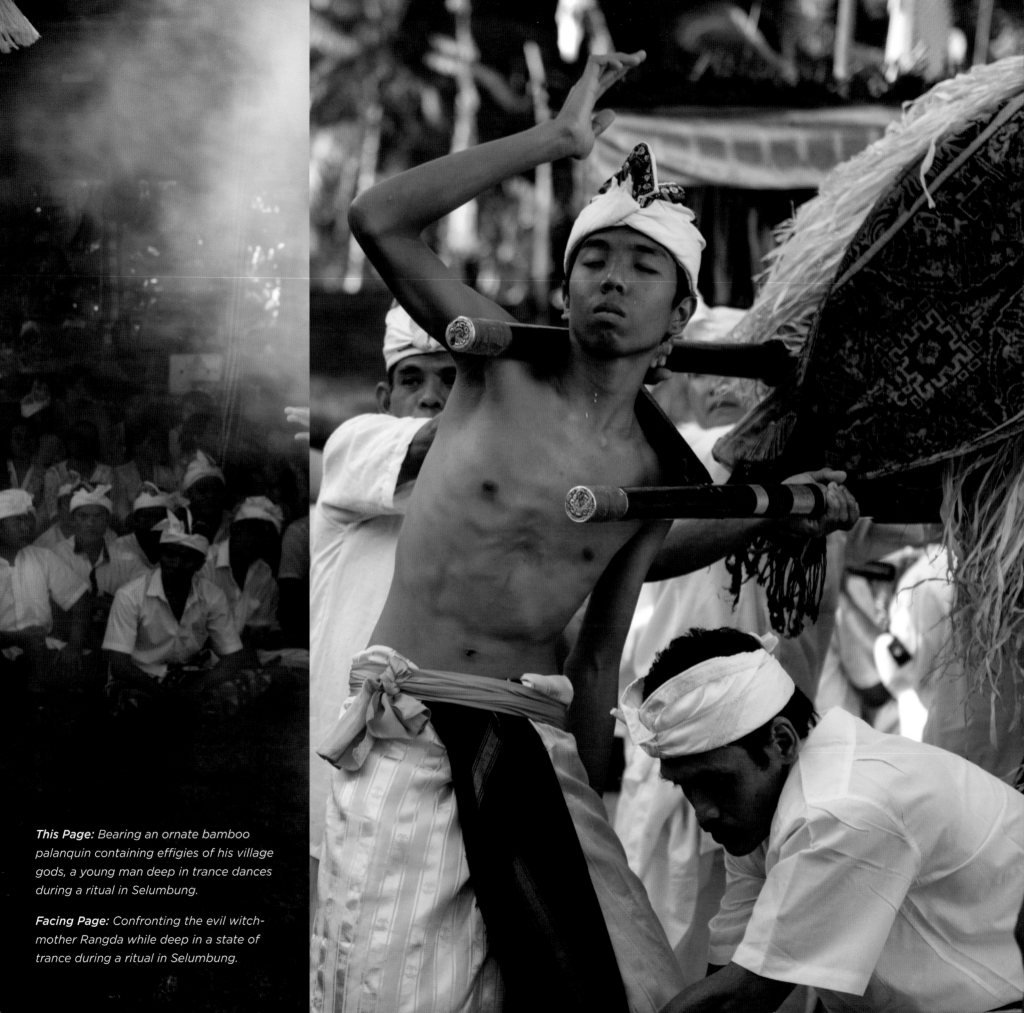

This Page: Bearing an ornate bamboo palanquin containing effigies of his village gods, a young man deep in trance dances during a ritual in Selumbung.

Facing Page: Confronting the evil witch-mother Rangda while deep in a state of trance during a ritual in Selumbung.

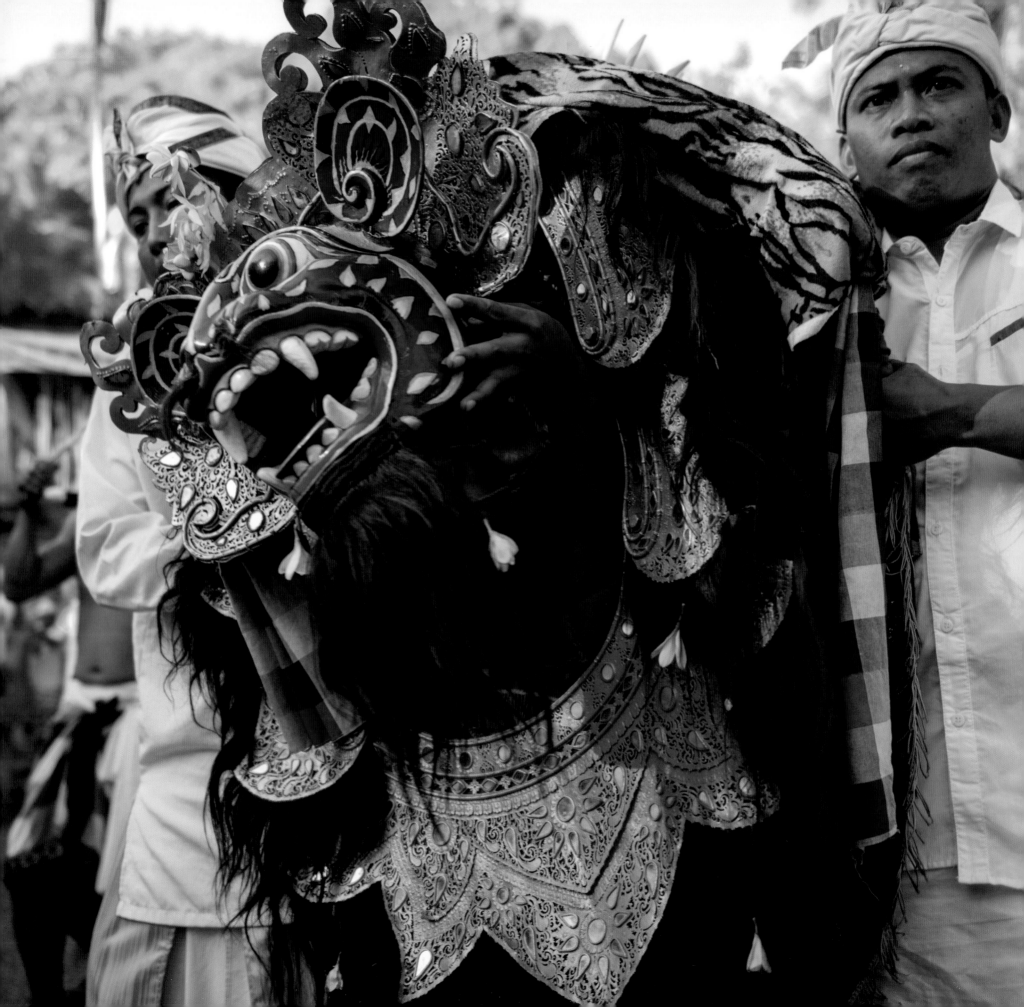

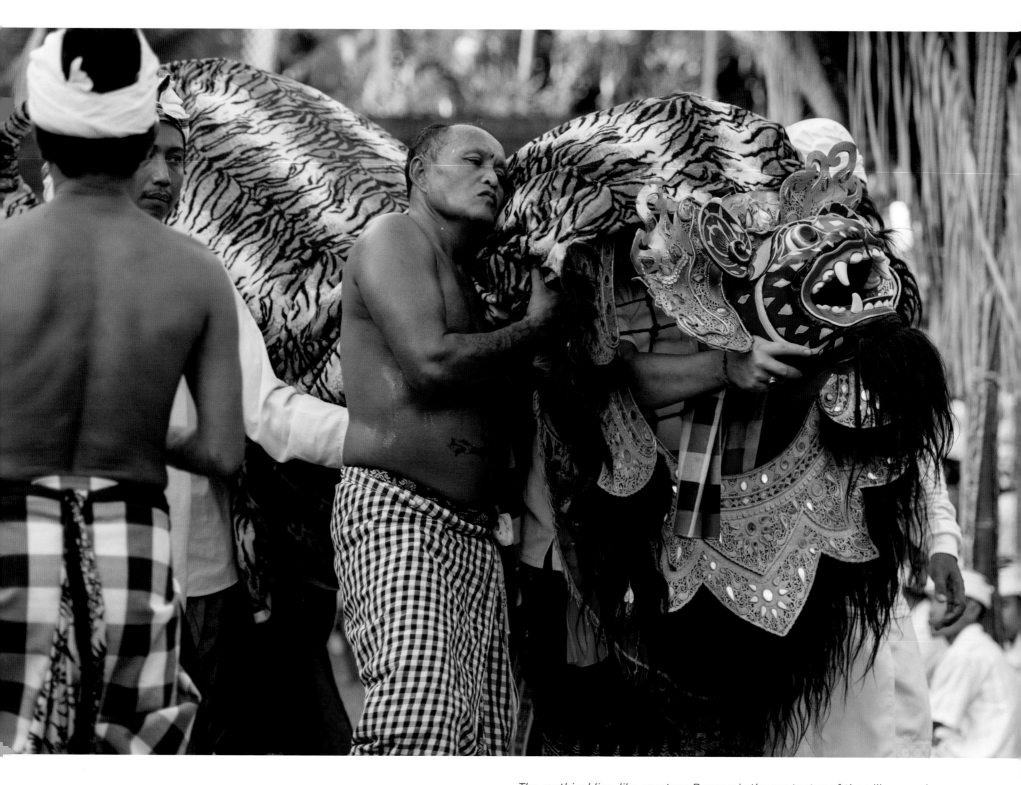

The mythical lion-like creature Barong is the protector of the village and representative of all forces for good. This particular Barong, from the village of Selumbung in Karangasem Regency, is covered in a fabric of tiger stripes and is being brought out for an Odalan ceremony at the village Pura Puseh temple.

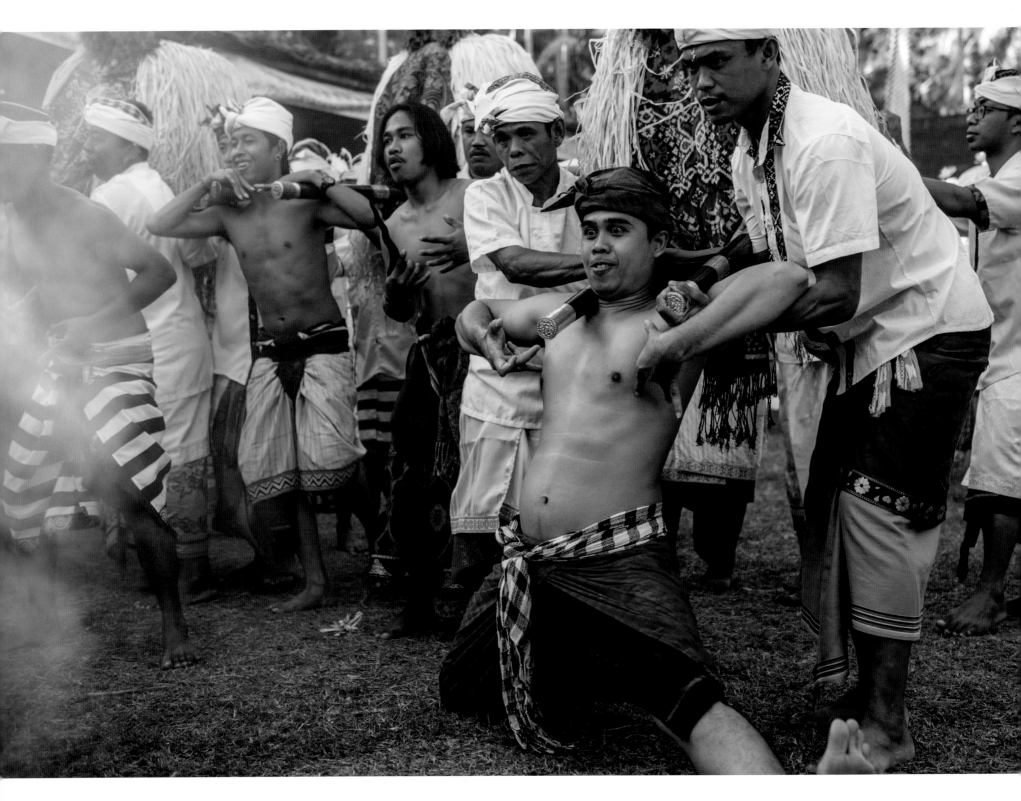

This Page: *Eyes bulging, a man experiences a deep trance state during rituals at Pura Pusek Desa Selumbung.*

Facing Page: *Ritual self-mutilation during a trance ritual in Selumbung.*

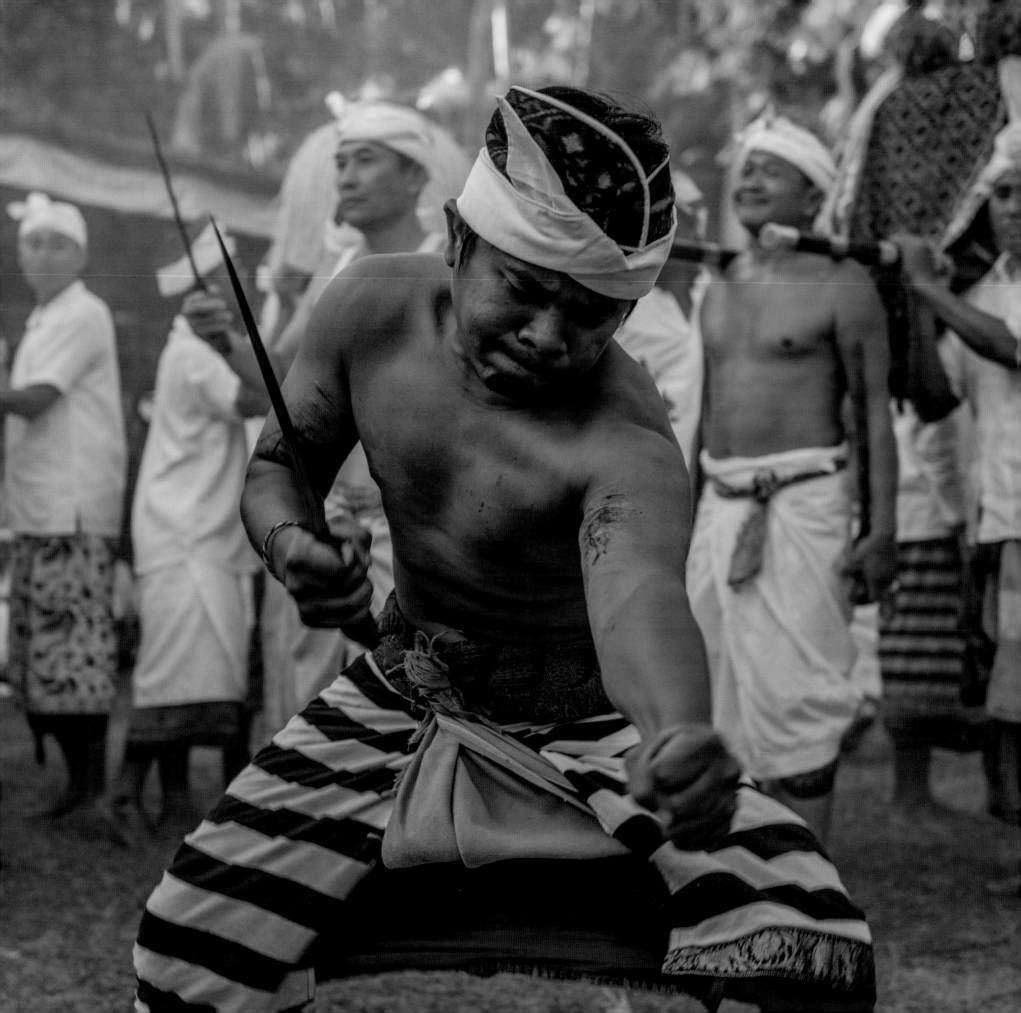

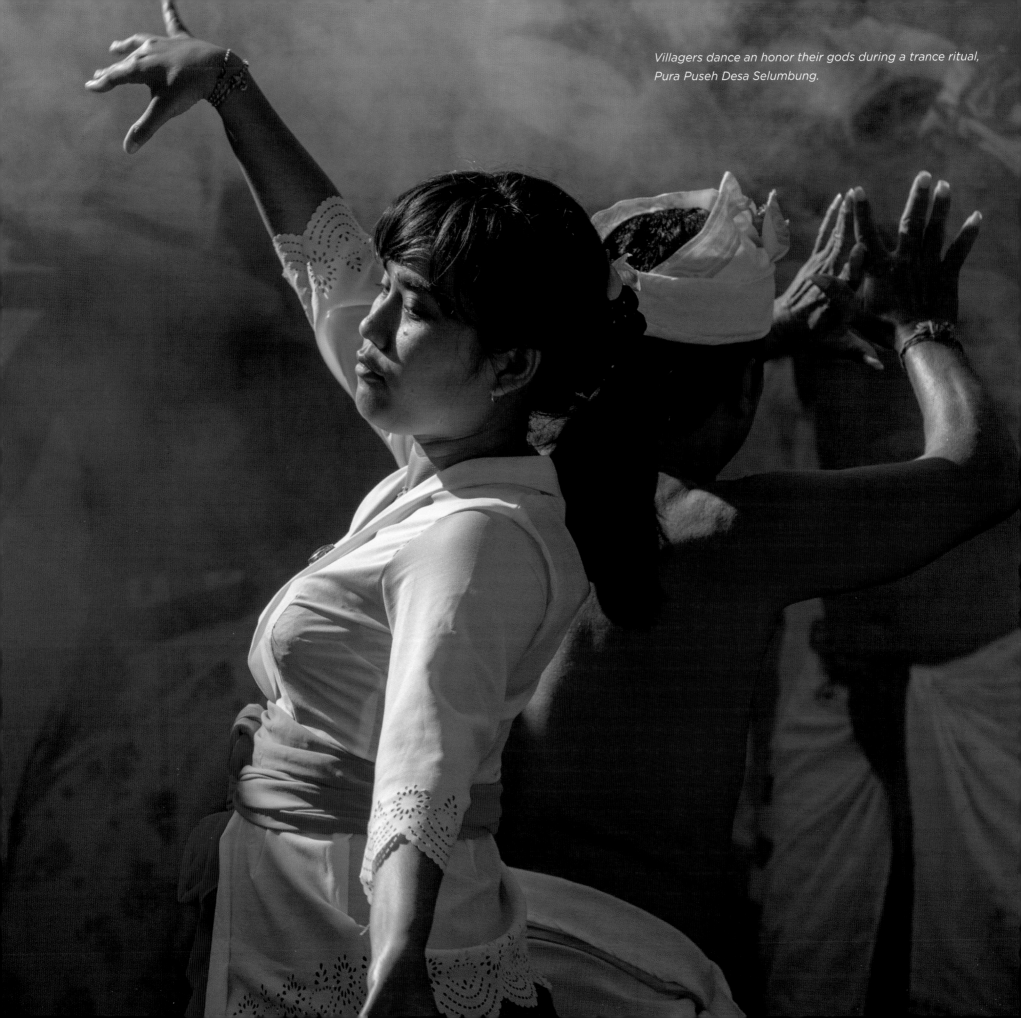

Villagers dance an honor their gods during a trance ritual, Pura Puseh Desa Selumbung.

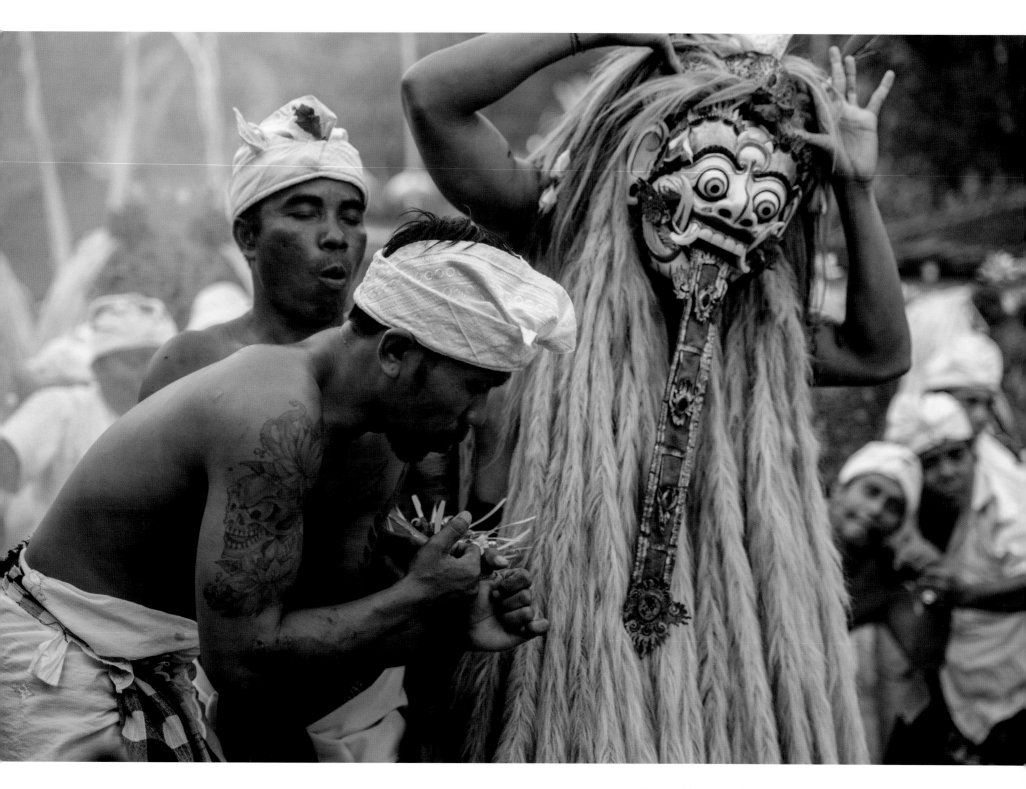

Taunted by the evil witch-mother Rangda, villagers in Selumbung fall into deep states of trance during an Odalan ceremony at Pura Puseh Desa Selumbung.

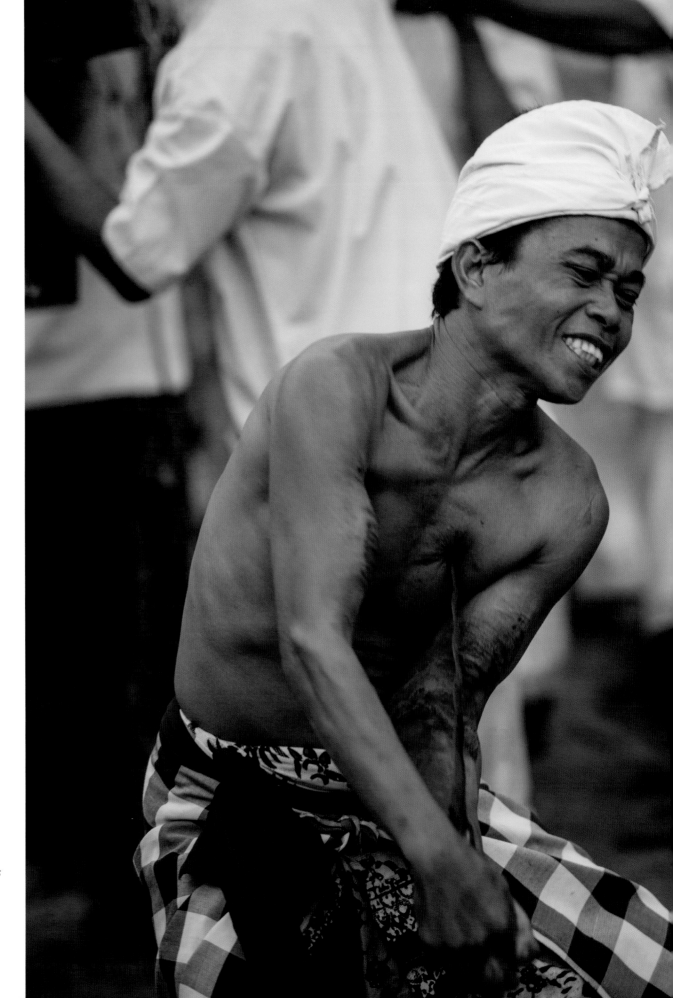

Ritual self-mutilation and self-stabbing with the magical daggers called Kris are common occurrences during Balinese trance ceremonies. While in a state of trance, the faithful are unable to pierce their skin with the sharp point of the Kris, though obviously applying a great amount of pressure.

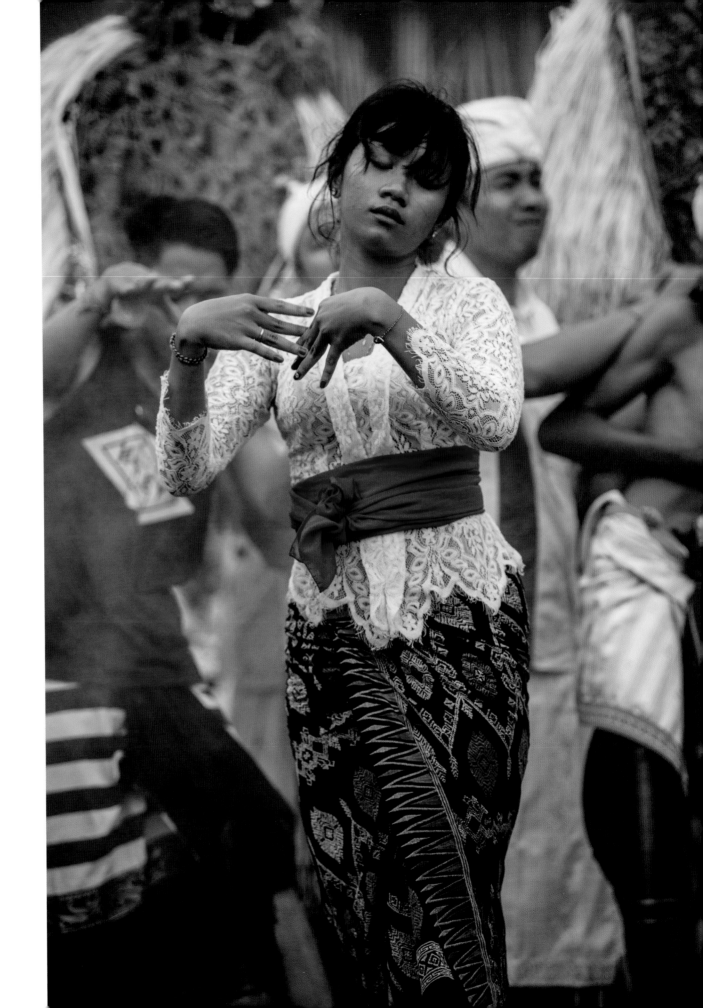

Woman in trance, Pura Puseh Desa Selumbung.

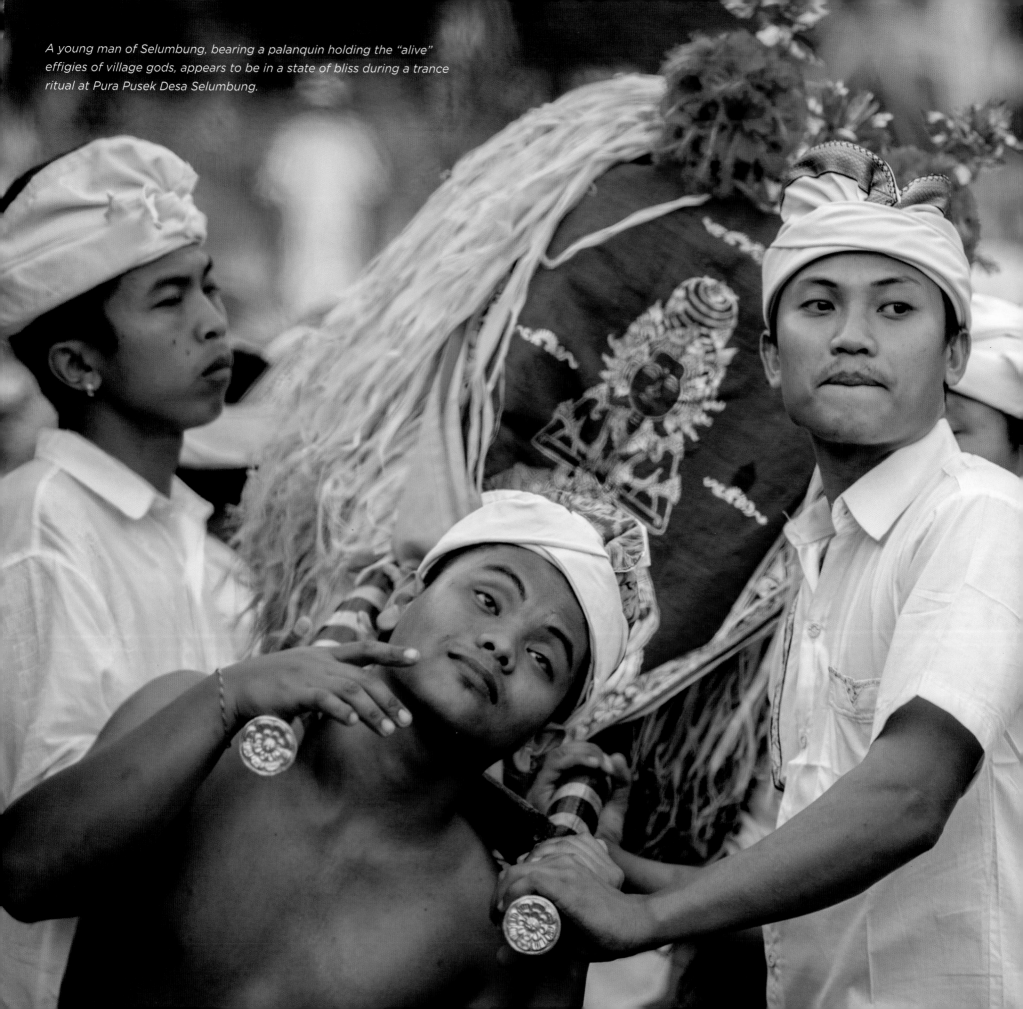

A young man of Selumbung, bearing a palanquin holding the "alive" effigies of village gods, appears to be in a state of bliss during a trance ritual at Pura Pusek Desa Selumbung.

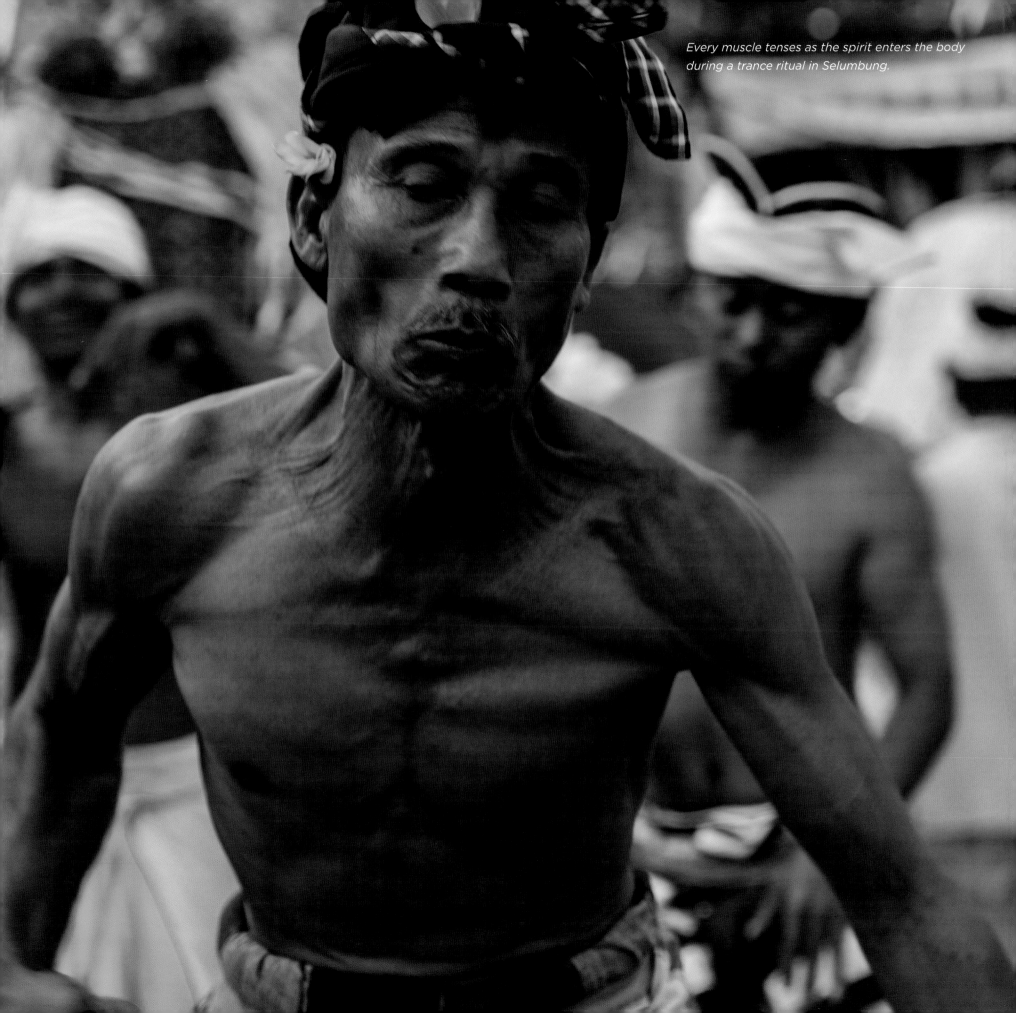

Every muscle tenses as the spirit enters the body during a trance ritual in Selumbung.

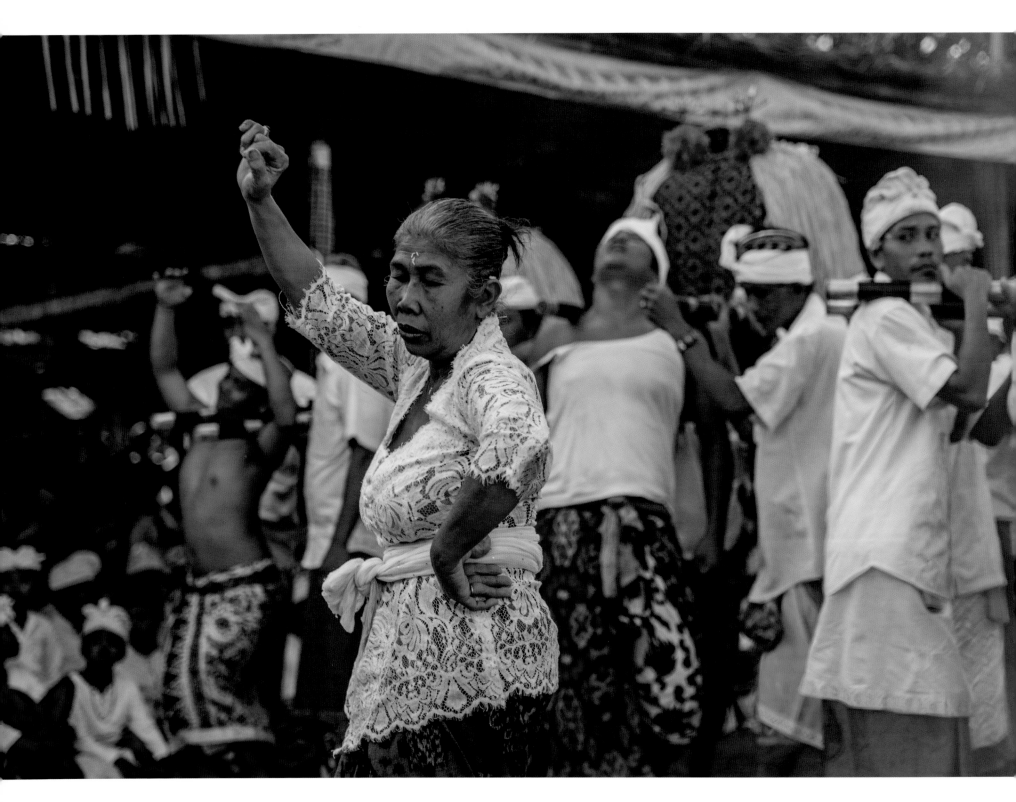

Dancing a graceful "Pendet" while in a state of trance, a woman from the village of Selumbung welcomes her gods during and Odalan ceremony at her village temple.

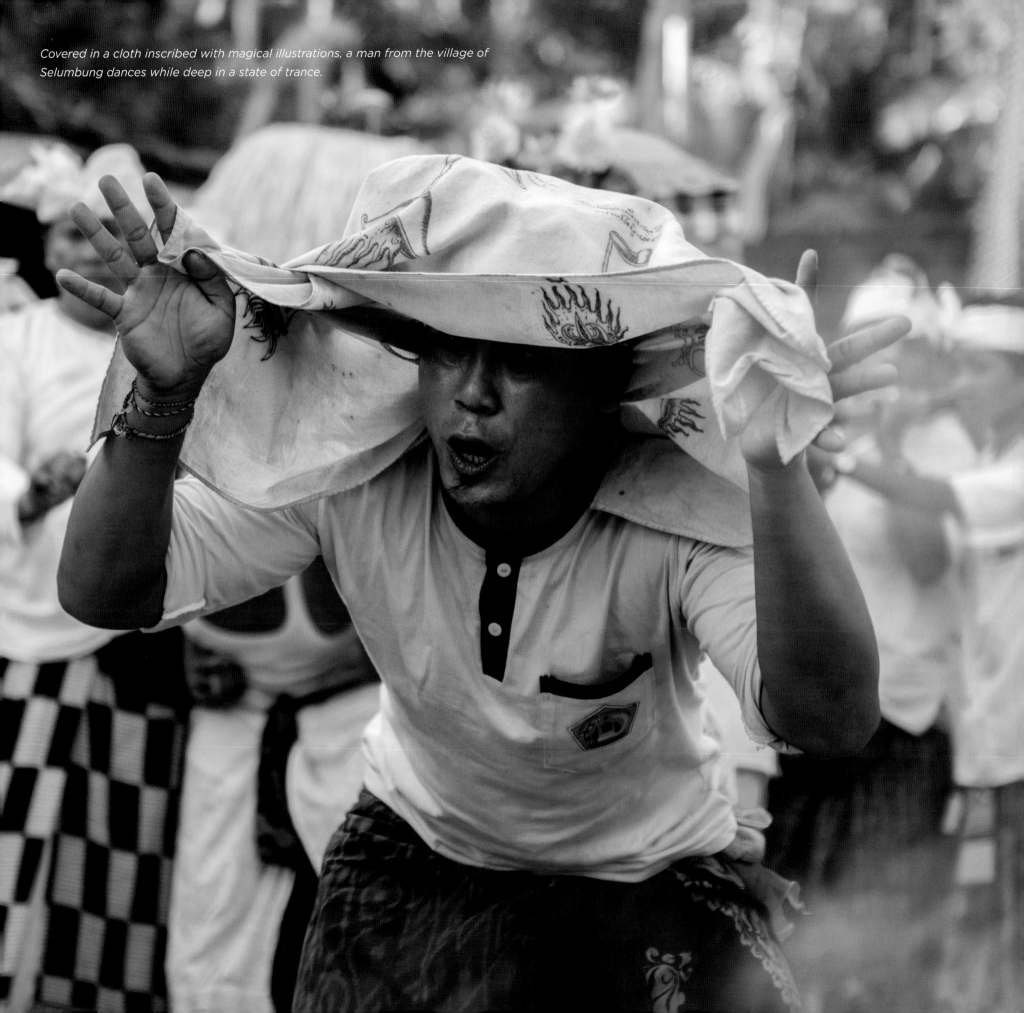

Covered in a cloth inscribed with magical illustrations, a man from the village of Selumbung dances while deep in a state of trance.

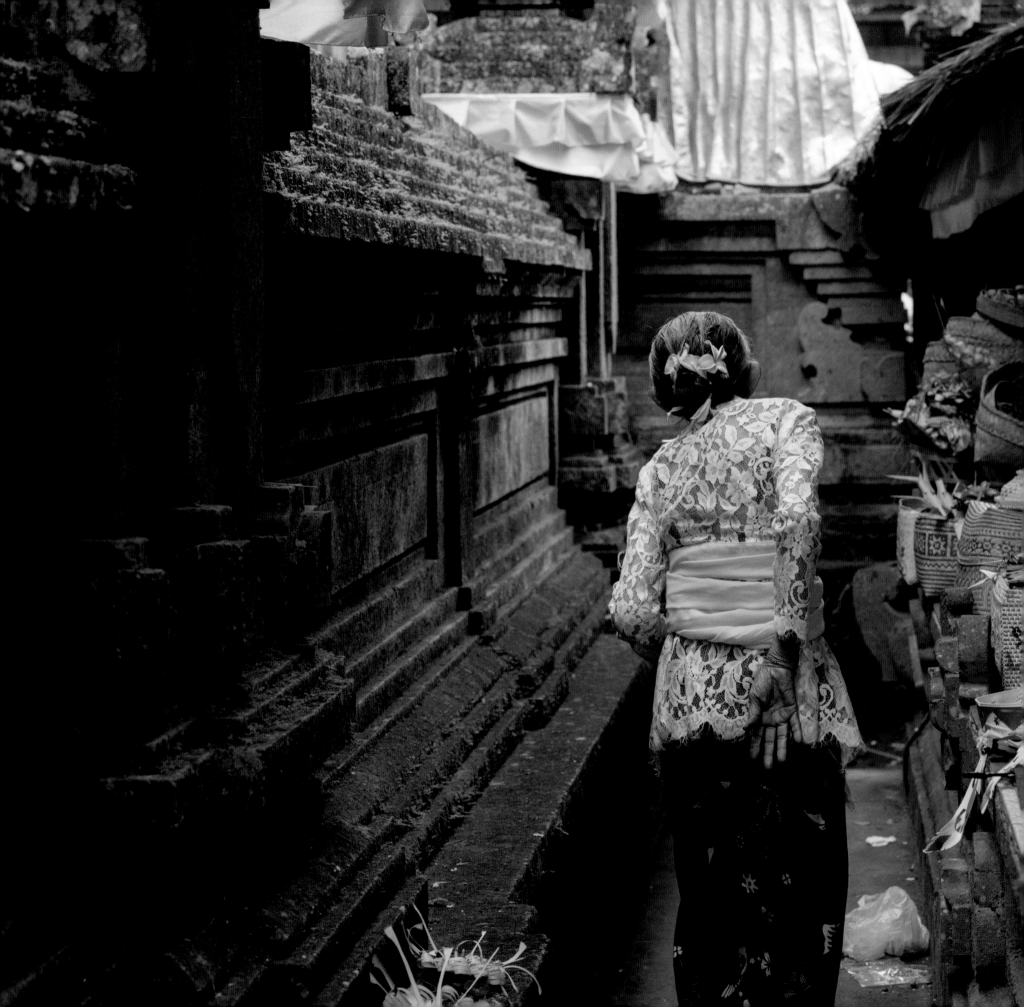

About the Author

Tony Novak-Clifford has spent the past 35 years chasing the light as a commercial, editorial and fine-art photographer; producing award-winning advertising campaigns and editorial features for local, regional and international brands and publications. Tony has called the Island of Maui, Hawaii home since 1982 and the Island of Bali his "home away from home" since the mid-1980s, making annual sojourns to visit "the most gorgeous culture on the planet". He is intensely curious about the human condition, and his sense of wanderlust has led him to explorations throughout Indonesia, New Guinea, and Cambodia.

His work has appeared in the pages of *The New York Times, Travel & Leisure, Forbes, Forbes Life, National Geographic Traveler, Architectural Digest,* in-flight magazines for United, Hawaiian Airlines, Alaska Airlines, Philippine Airlines, and many others.

Photo Credit: Tony van Den Hout